MW01078576

LEGACY

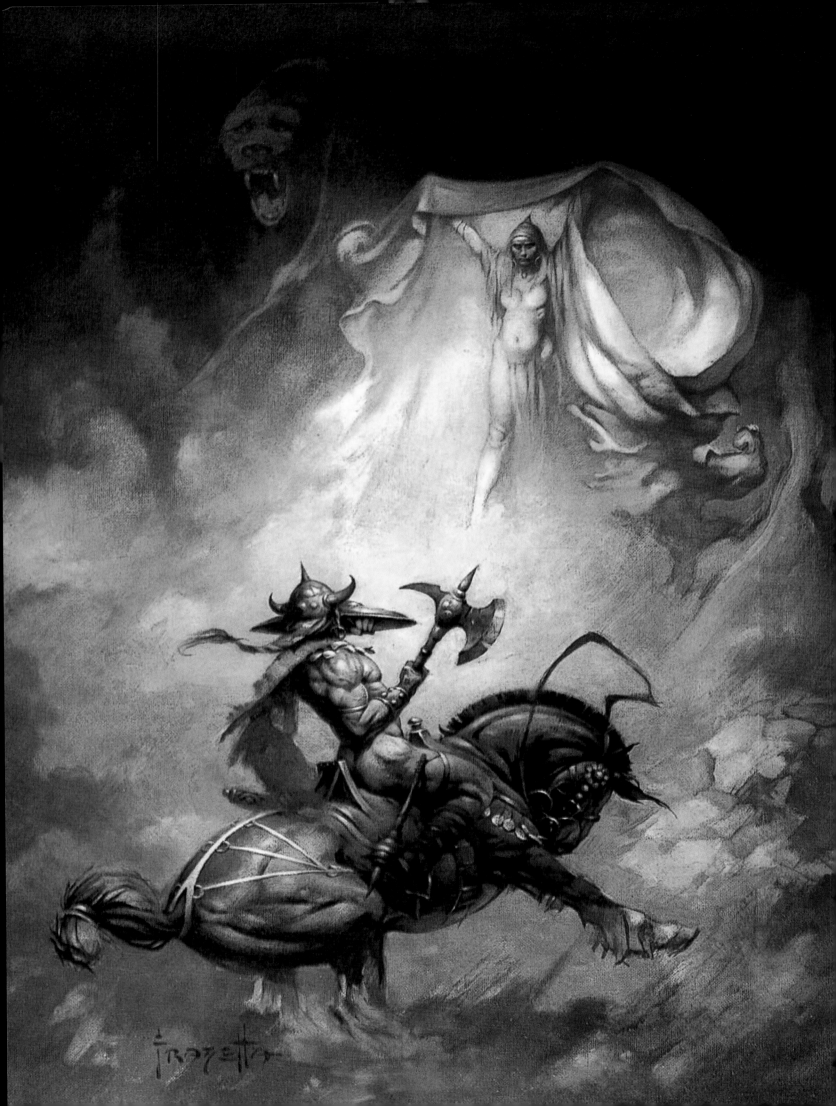

LEGACY

Selected Drawings & Paintings by

FRANK FRAZETTA

Edited by Arnie Fenner & Cathy Fenner

UNDER WOOD BOOKS

Grass Valley, California
1999

LEGACY: Selected Paintings & Drawings by Frank Frazetta
is copyright © 1999 by Frank Frazetta. All Rights Reserved.
Copyright under international and Pan-American Copyright Conventions.
An Underwood Books edition by arrangement with Frank Frazetta.
No part of this book may be reproduced, stored in a retrieval system,
or transmitted in any other form, or by any means, electronic, mechanical,
photocopying, recording, computer networking, or otherwise without
prior permission in writing by the copyright holder(s).

TARZAN ® & ™ by EDGAR RICE BURROUGHS, INC.
Vampirella is ™ by Harris Publications, Inc. Popeye is ™ by King Features Syndicate.
Comic book covers courtesy Steve Geppi and Diamond Comics Distributors.

Quotes by Frank Frazetta have been taken from a variety of interviews
with the artist appearing over the previous 30 years and from conversations
with the editors in San Diego, CA [1995], and East Stroudsburg, PA [1997 & 1999].

While every effort has been made to acknowledge the copyrights and trademarks of
parties represented in this historical retrospective volume, errors of omission or commission
sometimes occur. For this the editors express regret and request corrections for inclusion in
subsequent printings, but hereby must disclaim any liability.

Foreword copyright © 1999 by Danton Burroughs.
Introduction copyright © 1999 by Nick Meglin.
"Frank Frazetta: The Artist Next Door" copyright © 1999 by
Michael Friedlander. Commentary by Joseph DeVito
copyright © 1999 by Joseph DeVito.
Photographs of Frank and Ellie Frazetta are courtesy of and © 1999 Ellie Frazetta.
All other text copyright © 1999 by Arnie Fenner.
Book package copyright © 1999 Underwood Books/Spectrum Design

Book Design By ARNIE & CATHY FENNER.

Full color prints of Frank Frazetta's art are available from:
FRAZETTA PRINTS
P.O. BOX 919
MARSHALLS CREEK, PA 18335

*A project of this scope is always reliant on the generosity of
a group of people who usually wind up being sorry we have
their phone numbers. Our special thanks to:*
Bud Plant, Jim Vadeboncoeur, Nick Meglin, Joseph Lane,
Danton Burroughs, Joseph DeVito, Grover DeLuca,
Andrew Steven, Daren Bader, Michael Friedlander, Kenneth Smith,
Dr. David Winiewicz, Phil Hale, Bill Schanes, Steve Geppi, and
Diamond Comics Distributors.

Deluxe limited hardcover edition ISBN 1-887424-48-2
Trade hardcover edition ISBN 1-887424-49-0
First Deluxe Edition/August 1999
First Trade Hardcover Edition/September 1999

ENDPAPERS: A title sequence drawing for *Fire & Ice*. Pencil on paper, 16"x11".
FRONTIS: "Apparation", oil on canvas, 16"x22". Originally
published as the cover to *Brak vs The Sorceress* by John Jakes.
CONTENTS: Randy Bowen's sculpted interpretation of "Death Dealer" for
Dark Horse Comics.

Underwood Books
P.O. Box 1609
Grass Valley, CA 95945
www.underwoodbooks.com

CONTENTS

Frank Frazetta, Edgar Rice Burroughs, & Illustration
Foreword by Danton Burroughs
6

Frank Frazetta
Introduction by Nick Meglin
10

Frank Frazetta: Rolling Thunder
Biography by Arnie Fenner
14

Frank Frazetta: The Artist Next Door
Appreciation by Michael Friedlander
28

Selected Comic Art
32

**Selected Paintings & Drawings:
1948-1999**
46

As the grandson of the legendary creator of Tarzan, DANTON BURROUGHS *shares his insight into the rare perfect marriage between author and artist.*

frank frazetta, edgar *rice* burroughs, & illustration

foreword by danton burroughs

For nearly five decades the illustrations of J. Allen St. John were synonymous with my grandfather's books. He illustrated forty-six magazine stories by Edgar Rice Burroughs; illustrations that were beloved by both my grandfather and his many fans. Sadly, today St. John's name has almost been forgotten and is remembered mostly by my grandfather's fans and not the world at large. Although he worked in the period recognized today as the Golden Age of illustration, he never received much recognition—possibly because he chose to illustrate for periodicals and books which were not highly regarded at the time. Of all the authors whose stories St. John illustrated, only my grandfather's seems to have withstood the test of time.

In 1962 Donald Wollheim, editor of Ace Books, decided that he wanted to publish some of my grandfather's books and contacted the Library of Congress to determine if some of them might have slipped into the public domain. Apprised that some titles were public domain he began to reprint them in paperback format. The first of these books carried covers by fan artist Roy G. Krenkel. However, Krenkel was somewhat at a disadvantage because he had an inferiority complex. He also was not use to working towards a deadline. As a result he asked his good friend, Frank Frazetta, if he could help him paint some of these covers.

Little did Krenkel or Wollheim realize that Frazetta's art for my grandfather's

opposite: Frank Frazetta's cover painting for The Mad King *by Edgar Rice Burroughs. Watercolor on board, 8"x10". Ace Books, 1962.*

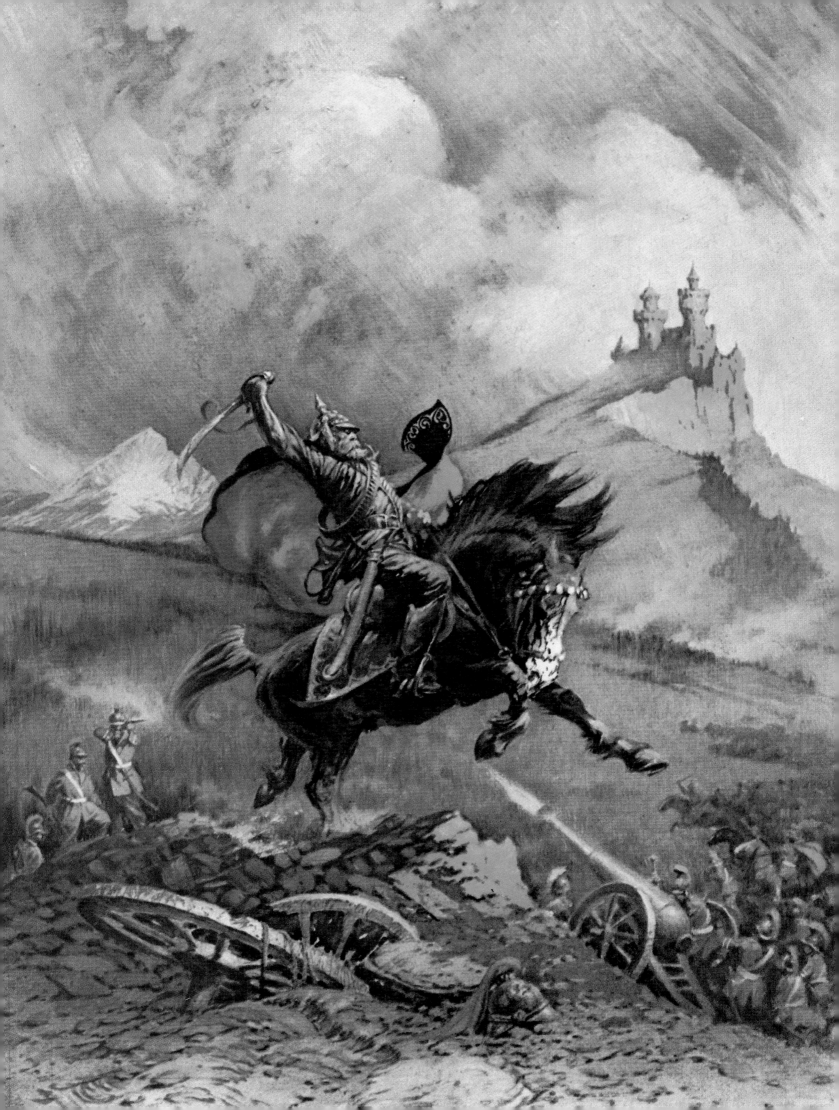

books would take readers and the publishing world by storm. Not only did Frazetta's covers help revitalize Ed's stories, but people who did not read them were buying the books simply for the artwork.

Interestingly, Frazetta had a difficult time getting his foot in the door at Ace Books. For some reason Wollheim had formed a dislike for Frank's art and would not give him assignments. It wasn't until Krenkel became bogged down in deadlines that Wollheim grudgingly agreed to give Frazetta a chance. And the rest is history!

I grew up around art. My father, John Coleman Burroughs, was an artist who had illustrated several of his father's books. He had also written and illustrated some stories on his own as well as collaborating on several others with my uncle, Hulbert Burroughs. My dad always extolled the virtues of St. John's paintings along with those by N.C. Wyeth, Frank Schoonover, and others—many of them have hung in our home and at the corporate offices of Edgar Rice Burroughs, Inc. So I've always been an enthusiastic fan of art and artists.

I remember when the Ace editions of Ed's stories hit the newstands: both I and my dad were bowled over by Frazetta's covers. My dad delighted in calling them to my attention and pointing out why and how they were so good. When

below:
The painting for Tarzan and the City of Gold *isn't the only piece of "hot" Frazetta art illegally hanging in someone else's home. His cover for* Conan of Aquilonia *was stolen from the Lancer offices when the publisher went bankrupt; Frank's unused painting for the film* Paradise Alley *was never returned; and a small Frazetta watercolor was stolen from respected art dealer Albert Moy in 1998.*

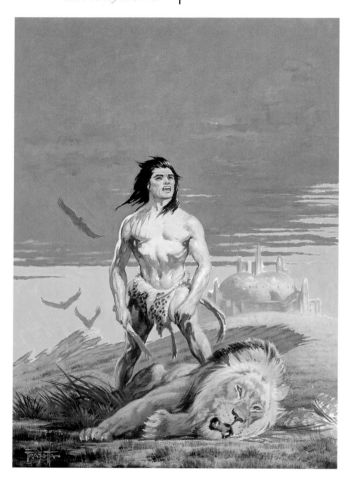

the article on Frazetta appeared in *American Artist,* dad gave it to me to read and told me that I should acquire any Frazetta art that I could because he felt that it would be a good investment.

Although the Library of Congress informed Donald Wollheim that some of Ed's stories were, indeed, in the public domain, it turned out that others were still protected under international copyright laws. Since they were still protected in Great Britain we were able to negotiate a contract with Ace which gave them permission to publish certain series and prevented them from continuing to publish others which were still under copyright.

When the original contract with Ace ran out, Edgar Rice Burroughs, Inc. negotiated a second agreement with them and, as a gesture of good will, they gave several of Frazetta's cover paintings to our corporation. (Sadly, two of these, *Tarzan and the City of Gold* and *Tarzan and the Lion Man,* were stolen during a burglary in 1982.) The corporate collection includes the covers for *The Son of Tarzan, Tarzan at the Earth's Core, Tarzan and the Lost Empire, The Land of Terror, Savage Pellucidar, The Mad King, Beyond the Farthest Star,* and *Lost on Venus.* Although it wasn't one of those originally sent to us by Ace, I have acquired Frank's painting for *The Monster Men* because it has always been one of my favorites.

We wanted Frazetta to illustrate our 1967 Burroughs volume, *I Am a Barbarian*, but he had to decline our offer because he felt the money was too low and he would not have been allowed to keep the art.

Even though fees were fairly uniform in the 1960s and it was a standard practice for the publishers to retain the original cover art, these issues nevertheless resulted in a conflict between Frazetta and Wollheim. Frank had refused to do any further work for them while Don was still editor. After Wollheim left Ace Books, Frazetta was able to negotiate a new working relationship with them, giving him more money per painting as well as allowing him to keep his originals.

There is a definite difference between Frazetta's first series of covers for Ed's stories in the 1960s and those he painted for them in the 1970s—as well as those he illustrated for the Doubleday Science Fiction Book Club. They are more painterly and of a somewhat darker nature with a definite edginess. While the first series is exciting, even corny to a degree, in a pure pulp magazine sense (because this is what Wollheim wanted), the second series is purely visceral, grabbing the viewer by the throat as well as the crotch! Some are almost as powerful as a blow to the abdomen! My grandfather's stories always contained an underlying sense of eroticism, yet they are innocent enough for a child to read. Frazetta's Burroughs work is also innocently erotic. They have a design worked into them which draws the viewer's eyes around the painting until it forces them to focus on the most important aspect of what Frazetta wants them to see. Not only are they illustrations, but they are also works of art able to stand on their own merits.

Although J. Allen St. John never achieved any lasting fame in the art community (or in the world for his illustrations for my grandfather's fiction), I like to believe that Frazetta was catapulted into the ranks of revered illustrators *because* of his Burroughs paintings and illustrations. Certainly his talent would have eventually brought him the same fame that he enjoys today, but it was his art for Edgar Rice Burroughs' stories that brought him his initial recognition. Once, when I met him at a San Diego convention, I asked him about the fact that he reportedly was so disgusted by his treatment from Ace the first time that he refused to give them his best work. To which he replied, "Hell, I was upset because they were paying me peanuts and keeping my art, but I had fans out there and I knew what they expected of me. I couldn't let them down, could I?"

Speaking for myself and all of those fans, the world is a brighter place because of Frank Frazetta and his art. I'm sorry that my grandfather didn't live to see his work—he would have loved it! †

below:
Frazetta's cover for The Monster Men *was considered a bit too racy for the time by the publisher. "The girl showed a little cleavage," Frank recalls, "and I think a little leg. So some art director up there slapped on some extra paint. They would've probably had a heart attack if I had turned in anything like the paintings I was doing for Ace in the '70s!"*

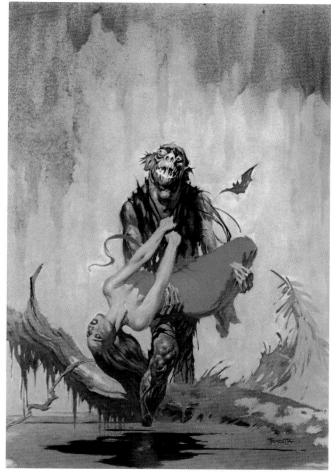

NICK MEGLIN, *co-editor of* Mad *magazine, has chased fly balls, whistled at girls (during a time when there was no such thing as "political correctness" and both men were single), and generally had a pretty damn good time as one of Frazetta's closest friends for nearly five decades. Who would be more qualified to talk about the man behind the legend, we ask you?*

frank frazetta

If one picture is worth a

a thousand words, how many words are necessary if that picture was painted, drawn, sketched or doodled by Frank Frazetta? None. The art says it all so completely that words serve little purpose. Just the opposite appears to be the case when it comes to the artist himself, however. Judging by the gazillion words already written about Frazetta, a definitive portrait of the artist is obviously more elusive. I've certainly contributed my share through the years. Because I have known Frazetta longer than anyone else who has written about him (with the possible exception of Ellie!) doesn't make my efforts to capture the enigmatic artist easier than others who attempt it. To the contrary, my genuine affection for my friend leaves me with a totally subjective perspective that I must keep in check. Subjectivity doesn't make me less accurate, only more passionate. Neither jealousy nor the desire to "knock him down a few pegs" were ever part of my agenda as is the case with much that I've read. But fact is fact while fiction makes for more interesting copy, I guess.

As I read over several of my past articles devoted to him, it became obvious that they were very similar in both approach and content. Don't blame my talent (or lack thereof), blame Frazetta. The truth is Frank hasn't changed a percentage point since those fun-filled days in Brooklyn's Avenue Z schoolyard. Furthermore, I'd swear in court that when Angelo Torres and I visited him last, the bastard was wearing the same jeans he wore then. No, not the same *brand* jeans, the *same* jeans! Fritz (as he was often called in the neighborhood) never went Hollywood despite the fame and fortune that resulted from his legendary work. During that same visit we reminisced about that old Ford convertible he drove back then and his immediate response was, "I wish I had that car today." Not because of its antique value, mind you. He just loved that "bullet." This from a man who can afford any car (or cars) he

introduction by nick meglin

opposite: Frank Frazetta's cover to The Secret People *by John Beynon Harris (pseudonym of John Wyndham). Lancer Books, 1964. Watercolor and ink on board, 11"x16".*

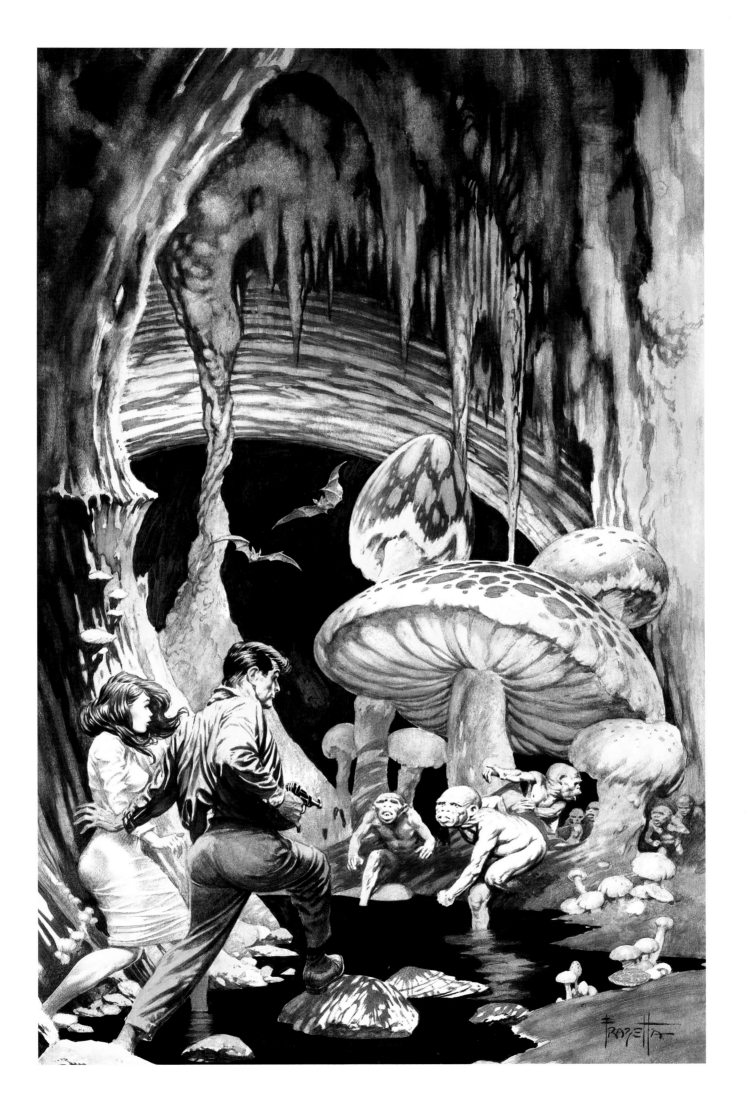

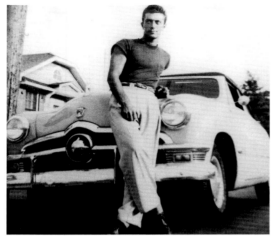

wants parked in his driveway. Frazetta's appreciation for talent in others hasn't changed that much either. Sinatra is still the greatest singer that ever lived, Di Maggio the most graceful and classiest of players, and, as always, much praise is still bestowed upon the likes of Foster, Eisner, Pyle, Toth, Crandall, Disney, and others on a surprisingly long list.

In 1998 the Society of Illustrators elected Frank Frazetta to the Illustrators Hall of Fame. The artist happily joined some of his heroes, most notably Howard Pyle and Norman Rockwell, in this honor. In accepting his medal (Frank couldn't attend and asked me to appear in his absence) I spoke as I always do, without a planned speech. When asked to repeat it all in print for the *Illustrator's Annual*, I tried my best to deliver what was requested, but know it fell short of the spontaneous words of that memorable evening. Some of what I think I said follows: The work of Frank Frazetta is as atypical as his approach to it. Unlike most artists, Frazetta prefers to work in a vacuum, free of influences and unencumbered by reality. He creates a new world with each painting and doesn't want facts (what's so) to interfere with fiction (what isn't) so that his magical brush can bridge the span between two diametrically opposite perceptions.

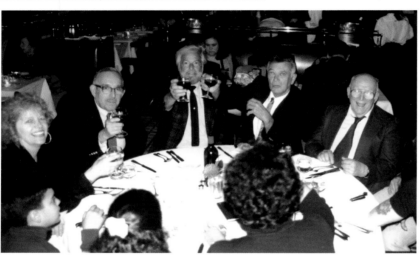

above:
"I wish I had that car today."
Frazetta poses with his
convertible in the mid-1950s.
The photograph beneath was
taken at a formal dinner
celebrating the opening of
Frank's first New York
gallery show in 1995.
Left to right: Ellie,
Angelo Torres, Nick Meglin,
Frank, and George Evans.

With only his imagination as reference he paints with such persuasive accuracy that the viewer often accepts a Frazetta landscape as if it were the camera's vision. And with such craft that none can doubt the artist had indeed painted that vista on-the-spot despite its interplanetary location.

How he achieved the level of excellence and acceptance as the dominant artist of his genre is a question that addresses his natural drawing ability and not formal art education, since he had none as an adult. As a Brooklyn-born and raised youth displaying an astonishing talent for drawing, Frank attended private painting lessons from a local artist between eight and twelve years of age. That proved to be the only training he experienced. All that followed can accurately be labeled "self taught."

His early years as a cartoonist proved invaluable to the development of his phenomenal visual imagination. At age sixteen his animated comics caught the attention of the Walt Disney Studios, but Frazetta never considered leaving the neighborhood baseball diamonds where his exploits were also catching attention from professional scouts. At nineteen Frazetta was named Most Valuable Player of the Parade Grounds League, a highly regarded minor league. He burned up the league with a .487 batting average.

But despite baseball sharing an equal passion, it was his art that Frazetta knew would be his life's work. It was more a rational decision than an emotional one. Factoring in equal success as a professional at the top of each of the respective fields, he'd obviously enjoy more longevity as an artist while still having fun as an athlete. His legion of fans and followers of his art still applaud his decision. The Brooklyn Dodgers, at the time, did not. No matter. If Frazetta had wanted to move to California he would have taken the Disney job and not a centerfield gig with the L.A. Dodgers!

As he became more involved in the representational comic form, Frazetta realized that his extraordinary drawing skill alone wasn't enough to satisfy his needs as a storyteller. Exaggerated action, dramatic lighting, dynamic composition, and an imaginative and highly personal color sense all played a part in depicting the quintessential moment of a bigger-than-life scene that became his illustration hallmark.

Frazetta's career exploded when at long last the perfect subject matter was given to the perfect artist to depict it. Starting with new editions of Edgar Rice Burroughs' Tarzan adventures, Ace Books was ecstatic with the success of their series brandishing

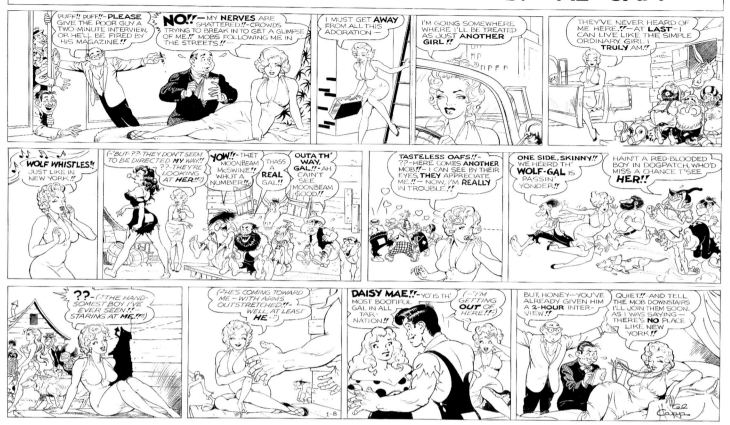

Frazetta covers. Lancer Books enjoyed similar successes with their Conan the Barbarian series. The Society of Illustrators presented Frank Frazetta with the prestigious Award of Excellence twice in their annual exhibitions: first in 1972 for his painting for Robert Silverberg's *Downward to the Earth* and again in 1974 for his cover to Burroughs' novel, *Back to the Stone Age.*

To Frazetta the blank canvas is not a proving ground for his remarkable ability as much as it is an undiscovered planet to explore and discover what imagery it has to offer. When not bridled with an actual subject to depict (as, for example, a book cover), he will begin a new work "somewhere in the middle" of an action, mood, or composition, either referring to a quick thumbnail sketch representing his first pass at story-telling or letting his imagination guide the path of light pencil work or direct thinned oil line. As in all his art, Frazetta maintains no set work procedure, relying on mood, music, or whim to determine that day's approach. From these minute beginnings evolve works that appear to have been labored over for many months, despite the fact that most were completed over-night, others within two or three days.

Materials have always been held with minimal consideration by the artist. Many of his bristle and sable brushes date before the oldest of his four children was born, still serviceable by Frazetta's standards despite the wear. More amazing is the watercolor set used to execute all of his early work in the medium. Also still in use today, as far as Frazetta is concerned nothing available in stores currently "matches the vibrancy of that Mickey Mouse 12-color set" he has cherished all these years.

Obviously, the art of Frank Frazetta has little to do with methods and techniques and all to do with natural talent. The ability to transform the unbelievable and abstract into imagery both believable and accessible can't be taught. Only imitated. And, as usual in the case of those most often imitated, never equaled. †

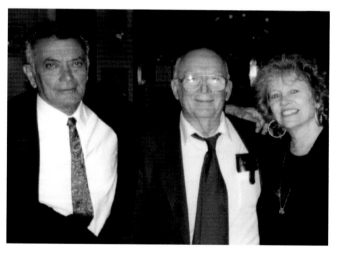

above:
Frazetta's luminous Li'l Abner *Sunday page for January 8, 1956 starring Marilyn Monroe. The photo below of Frank and Ellie flanking George Evans was also taken at the dinner commemorating the gallery event.*

frank frazetta: rolling thunder

The windows rattle as the roar of a dinosaur (T-Rex? Deinonychus?) rolls up the steps from the studio and fills the house with antediluvian thunder. Ellie Frazetta—petite, blonde, 5-something-feet of electricity and contradictions—smiles across the kitchen table at me, sets aside the paperwork and ducks her head slightly in an unsuccessful attempt to stifle a giggle. I smile back, also instinctively lowering my head conspiratorially, as a higher pitched (though certainly as impressive) bellow answers the call to battle. "The kids love their grandpa," Ellie says, confiding the obvious. Another baritone growl shakes the house and echoes through the pine-covered Pennsylvania mountains, a warning to all within earshot that either terror or amazement—fear or fun or both!—is coiling like a spring, ready to be unleashed on the unprepared.

I'm a visitor to the Land of Frazetta and I'm ready to meet with the man behind the legend.

I don't have long to wait.

<p style="text-align:center">† † †</p>

Frank Frazetta was born February 9, 1928, in Brooklyn, New York. The only son in a Sicilian family with three daughters, Frazetta exhibited a natural artistic ability from a very early age which was encouraged by his parents and teachers. At eight years old he was enrolled in the Brooklyn Academy of Fine Art under the tutelage of Italian painter Michael Falanga and there he received his formal training. Frank learned the fundamentals, painting still lifes and landscapes, drawing charcoal figure studies from nude models, until the age of twelve. Falanga's sudden death in 1940 forced the disbandment of the school and closed the book on Frazetta's only traditional art education. But rather than an ending, the closure of the Brooklyn Academy was merely a chapter in Frank's professional career, a many-

a biographical sketch by arnie fenner

facing page: *James Dean eat your heart out. Frank Frazetta, circa 1955.* Photograph by Ellie Frazetta.

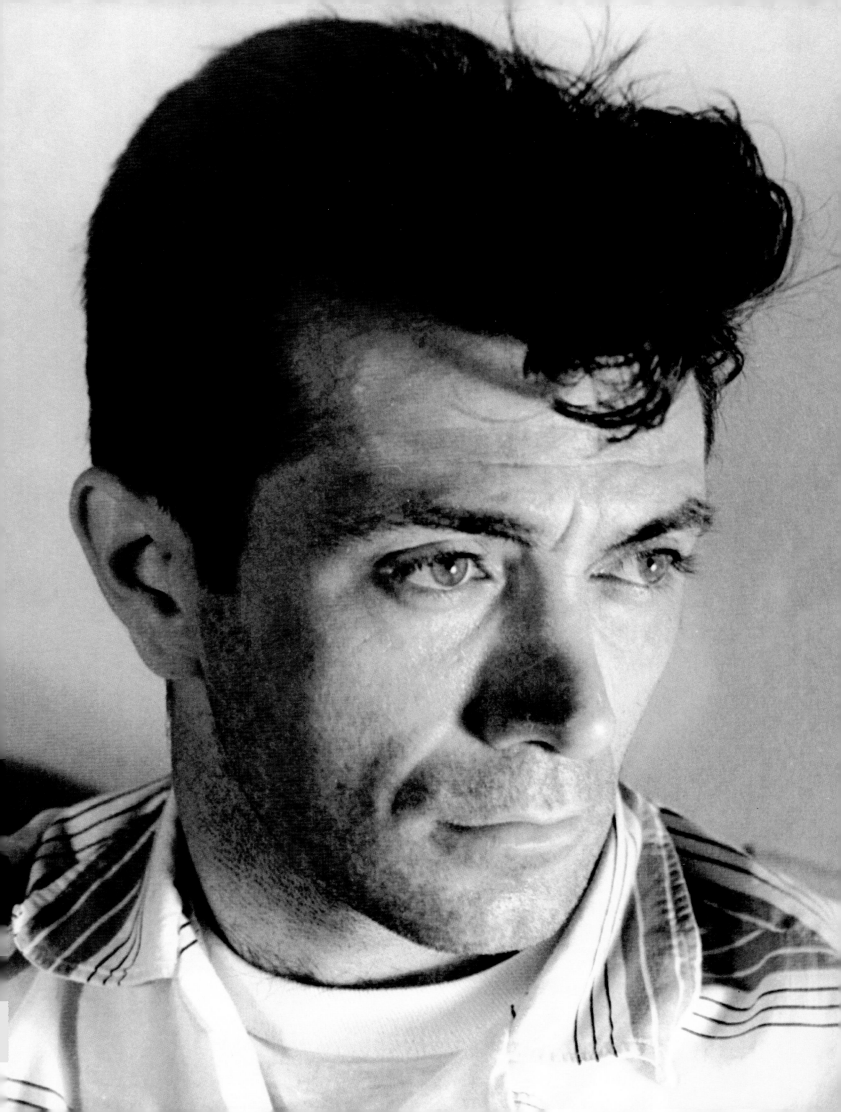

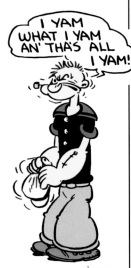

storied one that would span a full half century.

Through an introduction by a family member, Frazetta became an apprentice to pulp illustrator and comic artist John Giunta at the age of sixteen. Always a fan of the newspaper comic strips by Hal Foster (*Tarzan* and later, *Prince Valiant*), E.C. Segar (*Popeye*), and Milton Caniff (*Terry & the Pirates*), the idea of telling stories for a living was appealing and Frank was an apt and eager pupil. So impressed was Giunta with "Snowman," one of Frazetta's home-made comics, that he persuaded publisher Bernard Baily to publish a version redrawn by Frank (which Giunta finished in ink) in the comic *Tally Ho* #1 in 1944.

With the experience of his first published work under his belt Frazetta left Baily and Giunta to work briefly at Fiction House Comics where he was mentored by Graham Ingels (who would go on to popularity and notoriety drawing horror stories for EC's *Tales From the Crypt*) and met life-time friend George Evans. Fired after six months, Frank found employment with Standard Publishing and came under the influence of art director Ralph Mayo. Recognizing Frazetta's raw energetic talent and appreciative of his willingness to learn, Mayo gave him assignments drawing cute animal headings for short stories and humor comics like the *Li'l Abner* clone "Louie Lazybones." He regularly encouraged the young artist to refine his craft and learn anatomy—and was gratified and amazed at the rapid results.

† † †

Snow has mixed with the steady rain and Frank is on his second or third cup of coffee at Denny's, just up the highway from the photo studio that is shooting transparencies of his paintings. Three sugars. Cream. Stir. Blow. Sip.

"I just always wanted to tell stories," he says. "I mean, when I was a kid I didn't know from painting. The Brooklyn Academy was more of a social club, lots of fun, but Falanga wasn't preparing any of us to be *real* artists, meaning artists who could make a living—though he had his eye on me. He was talking about sending me to Italy to study painting before he died, but I don't think it would've changed what I wanted much. To me, Foster's *Tarzan* was *it*—I *loved* Tarzan, I wanted to *be* Tarzan, just like all my friends, let me tell you—Foster was a *fine* artist and that's what I wanted to do. I mean, *Prince Valiant* was great, too, though I got tired of Foster's playing up the English ideal and really didn't like the way he drew the Romans. These were the guys that ruled the world and advanced civilization, but in *Prince Valiant* they're short and bandy-legged and kinda backward. Gimme a break!"

Blow. Sip.

"Anyway, Graham Ingels was one of the first people to really see something in me—I thought Giunta had a lot of talent, but he didn't have much of a personality to go with it. But Ingels *believed* in me and that made me try harder. And I looked up to Ralph Mayo. He was British and seemed real worldly, you know? His approval meant a lot—*a lot*—to me. It was in the jobs for him at Standard that I started to do things that made sense with figures. My people started to move like real people, the animals like real animals. The *real* Frazetta started to come out—not my take on Caniff or Foster or Ingels or Mayo. Me."

Sip.

"Falanga was just disappointed by my interest in comics, but I really didn't care a whole lot. What did he know, right? Yeah, right. It took me years to realize that I could tell a whole story with one painting. I don't think I was slow, I think I just had to grow up some first and get comics out of my system."

Rain spatters against Denny's window. Thunder rumbles: low, throaty, and distant. More coffee arrives. Hot, black, and strong.

Three sugars. Cream. Stir. Blow. Sip.

† † †

The comic book industry of the late 1940s and early '50s featured the work of an exciting selection of talent: Jack

above:
Frazetta shares the life philosophy of his childhood favorite, E.C. Segar's "Popeye."

below:
Frazetta's charming drawings for short stories that ran as features in Standard's children's comics exhibited tremendous humor and animation. Frank received a tempting offer from the Disney Studios in 1944 to join them in California, but he turned them down. "I don't think they realized I was still a kid," Frazetta says. "To a kid in Brooklyn, California might as well have been on the moon."

opposite:
Frank's cover to Famous Funnies #215

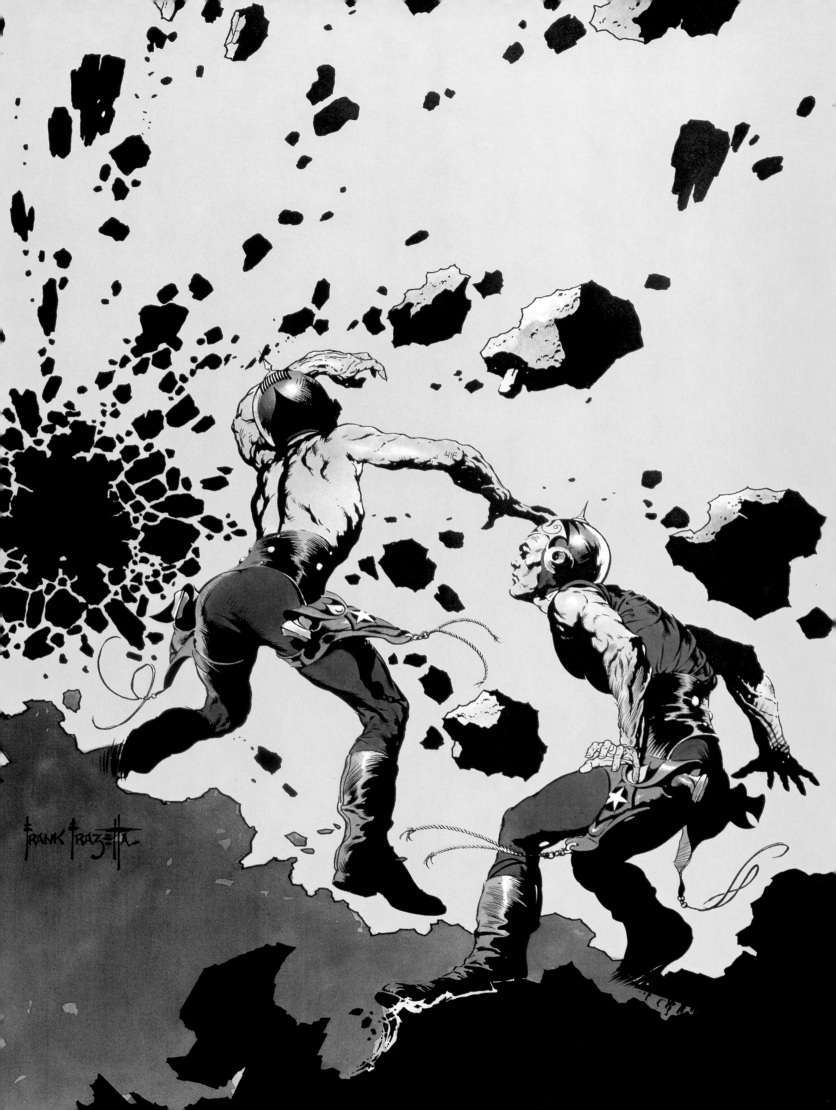

Kirby, Lou Fine, Will Eisner, Reed Crandall, and Jack Cole, to name only a handful.

Frank Frazetta fit in with the group of innovators very nicely.

He produced a memorable stack of work for virtually all of the major publishers of the day, including Magazine Enterprises, Toby Press, National (later to become known as DC), Prize Publications, and Entertaining Comics (fondly remembered as EC and best known today as publisher of *Tales From the Crypt* and other science fiction and horror comics as well as *Mad* magazine). Westerns, war tales, and love stories all benefited from Frazetta's unmistakable brushwork. His Buck Rogers covers for *Famous Funnies* are considered some of the best work done in the history of the comics while the first issue of M.E.'s *Thun'da* in 1952 (inspired by the works of Tarzan's creator, Edgar Rice Burroughs, and the only professional comic book Frank would ever draw from cover to cover) commands astronomical prices on the collector's market.

However, despite success in the comic *book* field, Frazetta had his eye on doing his own comic *strip*. In '52 he got his chance with *Johnny Comet*, a car racing-themed story scripted by Earl Baldwin (but credited to Indianapolis 500-winner Peter DePaolo for "marquee" appeal) for McNaught Syndicate.

In 1952 Frank also had his eye on a blonde and pretty seventeen-year-old named Eleanor Kelly. Both the comic strip and the girl would change his life.

<p style="text-align:center">† † †</p>

It is supposed to be the first day of Spring, but outside it's dark, cold, and wet. Inside is another story.

Bright, warm, bubbly, Ellie is bustling through the house handing me paintings, answering the phone, showing me drawings, getting after Frank. A ball of energy in a compact frame. She slams on the brakes, cocks her head, thinks for a moment, seemingly weighing the canvas in her hands. "Nope, I don't think you can put this one in the book." I ask why?, wide-eyed and innocent. It's a maybe 35-year-old painting of a beautiful nude woman, golden-haired, smiling over her shoulder at the viewer. It's a stunner and it positively glows.

below and opposite:
Frank sets the beat and Ellie
answers the call in this pair
of photos. New York, circa 1959.
"We liked to have fun," Ellie
says. "Life is meant to be
lived. Chasing after
a dollar all the time gets you
nowhere fast."

"Why?! Because that's *me!* I don't want my grandkids to see their grandmother like that! *Why?* he says!" I tease and joke with her—she laughs and teases back like a schoolgirl. Ellie isn't a kid though, and is certainly no one's fool. Her shrewd sense for business can be intimidating. But right now she's having fun.

"When I was younger I didn't really like posing for Frank. He was so serious and I thought it was all supposed to be fun and games. I didn't understand at first just how focused on his work he really was, how intense he could be."

The phone rings. "Fire Chief" Ellie is called upon to put out another fire, to solve another crisis. She hustles back in, a miniature force of nature, and hands me a drawing to consider. "Frank and I first met at Coney Island one night. He was with one of his buddies and they were giving me the eye and whispering to each other and nudging each other and laughing. So I walked right over to them with my hands on my hips and said, 'Hey, are you two talking about me?' And Frank said, well, yeah, and asked if I was the girl from the skating rink with the purple panties—I had this skating outfit with the short skirt and the purple pants. And I said that I was. And he was *gorgeous!* Like a movie star! And I knew there was something special between us right from the start." Her eyes sparkle, her voice is wistful, she looks toward the door leading to her husband's studio.

"He wasn't like any of the other boys I had dated. He was confident and passionate and funny. I used to work in the ticket booth at the movie theater and I knew Frank was serious about me when he brought Nick Meglin one night, then Roy Krenkel on another, to check me out."

She pauses. Smiles. "I guess I passed the inspection."

<p style="text-align:center">† † †</p>

We used to have
water pistol
fights
in our apartment
in the dark.
Have you ever
been squirted
with water
in a pitch-
black room?
Oh, it's
creepy! We did
all sorts of
silly things when
we were young.
I had to clean
up the mess in
the morning,
but so what?
We had fun
and it didn't
cost a dime.

Ellie Frazetta

Cover to Thun'da #1, *1952*

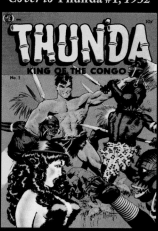

Johnny Comet didn't set the world on fire, but it *did* bring Frank to the attention of Al Capp, the contentious creator of the wildly popular *Li'l Abner* newspaper strip. Capp hired him in late 1953 as the ghost artist for the Sunday comic and Frazetta's first work appeared in 1954. His joining the studio was fortuitous timing: the comic book industry was collapsing following a senate witch hunt into the "correlation" between crime/horror comics and juvenile delinquency. *Li'l Abner* protected Frank from the economic crash that other artists endured as publisher after publisher slashed their lines or shut their doors entirely. He was also oblivious to the resurgence of and changes within the industry. His marriage to Ellie in 1956 had turned him into a family man with responsibilities. When Capp tried to cut his salary in half in early 1961 he resigned from the strip, believing he could reenter the comic book market where he had left off.

It was a rude awakening.

All of Frank's old clients had either disappeared or changed their art direction. The clout he thought he had, the reputation he felt he had established, meant very little. His frustration mounted as he was rejected by one publisher after another. But he still had friends. Despite having his own family to support, George Evans, his pal from his days at Fiction House, stepped in and shared his commissions with Frazetta when things looked especially bleak—a gesture of kindness Ellie and Frank are still appreciative of over thirty-eight years later.

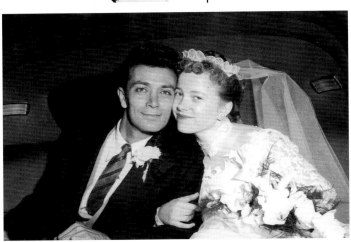

Jobs came slowly. Mort Dugger, the art director at Tower Paperbacks, provided the first break. He loved Frank's drawings of vivacious women and gave him commissions illustrating several soft-core "romance" paperbacks. From there he began doing art for the cheaper men's magazines that sprang up following the success of *Playboy*: often the most sophisticated thing about magazines like *Cavalcade*, *Gent*, and *Dude* was the Frazetta artwork.

In the meantime, Roy Krenkel had caught the attention of Ace Books editor Donald A. Wollheim with his drawings published in the fanzine *Amra*. Wollheim wanted to bring back the look of 1930s pulp artist J. Allen St. John for the paperback market, and he commissioned Roy to paint the covers for a series of Edgar Rice Burroughs reprints. Krenkel, a gifted artist who lacked self-confidence, had trouble from the beginning and asked Frazetta for help in solving problems of action and anatomy. As Roy began to fall further and further behind deadline, Frank was ready to step in.

† † †

The windshield wipers keep rhythm with the songs playing quietly on the oldies radio station. The skies over Bethlehem and Allentown are leaden, low, promising more precipitation. Construction snarls the highway, making entrances and exits an adventure. Frank is looking out the window, watching once familiar landscape being chewed up, spat out, and reconfigured by massive yellow, modern-day dinosaurs.

"Roy just wasn't up to the job," he recalls. "He'd start out fine, but toward the middle he would just freeze-up. Lighting would throw him. It got to a point where the idea of painting hair would just stop him in his tracks. I'd go, 'C'mon, you can do *this*, or surely you can do *that*...' but he'd just give up. He'd work harder at explaining why he *couldn't* do something and why I *could* than he did at trying to paint it at all. We didn't collaborate, really, I was just helping him out, trying to paint in his style. Roy's approach to Burroughs was very St. John-inspired—and that's what Wollheim wanted. When Ace finally agreed to let me take a shot on my own I had to fight their snooty attitude: they wanted a look that was St. John via Krenkel and all I wanted to do was give them Frazetta the best I could. It was tough. Wollheim looked down his nose at me and, yeah, that hurt my feelings, especially in the beginning when I was trying to give them good work. Look at *Tarzan and the Jewels of Opar*—he actually *sneered* at that one! Though that didn't stop Ace from keeping my originals and selling them to fans! Oh, nooo! So I just got mad and decided, 'Okay, pal, I'll paint these covers 'cause I need to feed my family, but the day will come when the shoe is on the other foot.'" I slow the Ford Explorer, getting ready to merge into traffic, and ask if he felt the shoe *had* ever been on

above:
Frazetta's watercolor drawing of Li'l Abner for a greeting card (one of the fourteen he produced for the Capp Studio which were published by American Greetings) watches over Ellie and Frank's wedding picture. They were married on November 17, 1956, coincidentally Sadie Hawkin's Day, the fictitious holiday dreaded by all the bachelors populating the village of Dog Patch in the Li'l Abner newspaper comic strip. "Al Capp was certain we had done it on purpose," Frank says. "It was an accident: Sadie Hawkin's Day was the last thing on our minds."

opposite:
Frazetta's watercolor illustration for a short story, "Diena" by Dick Dalton, which appeared in Dow Chemical's corporate magazine, Elements *(Vol. 1 #3, 1973).*

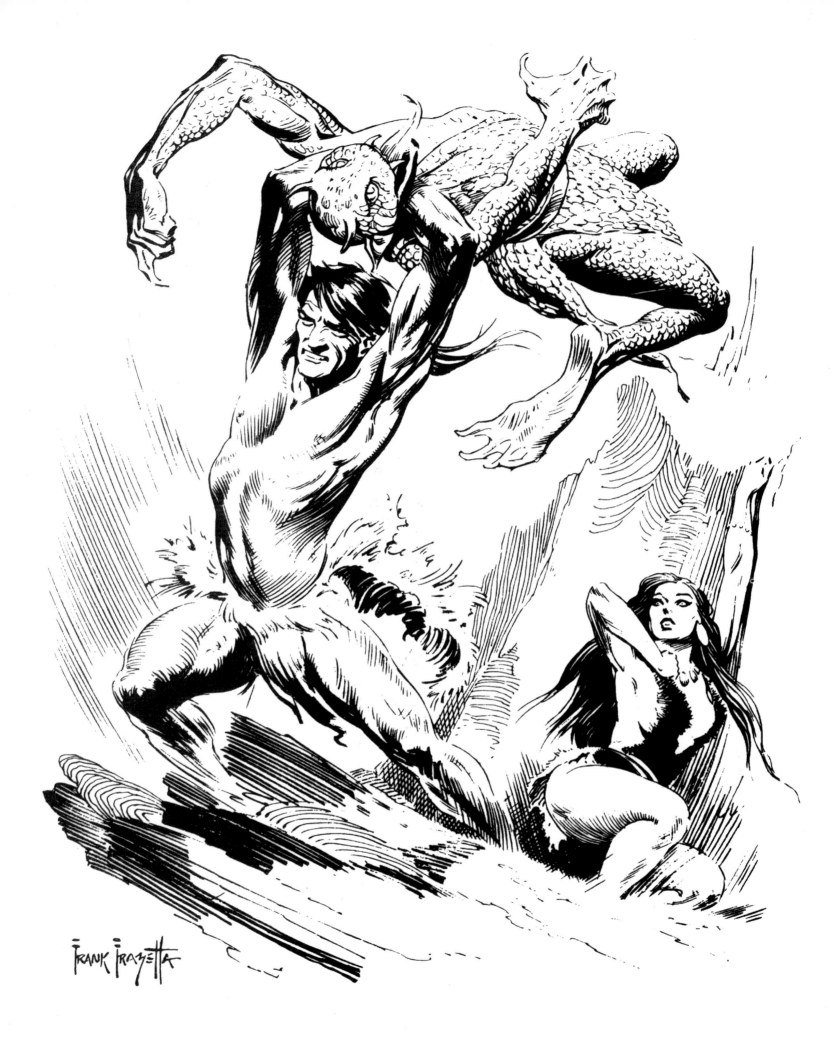

Legacy: Frank Frazetta

foot. "Well, after he left Ace and started his own company [DAW Books], Wollheim called wanting me to do a cover." Frank grins his wolfish grin. "He couldn't afford me."

<p style="text-align:center">† † †</p>

Sales of the Ace Burroughs books shot through the roof and other publishers started to take notice. In 1964 James Warren, publisher of *Famous Monsters of Filmland*, gave Frazetta *carte blanche* to paint whatever he wanted for the covers of his new magazine-sized horror comic, *Creepy*. Offered the same deal for Warren's other publications, *Eerie* and *Blazing Combat*, Frank produced an exciting series of covers unmatched for their vitality and quality.

In late 1965 he was approached by Lancer Books' editor Larry Shaw to paint the covers for a series of paperbacks reprinting the pulp adventures of Robert E. Howard's creation, Conan the Barbarian. Offering Frank double the fee Ace was paying and stipulating that his originals would be returned after publication, Lancer provided just the opportunity he had been waiting for. Frazetta applied himself to the commission with enthusiasm, intensity, and vigor. The resulting paintings (the first, *Conan the Adventurer*, was released in 1966) propelled Howard onto the bestseller lists and made Frank one of the hottest illustrators working in America.

At the same time he was setting the book racks on fire Frazetta was gaining a reputation in the advertising arena. His painted caricature of Beatles drummer Ringo Starr for a parody of Breck Shampoo ("Blechh Shampoo") featured on the back cover of *Mad* magazine caught the attention of United Artists' ad agency. The commission to paint the movie poster for *What's New Pussycat?* not only brought Frazetta the largest paycheck to that point of his professional career, but also gave him a feeling that, at last, he had achieved a level of financial security. During the following years he was in constant demand and produced numerous film posters and record album jackets besides book covers.

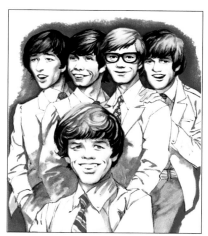

opposite:
One of Frazetta's illustrations for the Canaveral Press edition of Tarzan At the Earth's Core, *by Edgar Rice Burroughs.*

Courted by clients, visited by Hollywood celebrities, lionized by an international legion of fans, Frank came into his own in the late 1970s and early '80s. He was profiled in magazines like *American Artist*, *Esquire*, and *Newsweek*; served as designer and co-producer of *Fire & Ice*, an animated film (directed by Ralph Bakshi) that was inspired by his paintings; and was the subject of five bestselling monographs, edited by Ian and Betty Ballantine and published by Bantam Books.

Puzzles, posters, trading cards, t-shirts, and wall clocks all featured his distinctive works and all contributed to Frazetta's status as a pop-culture icon. Just as Andy Warhol represented the frivolity of the underground/counter-culture (while poking fun at the formal world of modern art), Frank provided a contemporary link to the classic illustrators of the Brandywine School from the early 1900s. Simultaneously, his insistence that publishers acknowledge his rights and respect his vision inadvertently opened up opportunities for a new generation of artists that were following in his footsteps.

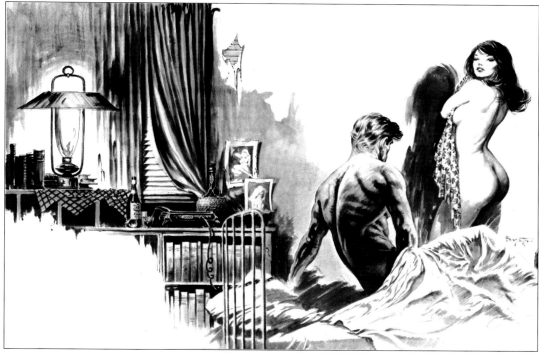

above:
An album cover portrait of the boys in the band for Both Sides *of Herman's Hermits (Capitol Records, 1966) overlooks some hanky-panky in Frazetta's steamy illustration for the short story "The Perfect Gentleman" by that master of contemporary literature, "Kain" (Cavalcade, February, 1964 issue).*

<p style="text-align:center">† † †</p>

Applebee's (*America's favorite neighbor...*) provides a refuge from the damp, the road, construction. We've checked the progress at the photo studio several times: each transparency takes an hour to go through the processor and past experience has proven that there will be mistakes. We try to catch them as they happen. It's a waiting game.

opposite:
Another of Frazetta's influential covers for Famous Funnies, *this one for issue #213 (September, 1954). "I just tossed in all the instruments and gadgets to tease Wally," Frank laughs. One of the trademarks of his friend Wallace (Wally) Wood's science fiction comics of the 1950s were his highly detailed interiors of various rocketships.*

"He only played good guys," Frank says, nodding toward a photo of John Wayne hanging on the wall opposite our table. "Aaaa, why bother?"

I react in mock indignation. Don't disrespect The Duke, I warn him. I'll have to take you outside and open a can of whup-ass. Frazetta laughs—deep, rich, hearty—and I get the distinct impression he's not too worried.

"All these movie 'tough guys'—yeesh! Eastwood's not Dirty Harry. He was out at the house a couple of times—nice guy. Arnie Schwarzenegger is a sweetheart—he sent a batch of toys for my daughter Heidi when she was sick—but he's not a killer. Now *Robert Mitchum*! There's a guy you could *believe* in his roles—you never knew which way he was going to go. Even Mature had something dangerous about him, despite being a matinee idol. There was an edge there, something just under the surface. And Seagal is just a killer: he could walk into a room and take *everyone* out. That's the feeling I've tried to achieve in a lot of my paintings—these are guys who walk their own road. They're loners. They don't need a gang or an army to do their dirty work or make them tough: my guys wade in there and take care of their own business. They're not monsters, but they don't step out of *anyone's* way and when something sets them off, look out!" He looks at me, eyes mischievous, unable to resist another jab at The Duke. "But John *Wayne*! C'mon, you always *knew* he was going to wind-up his fist like Popeye to throw a round-house punch that my grandmother could've ducked!"

My aunt Margie was tougher than Victor Mature, I respond. Steven Seagal runs like a girl.

Frank almost spits his coffee out.

† † †

Life was pretty good for Frank and Ellie. They moved from New York to a sixty-seven acre farm in the Poconos of eastern Pennsylvania with their children: Frank Jr., Holly, Heidi, and Bill. They started a business, Frazetta Prints, that sold posters and limited editions of his work as fast as they could be produced. They purchased a three-story brick building in East Stroudsburg that provided space for their sons' businesses and housed the first incarnation of the Frazetta Museum, a permanent exhibition space for Frank's paintings and drawings.

Frank worked as much or as little as he pleased, accepting only those commissions that interested him. Always athletic, he led a vigorous life playing baseball, bowling, golfing, and target shooting. He studied martial arts for several years, cultivated his life-long interest in photography, and began collecting cameras. Things couldn't have seemed better.

But there were potholes in the highway of financial security and critical acclaim. A shooting accident sent a tiny sliver of metal into Frank's eye—his recovery was quick and complete, but the incident was blown out of proportion by the rumor mill that had always seemed eager for tidbits of Frazetta gossip. A much more serious problem began in 1986: an undiagnosed thyroid condition played havoc with Frank's physical and emotional health, emaciating his body and robbing him of the ability to create art. It was nearly eight years before a doctor was willing to experiment with his medication; once the proper dosage was determined Frazetta's recovery was remarkably swift and he began drawing and painting with renewed energy and, it seemed, a sense of urgency.

† † †

The cabinets are full of cameras and lenses—cheap and expensive, old and brand new. There are boxes of photos, closets of equipment, stacks of magazines, a professional darkroom. Photography is one of Frank's passions and a camera is rarely far from his hand. "People think I've wasted time snapping pictures that I could've used painting," he says. "I don't think so. Photography taught me a lot about composition and perspective, though I probably didn't realize it at the time. Sometimes things you normally take for granted everyday look completely different through a view-finder."

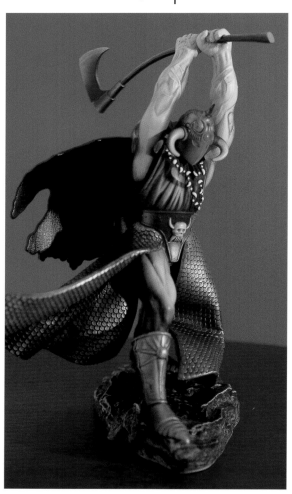

above:
"Play with me or I'll kill you." Frazetta's penultimate creation, Death Dealer, produced by Warner Brothers Toys, was the first in a line of collectible figures which debuted in 1998.

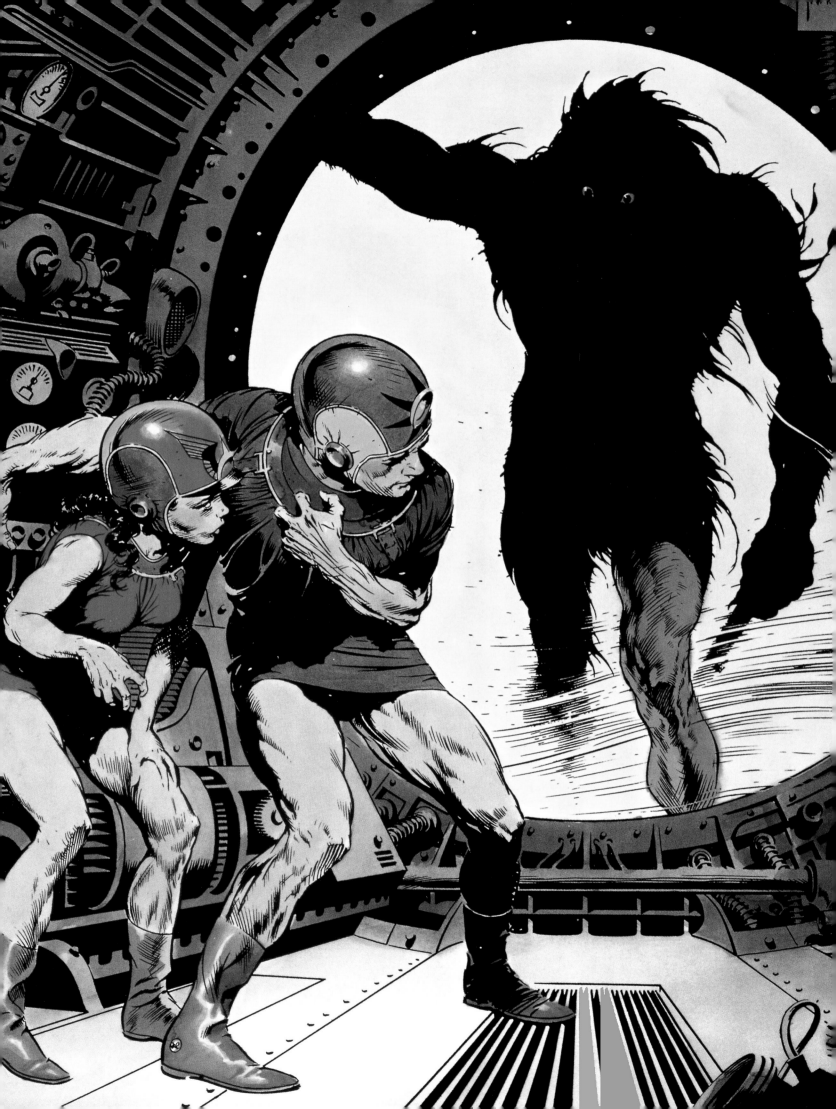

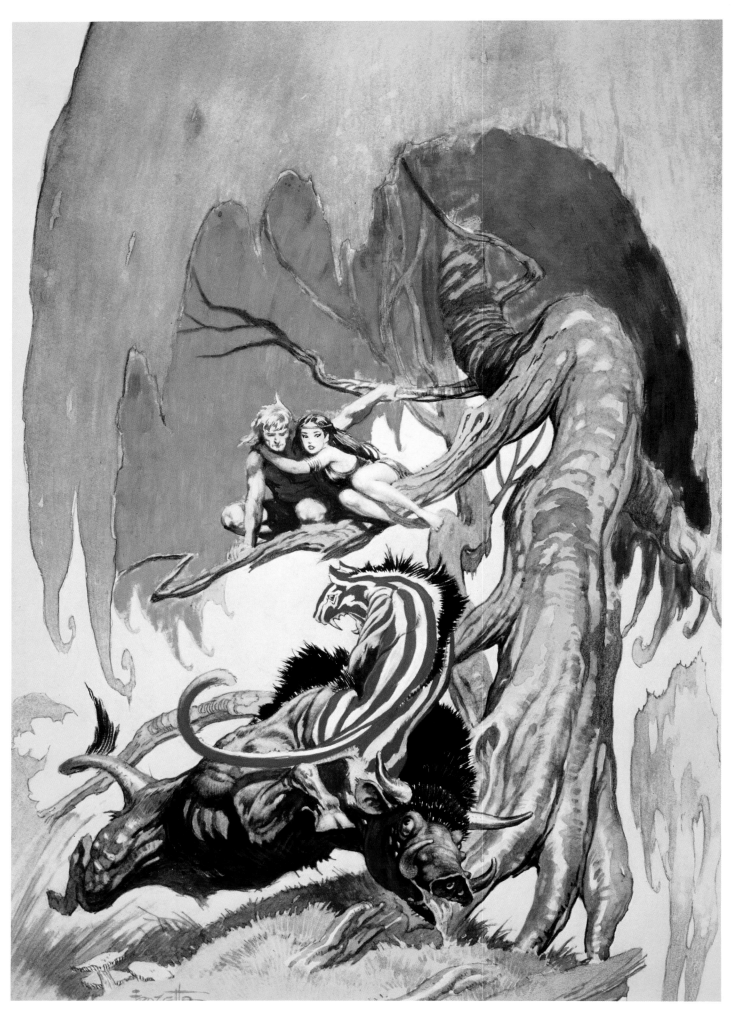

Legacy: Frank Frazetta

I ask if he had used photo references for his paintings. "Everybody probably thinks so," Frank responds, "but the truth is I haven't. If I see something, I remember it. If I've taken a picture, I've always got it right here." He taps his forehead. "I don't know what it is, but I'm able to pull images right out of my head—I've got a crystal clear picture of how someone looked or how a horse galloped. I don't have to go searching through a swipe file: everything I've photographed, everything I've seen, is riding around in my head, ready for me to use whenever I want it. And even then it's just a starting point. I've never seen a mammoth; the guys I got in fights with weren't Conan. I've never seen the clothes or the weapons or the actions I paint. It's all pulled out of thin air. An artist *has* to have an imagination and he has to get the audience caught up in his imagination. They've got to see what *he* sees. Too many young guys today are married to their reference pictures—without them, they're lost. That's just a dead end. You don't want people admiring your art because it looks just like a photo—why not look at the photo? No, you want them to appreciate it because you're showing them something that could *never* be photographed. *That's* imagination.*"

† † †

Unfortunately, Frank's creative resurgence following the proper treatment for his thyroid condition was cut short. A series of strokes, the first in 1996, made painting a difficult task and forced him reluctantly into semi-retirement. A planned move of both his family and the museum to Boca Grande in Florida was canceled. In 1998, in a gesture considered the crowning recognition of an illustrious career, the Society of Illustrators inducted Frank into their Hall of Fame.

But that doesn't mean life has come to a standstill for Frank Frazetta. Far from it. During my visit to Pennsylvania to select the contents for this book the Frazetta household was bustling with activity: Warner Brothers Toys had prototypes of figures based on Frank's paintings ready for approval; Clayburn Moore of Moore Creations had sent photos of his sculpture based on the *Conan the Adventurer* cover for creative input; Frazetta had a painting on his easel that he was working on; Frank Jr. was overseeing the final preparations of the official Frazetta website; Frank and Ellie were supervising an army of contractors, carpenters, and roofers as construction of the new Frazetta museum inched toward completion. Adjacent to their house and overlooking their private lake, the museum will provide the public the opportunity to explore in detail the fantastic worlds as created by of one of this century's most vibrant, important, and original artists.

† † †

Several days of rain and snow have given way to bright sunshine and I'm sitting with the Frazettas in Frank's studio getting ready to say goodbye. Ellie has been talking about moving a special table into the room to facilitate Frank's sculpting and he's brought out a clay figure he's been working on to show me: a woman, roughed-in yet impeccable anatomy, perfectly Frazetta.

"You know, I could be such a lazy guy. I always had all of these pictures in my head, all of these characters and stories, and I just never got around to doing a lot of them. I'd pull out what I needed when I needed it and figured, what the hell, I'll get around to the rest of them someday. Nothing seemed worse to me than to be shackled to the drawing board, I just couldn't get into that grind. I'd wait until the last day before a deadline, just paint like hell, then off to the ball diamond for me. The other guys my age did, what, a thousand, two thousand book covers? Hundreds of movie posters? Wow, I couldn't have done that—no, I *could* have, but I didn't *want* to do that. Art came so easily for me; art was a talent I had and I did it well, but it wasn't *all* that I was." Frank seems reflective, his fingers work instinctively, unconsciously at the clay figure. He's not melancholy, simply being matter-of-fact. "I want to paint, I want to sculpt, I *want* to bring those characters to life, I *want* to. But these days my body just doesn't always want to do what my brain tells it to. Everyone tries to encourage me, and I hear what they say, but something that used to be easy can now sometimes come really hard..." He pauses. The figure's rough anatomy is now smooth, buttocks are perfectly shaped, the back is muscled, a pretty face, upturned nose, high cheeks, Ellie—not there a few minutes ago—has started to appear.

"Hey!" Frank's eyes gleam, his brows arch, there's a hint of Frazetta thunder in his voice. "This is pretty easy!"

†

opposite:
Frazetta's cover painting for Lost on Venus *by Edgar Rice Burroughs (Ace Books, 1963, watercolor on board). "This was sort of cute," Frank says. "More of a kiddie picture. As a painting, forget it, but it's fun, with the weird color and the rolling eye on the pig-bull. I remember Roy Krenkel laughing and calling him Ferdinand the Bull."*

below:
Frank Frazetta. Photograph by David Winiewicz

above:
Frank and Ellie Frazetta, 1956.

MICHAEL FRIEDLANDER, *publisher, editor, and entrepreneur (creator of* Goliath), *spent a lot of time with the Frazettas in the 1990s. Close familiarity, rather than making him blase, has only increased his enthusiasm.*

frank frazetta: the artist next door

It was 1989 and I was about to publish the work of Kelly. Since Ken had been Frank wondered if Frank would be interested in writing the book. Ken had agreed and had supplied Frank's phone Frazetta's work for years but was very nervous about a dozen rehearsals of, "Hello. May I speak with picked up the phone and dialed. fantasy artist Ken Frazetta's student, I an introduction for number. I'd been a fan of calling him. After at least Mr. Frazetta?" I finally

Frank didn't know me and I was a mere 25 years old. But he answered the phone and was extremely polite and accommodating. After a 30-minute chat, he invited me to visit for the day. I was stunned, but I accepted. Who wouldn't?

That first visit was wonderful. We spent half the day looking over all of the original paintings; paintings that I had hung on my walls in poster form since I was 12 years old. Those posters captured only a fraction of the depth and vibrancy of the originals. During that time, and after, we got to know each other. I'm not kidding when I say that Frank could be your next door neighbor. He is down-to-earth, extremely open and very approachable. I left his home that day wishing I could tell the world just how genuine and caring Frank is. I finally have that opportunity here.

Frank later wrote a terrific introduction for the Ken Kelly art book and we kept in constant touch by phone. We talked about everything from golf to bowling to baseball to our health. In between calls, whenever I had the chance, I drove up to visit.

One time Frank was working on a lovely painting of a voluptuous nude riding

an appreciation by michael friedlander

opposite: Frank Frazetta's cover to Famous Funnies #209. Magazine Enterprises. Watercolor and ink on board, 1953.

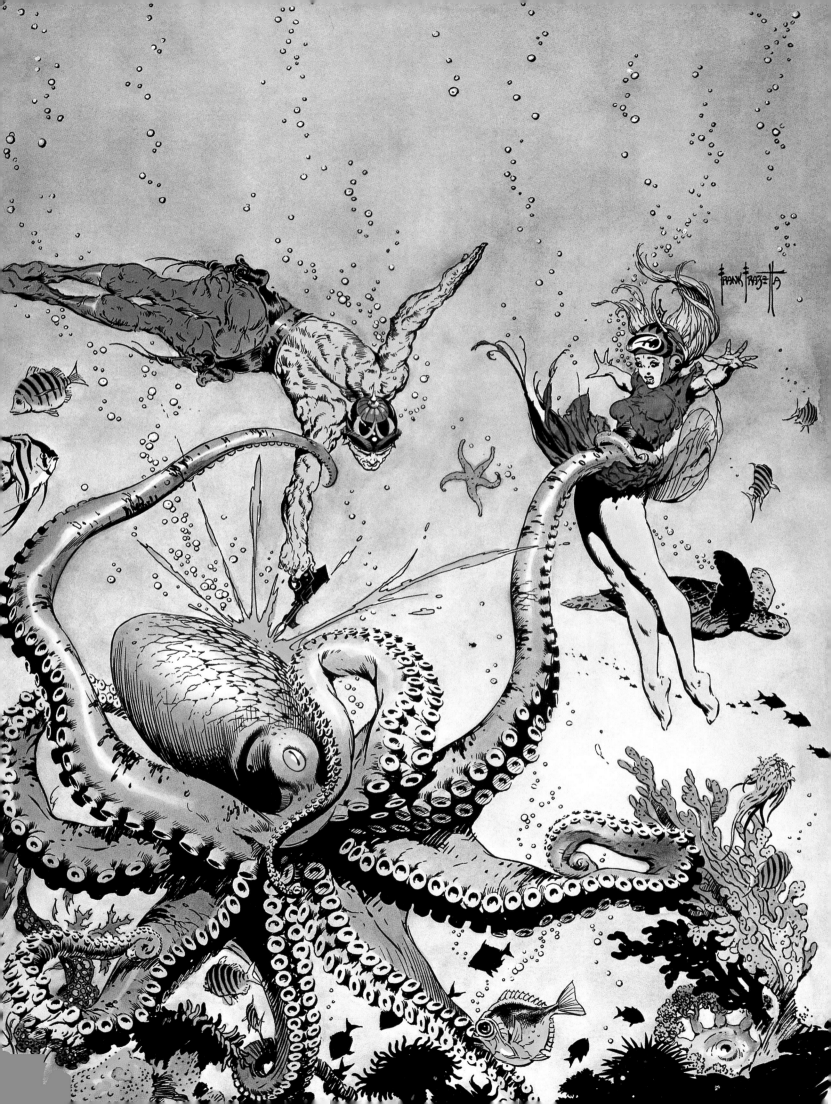

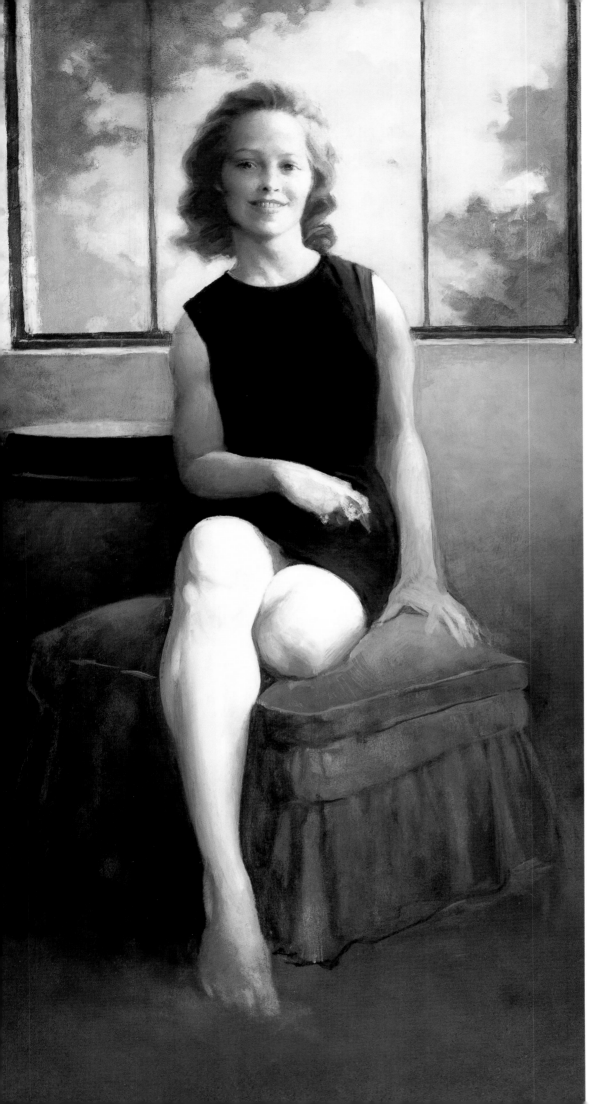

horseback across the twilight surf. It was wonderful to witness aspects of the painting changing with each stroke of the brush. He used no drowning plan for paint placement; brushstrokes just landed where he knew they belonged. Without maps provided by intense photo reference, Frank's execution is reminiscent of the Old Masters. He lets the work develop on the fly with a life all its own.

Leaving the easel, we then sat on the couch and talked art. After much discussion the subject of drawing ability came up. I threw in, half joking, that I would love to watch Frank draw. Son-of-a-gun if he didn't oblige me!

"Sure. Why not?! What would you like me to draw?"

Feeling suddenly like a kid in a candy store with an "everything-you-can-grab-for-free special," I stumbled for something to suggest. Finally I blurted out, "How about a gorilla fighting a lion?" Frank looked at me as if to say, "Oh brother," but he picked up his pencil and said, "Let's get

to it." There was no laid out, complex preliminary pencil outline. What materialized was purely from the imagination. Before my eyes an exquisite drawing took shape. Soft lines were laid down which led to sharper refinement. Finally, everything from a soft eraser to a smear from his finger produced the delicate shading that completed the work. The drawing took about 20 minutes. We chatted a bit more and then it was time for me to hit the road. But first, "King Kong and Snake."

I had asked about that painting earlier and Frank had generously promised to bring it out when we got back to the house. We were inside the door for all of two seconds when I reminded him. He lifted the painting from the studio closet and set it down. And I watched in horror as it toppled over. Being a large heavy oil on masonite, it fell hard, face down.

Frank quickly stood the painting back up and it looked undamaged. But I pointed out a small chip of sap green paint left on the floor. Frank picked it up, looked at it and gave it a flick to the air and a forget-about-it wave. He left and I was alone in the room. Gee, I figured, why not? I got on my hands and knees. picked up that chip and put it in my pocket—a compliment, I guess, and a tribute to how easy it is to become overwhelmed by his creations, lost in sensory overload.

Like a brilliantly produced film, his visions remove you from the real world. Lush vegetation, haunting lighting, and powerful figures overtake you. His "subtleness" whacks you over the head. His art commands you to look at it. It lives in your mind's eye long after every viewing.

Frazetta the Artist and Frazetta the Man are both the "next door neighbor." We look at and understand his work immediately. Intellectual art critics explaining each painting and why we should like this artist's work aren't necessary. We choose Frazetta's art because we like Frazetta's art. No artsy-fartsy BS, just straight, potent art. Art for the masses. Art for us all. †

opposite:
Frazetta's painting of his wife on the facing page was created around 1960. Though unfinished, it practically vibrates with personality.

below:
One of Frazetta's masterful brush and ink illustrations for Tarzan and the Castaways, *by Edgar Rice Burroughs, published by the Canaveral Press in 1964.*

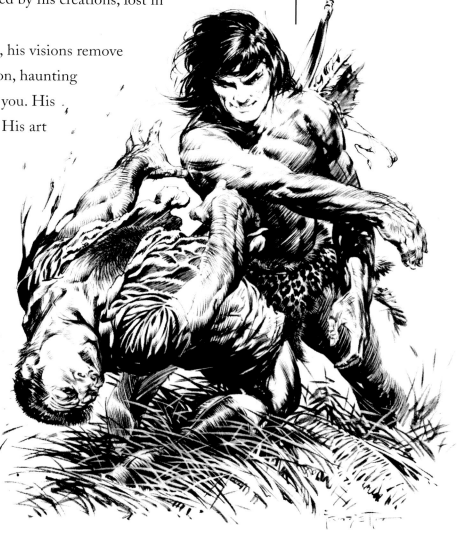

Legacy: Frank Frazetta

it's a mis

think of frank

co

stake to frazetta as a comic book artist: he's a *fine artist* who occasionally did comic art.

harvey kurtzman

Selected Comic Art by
FRANK FRAZETTA

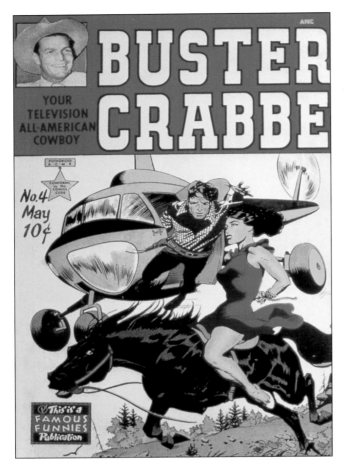

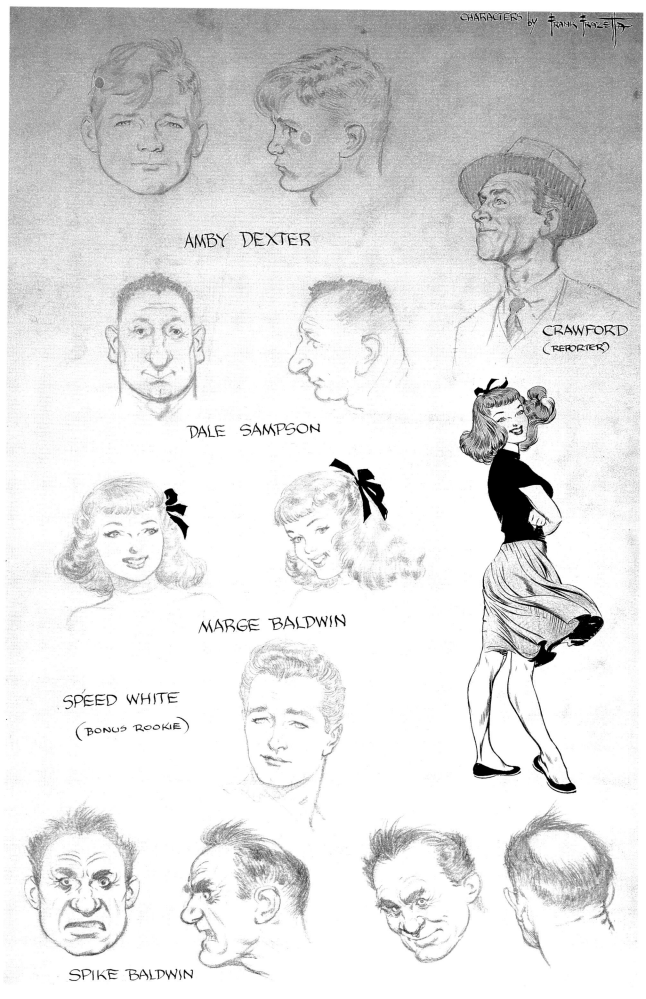

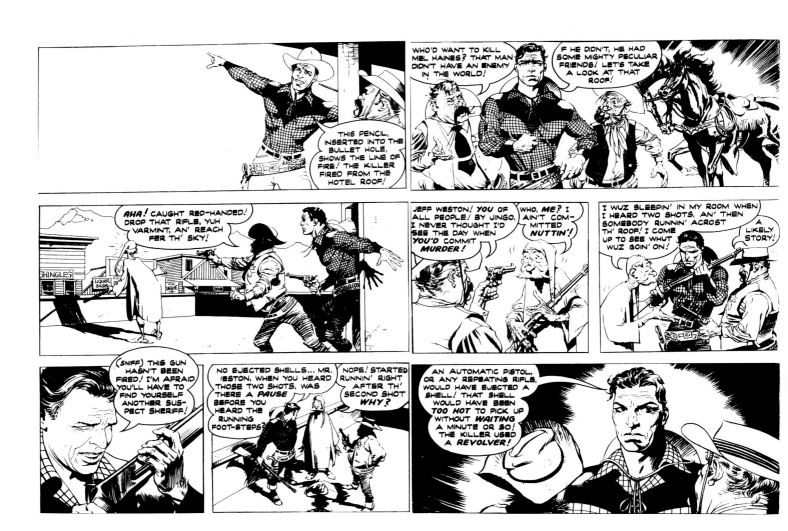

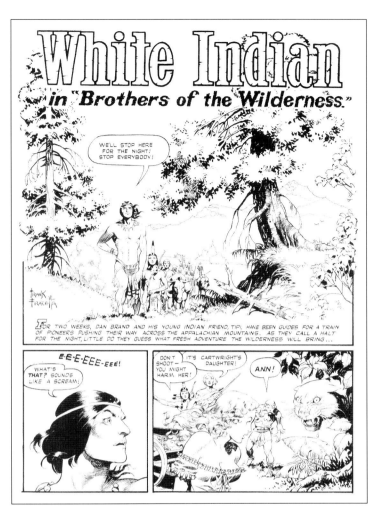

previous pages:
A selection of 1950s comic book
covers by Frank Frazetta.

A page of character studies
for an unsold newspaper
comic strip entitled "Ambi Dexter," circa 1952.

clockwise from top left:
Frazetta's "try-out" page for
BusterCrabbe Comics, circa 1949.
Previously unpublished.

The splash page to one of Frank's
stories for *White Indian #1*,
Magazine Enterprises, 1952.

A sample page for an unsold
newspaper strip entitled
"Sweet Adeline," circa 1952.

following pages:
Frazetta's beautifully rendered
romance story for
Personal Love #24, reprinted
here for the first time since 1952

IT WAS ALL THERE---WAITING FOR ME. A WAY OF LIFE THAT MEANT WEALTH, GRACIOUS LIVING, A CHANCE TO CRASH THE BLUE BOOK. BUT WHEN BILL KISSED ME, I KNEW I HAD FOUND---

A LOVE OF MY OWN

YOU COULDN'T LOVE A GUY LIKE ME. AFTER ALL, I'M ONLY A SHAVETAIL. YOU WON'T FIND MY NAME IN THE BLUE BOOK LIKE THE COLONEL. PICK YOURSELF A WINNER!

NO--(SOB)--I DON'T WANT ANYTHING--BUT YOU...(SOB)...BILL!

Beauty and brains--that's what I was blessed with, and shortly after I joined the Wacs. I made Lieutenant...

LT. KENT, I--UH--WOULD APPRECIATE IT IF YOU'D HELP ME WITH THESE PAPERS.

I'LL BE GLAD TO, COLONEL ARMSTRONG!

The Colonel's name had long been part of the blue book and I was flattered by his attentions...

PERHAPS YOU'D LIKE TO JOIN ME FOR DINNER, LIEUTENANT KENT--OR SHOULD I SAY--LILA?

LILA SOUNDS BETTER.

Legacy: Frank Frazetta

Legacy: Frank Frazetta

Reluctantly, he released me and I felt miserable. The following day...

I ASKED THEM TO SEND SOME SNAPSHOTS OF SKY ACRES, LILA...

IT WILL BE EVEN LOVELIER WHEN YOU'RE THERE...

CARL!

I DO LOVE YOU, LILA!

LOOKS LIKE I'VE HIT THE JACK-POT!

I kept my engagement to the Colonel a secret from Bill, and continued to see him whenever possible.

HAVEN'T HEARD A JAM SESSION LIKE THIS IN MONTHS...

SOUNDS GOOD!

BILL--THE MUSIC HAS STOPPED!

LILA, I LOVE YOU---!

Legacy: Frank Frazetta

41

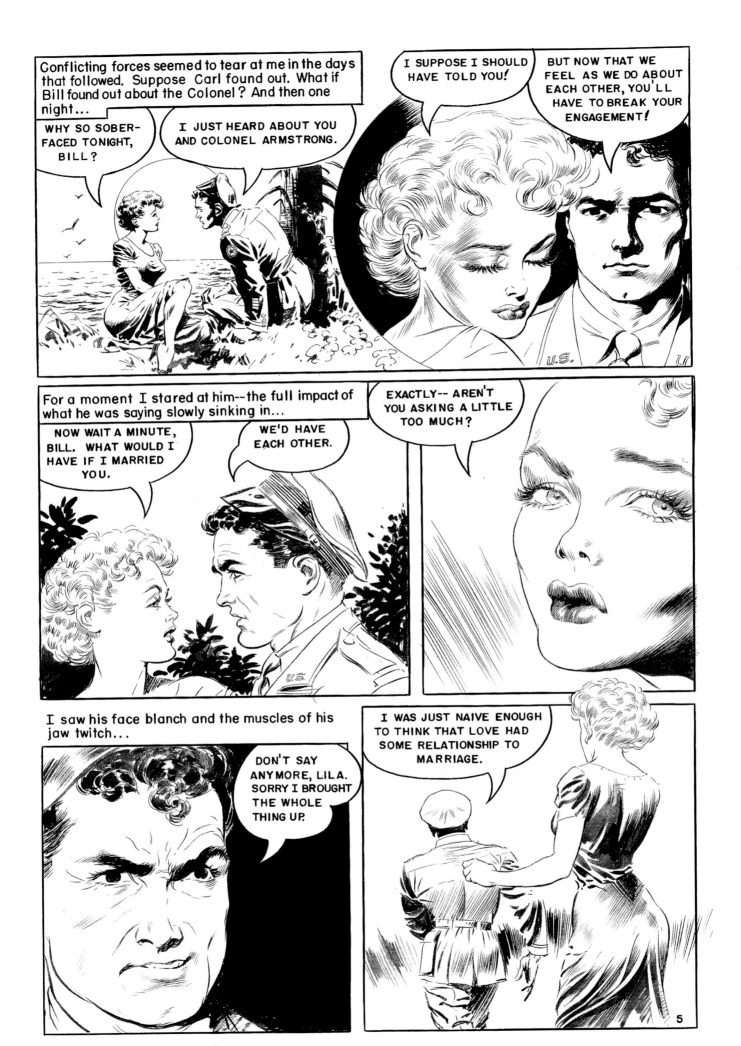

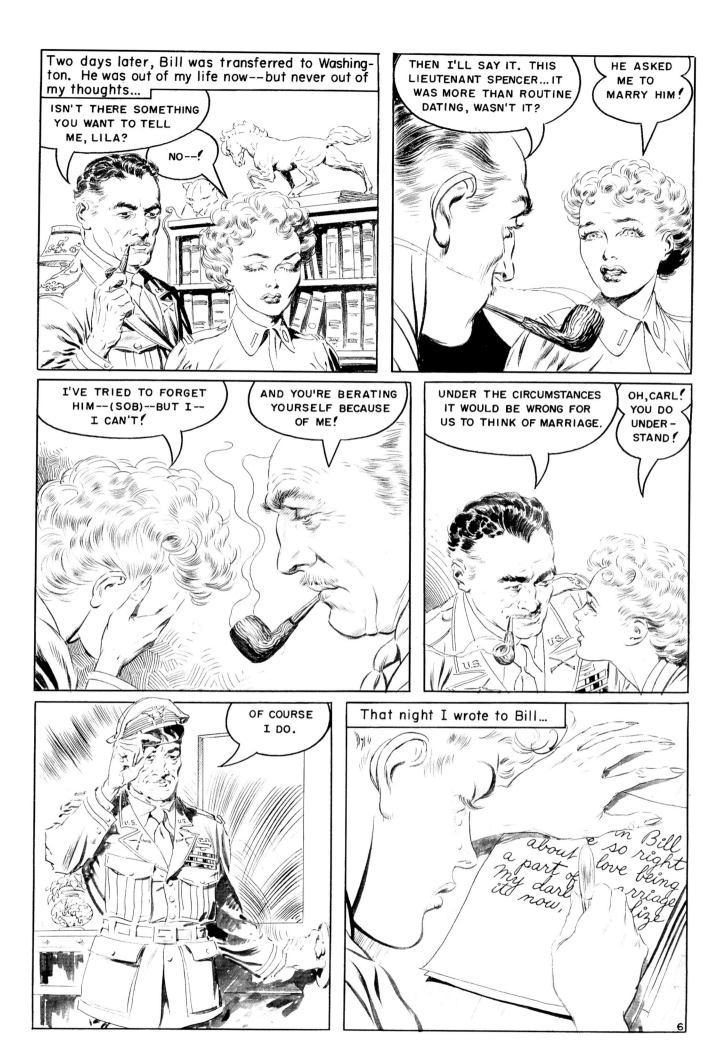

Legacy: Frank Frazetta

43

But two days after I mailed the letter, an item in the post newspaper caught my eye...

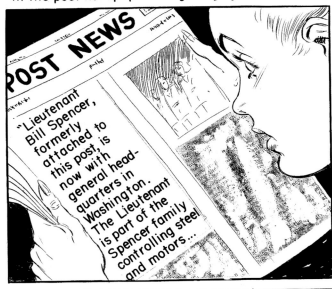

POST NEWS

"Lieutenant Bill Spencer, formerly attached to this post, is now with general head-quarters in Washington. The Lieutenant is part of the Spencer family controlling steel and motors...

SOMETHING WRONG, LILA?

N-NO-- I'LL BE ALL RIGHT!

There was no sleep for me that night.

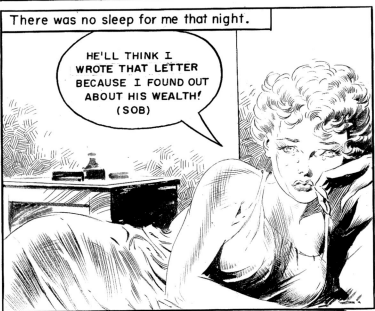

HE'LL THINK I WROTE THAT LETTER BECAUSE I FOUND OUT ABOUT HIS WEALTH! (SOB)

I went completely to pieces after that.

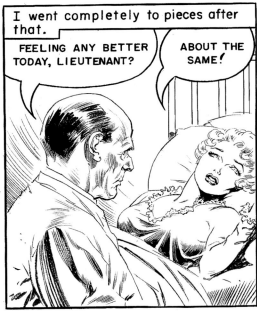

FEELING ANY BETTER TODAY, LIEUTENANT?

ABOUT THE SAME!

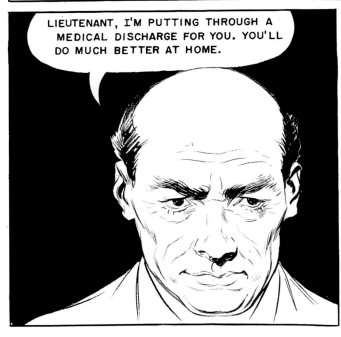

LIEUTENANT, I'M PUTTING THROUGH A MEDICAL DISCHARGE FOR YOU. YOU'LL DO MUCH BETTER AT HOME.

And a few weeks later found me on my way home...

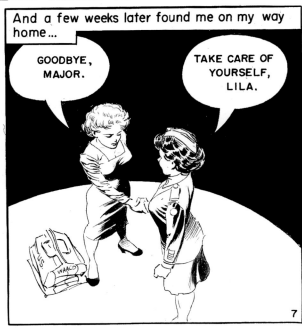

GOODBYE, MAJOR.

TAKE CARE OF YOURSELF, LILA.

7

Legacy: Frank Frazetta

Legacy: Frank Frazetta

and
he's it!

burne hogarth
chastising his students at
The School of Visual Arts

Selected Paintings & Drawings by
FRANK FRAZETTA

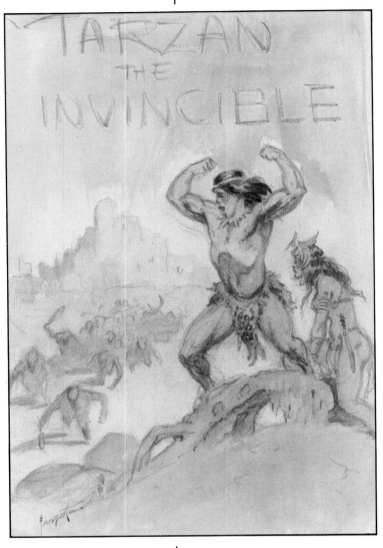

above:
Watercolor and colored pencil
preliminary rough for
Tarzan the Invincible
by Edgar Rice Burroughs
[1963, 6½" x 8"]

opposite:
Book cover to
Tarzan the Invincible
by Edgar Rice Burroughs
[Ace Books, 1963, 9"x12"
watercolor on board]

This painting for *Tarzan the Invincible* was one of Frazetta's earlier covers for the Ace Books paperback reprints of the adventures by Edgar Rice Burroughs. Edited by Donald A. Wollheim [1914-1990], Ace initially awarded the cover commissions to Frank's long-time friend Roy Krenkel [1918-1983]. As Krenkel began to fall behind deadline he would regularly call upon Frazetta to help him complete assignments: eventually Frank was given the approval to paint covers alone, despite Wollheim's initial misgivings. The immediate popularity of Frazetta's covers in the market eliminated Ace's doubts that he could handle the job.

Of this painting Frank says: "Not bad. The figure's a little top-heavy, but it's a fun little painting. I don't think it took any more than eight or ten hours from start to finish."

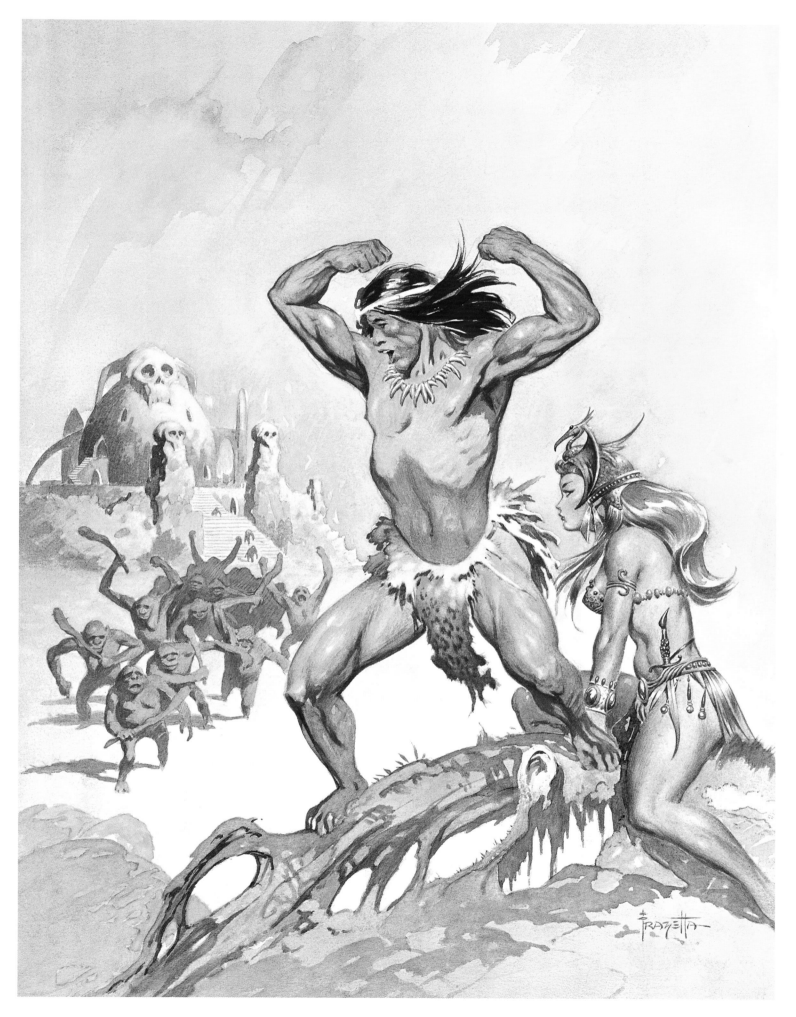

Legacy: Frank Frazetta

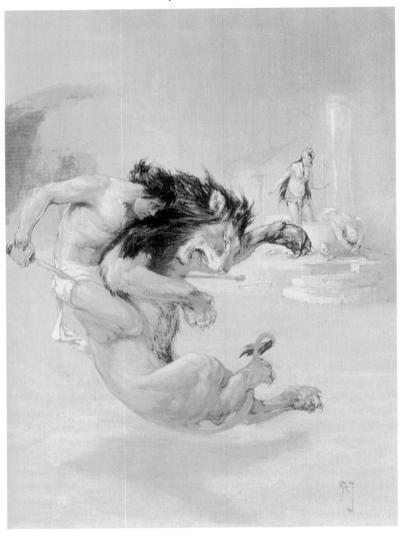

above:
J. Allen St. John's cover painting for the 1918 hardcover edition of *Tarzan and the Jewels of Opar* by Edgar Rice Burroughs

opposite:
Book cover to *Tarzan and the Jewels of Opar* by Edgar Rice Burroughs [Ace Books, 1963, 10"x15" oil on canvas]

Frazetta broke from Wollheim's instructions that his ERB covers should look like St. John's interpretations with this painting for *Tarzan and the Jewels of Opar.* The lighting, detail, and action owe more to contemporary film (particularly with Tarzan leaping from "off camera" into the frame) than to the pulp-era. Frazetta observes, "I don't know, something just clicked with this one. I think I was responding to the fan mail and I tried to do something special for the Burroughs fans. I loved it. You can't imagine how hard it was for me to hand the original over to Ace, knowing I'd never see it again. There's no way in the world I would hand anybody a painting like that today, for any money—*any* money, mind you—and then forget it ever existed."

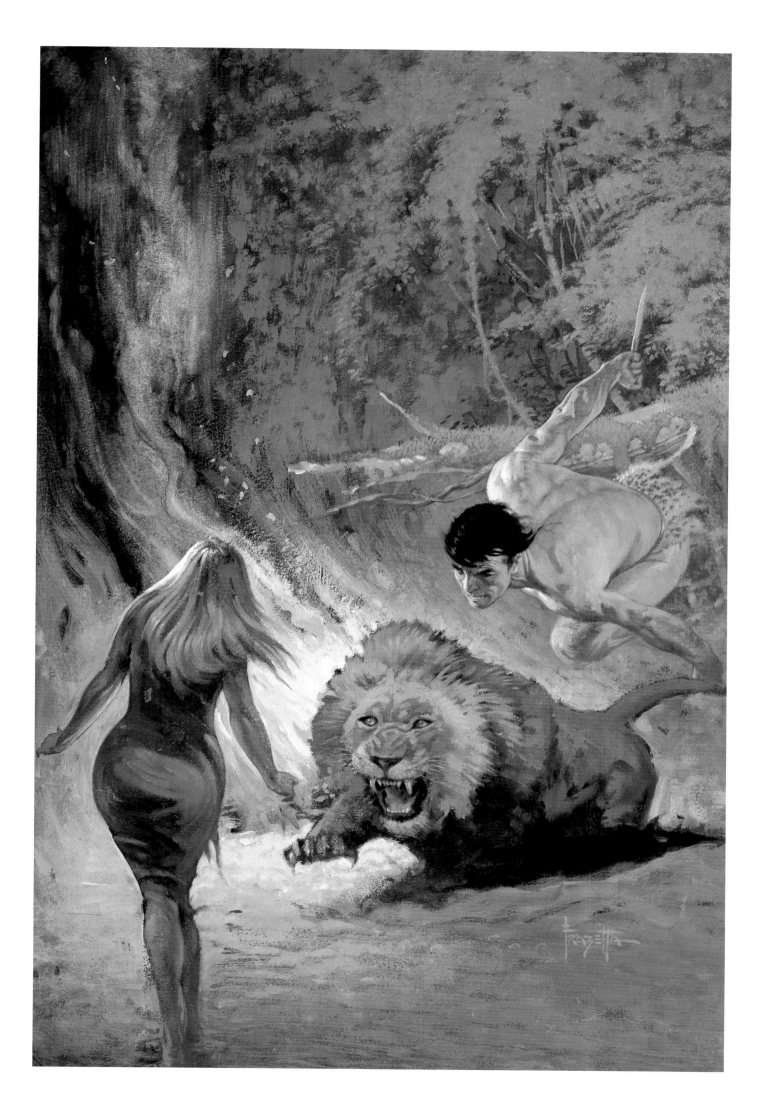

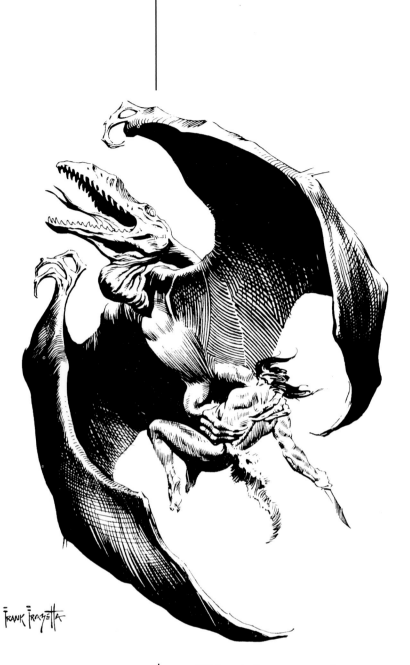

FRANK FRAZETTA

above:
Interior drawing for
Tarzan At the Earth's Core
by Edgar Rice Burroughs
[Canaveral Press, 1962, 9"x11"
ink on board]

opposite:
Book cover to
Tarzan At the Earth's Core
by Edgar Rice Burroughs
[Ace Books, 1963, 9"x12"
oil on board]

"This painting was a vast improvement over my first Ace cover," Frazetta recalls [*Tarzan and the Lost Empire*; see p. 12, *ICON*]. "Some of my sense of design had started to show through. This was an attempt at pure painting, but still keeping St. John very much in mind. I had painted this originally on a cheap piece of illustration board—I was notoriously chintzy with art supplies—and the board started to warp right before my eyes. I tried to straighten it out and it cracked in half. It was such a simple piece that it was faster to repaint it rather that try to repair it. I gave the one that was broken in two to Vern Coriell— I think he just stuck the two pieces in a frame and hung it on the wall."

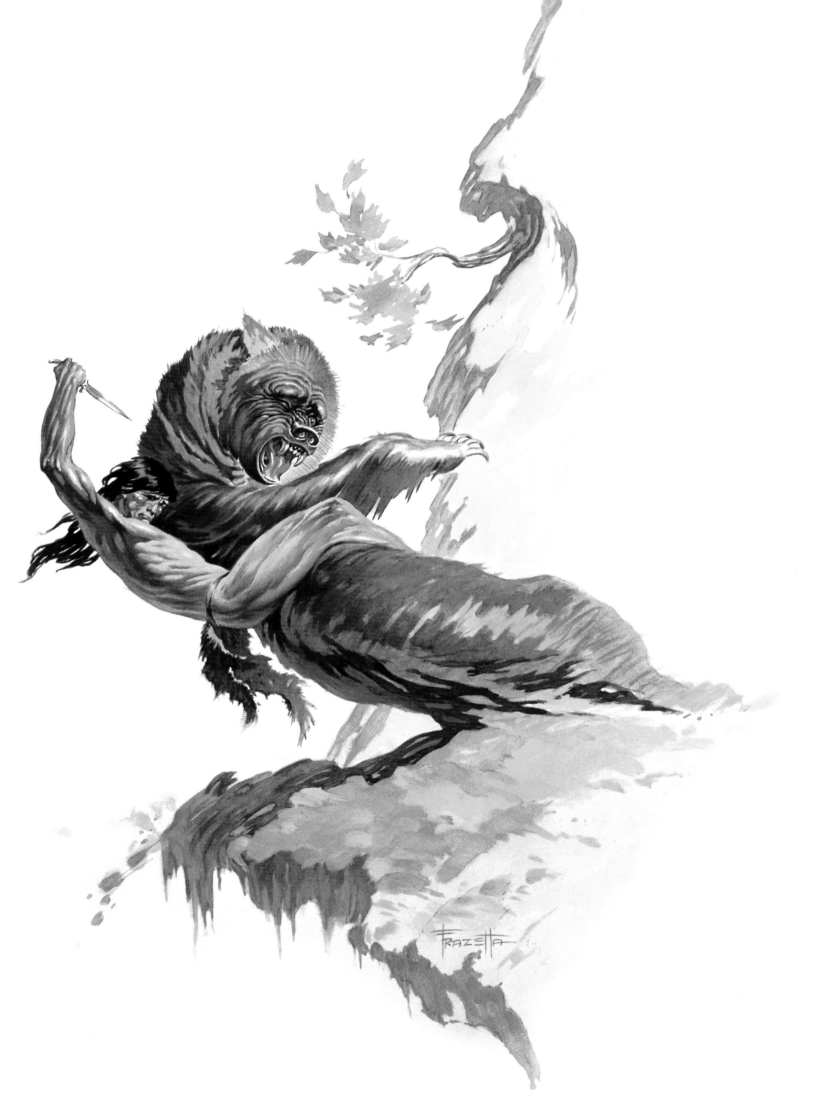

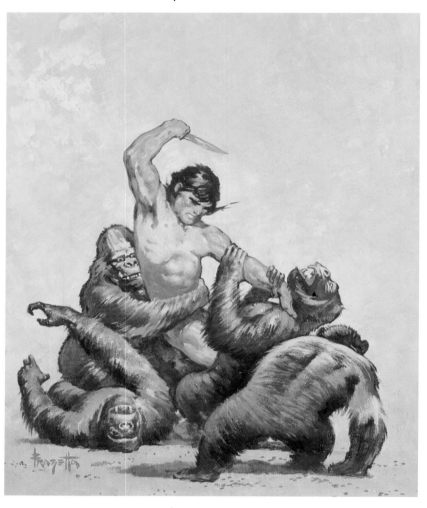

above:
Cover painting for
Tarzan and the Lion Man
by Edgar Rice Burroughs
[Ace Books, 1963, 9"x11"
watercolor on board]

opposite:
Book cover to
Jungle Tales of Tarzan
by Edgar Rice Burroughs
[Ace Books, 1963, 10"x15"
watercolor on board]

Anyone who believes that Frank never makes a mistake or doesn't critize his own paintings hasn't had the opportunity to hear him speak, particularly about his first series of ERB covers. "The *Jungle Tales of Tarzan* painting is bad. I painted it and *City of Gold* and *Lion Man* all in a single weekend—and they really look it. And that wasn't two solid days of painting, either: I did some goofing around as well. I don't think each painting has more than two or three hours devoted to it—all three are awful, but what the hell, you just don't *do* three paintings over a weekend, especially if you don't want them to come back thirty years later and show up in a book!"

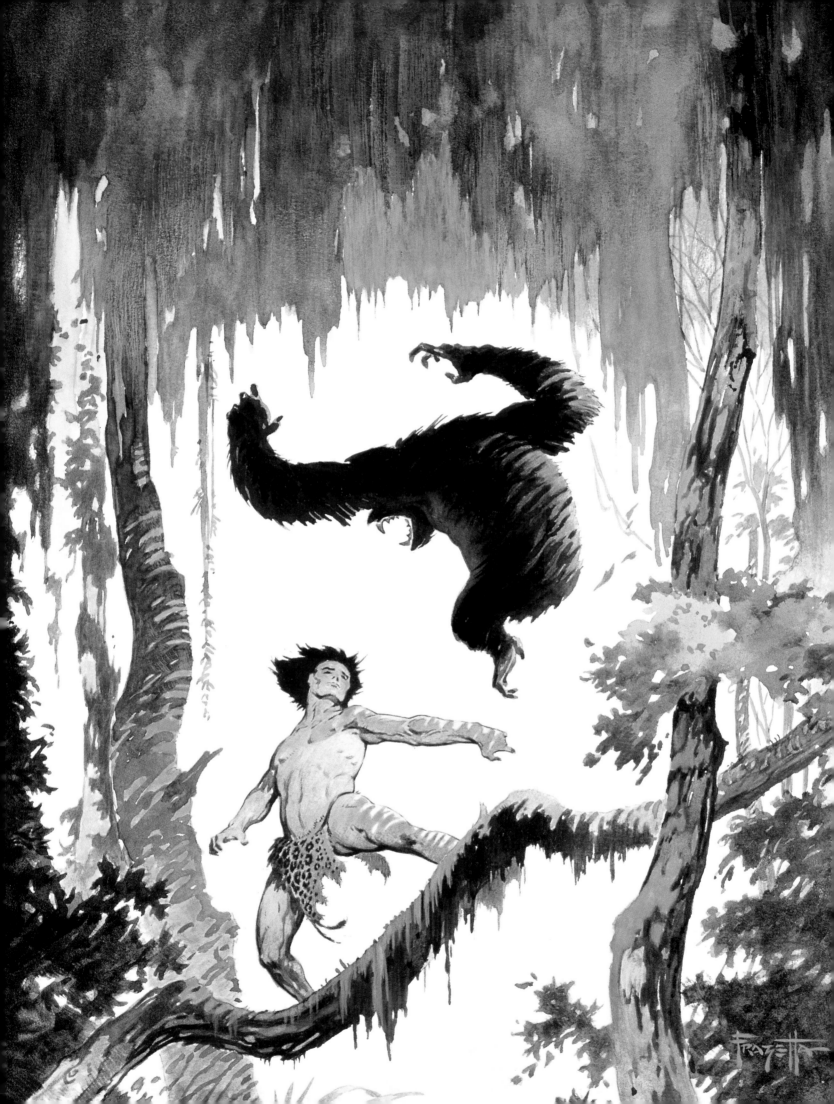

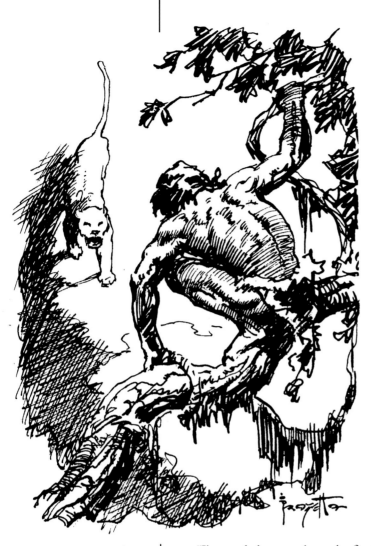

above:
A sketchbook drawing
of Tarzan, circa 1962
[4"x5", ink on paper]

opposite:
Book cover to
The Lost Continent
by Edgar Rice Burroughs
[Ace Books, 1963, 8"x10"
watercolor on board]

overleaf:
A previously unpublished
drawing of Tarzan at the
"Dum-dum", a ceremony of
the great apes. [Personal work,
circa 1991, 12"x16",
pencil on charcoal paper]

"I've tended to rag about the first covers I did for Ace over the years," Frazetta says, "but I thought this one was pretty nice. And for me it was a pretty small original. People need to understand that Capp was such a powerful influence for so long that it took me awhile to get *my* drawing skills back. I was used to drawing funny hands and feet and just rendering things like a cartoon, so this was another step back toward doing things in my style instead of like *Li'l Abner*. If you're a right-handed batter and you bat left-handed for a couple of years, you can bet you forget to bat right-handed."

Angered at being forced to let Ace keep his originals, Frazetta sometimes repainted those he especially liked: a second version of *The Lost Continent*, brighter and rendered in oils, resides in the family's private collection.

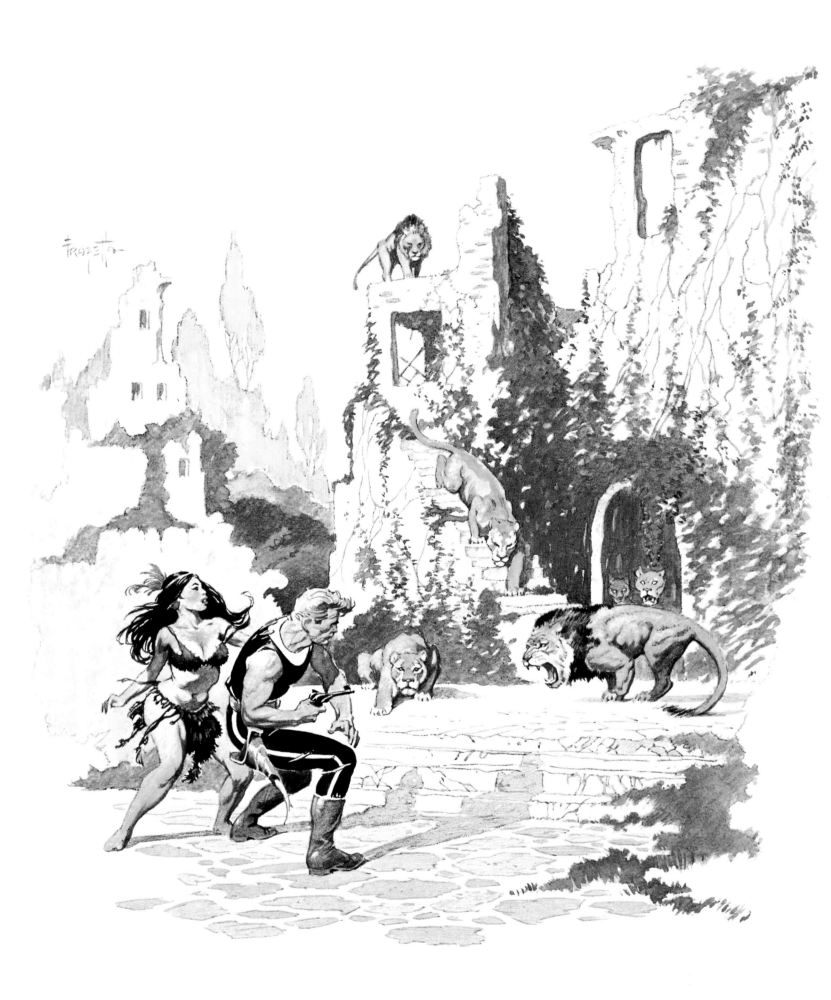

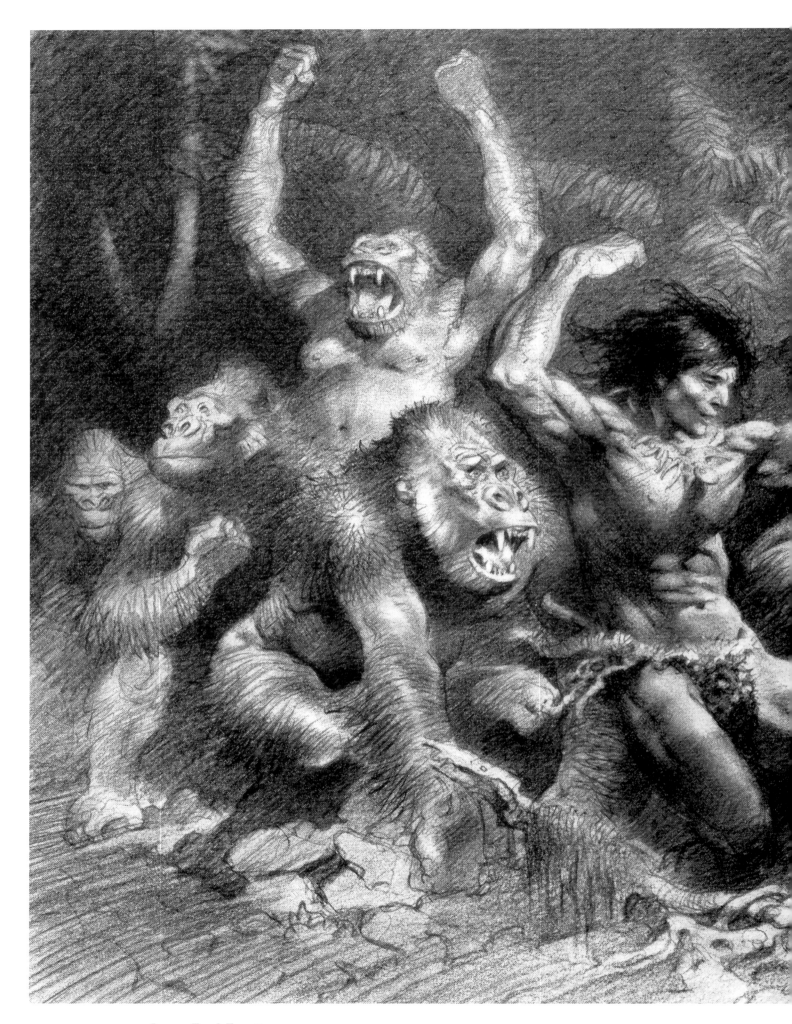

Legacy: Frank Frazetta

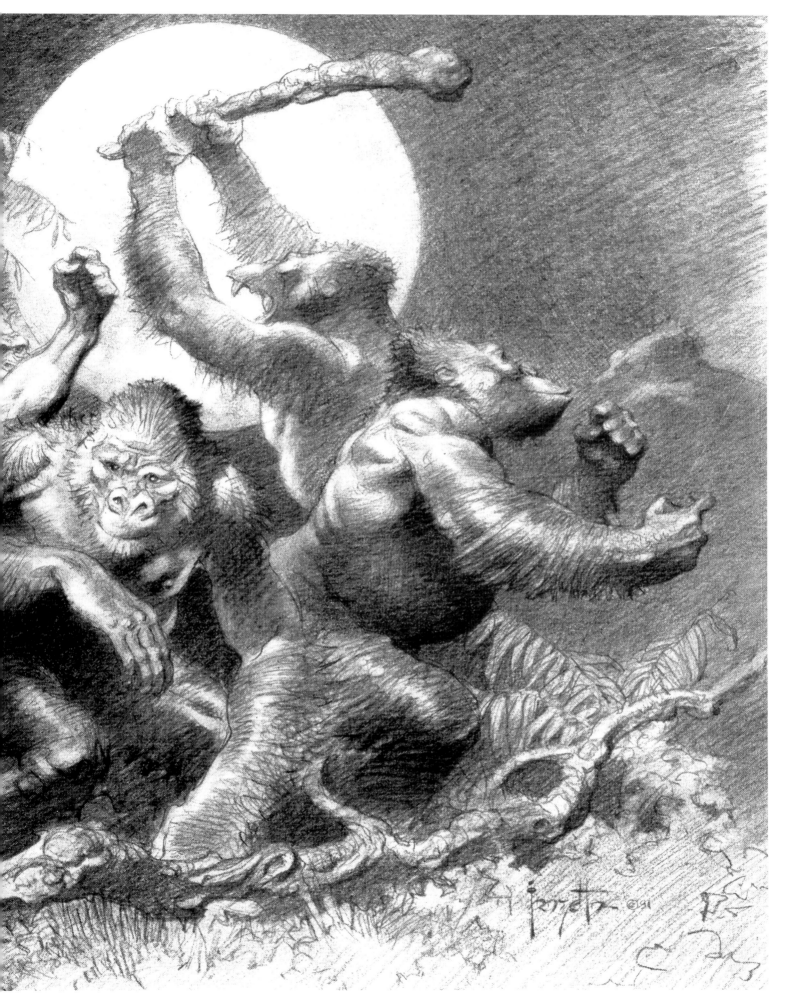

Legacy: Frank Frazetta

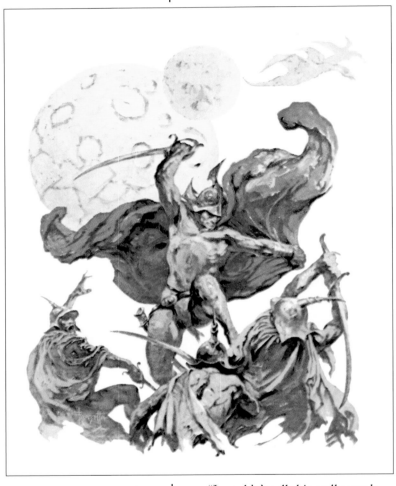

above:
Book cover to
Swordsmen In the Sky
edited by Donald A Wollheim
[Ace Books, 1963, 9"x11"
watercolor on board]

opposite:
Book cover to
Land of Terror
by Edgar Rice Burroughs
[Ace Books, 1964, 8"x10"
watercolor on board]

"I wouldn't call this really much of a painting," Frazetta says. "I used a different kind of opaque watercolor than I had been and the original is spotty as hell. If you want to pick it apart, sections of it look okay, I guess. It has a certain atmosphere, but it's by no stretch of the imagination a great piece of work."

When Frank was given the commission from Ace in the early 1970s to paint new covers for the Burroughs books he was much more satisfied, both financially and artistically, than he was a decade earlier. [See *ICON*, p. 99, for Frazetta's preferred cover for *Land of Terror*.]

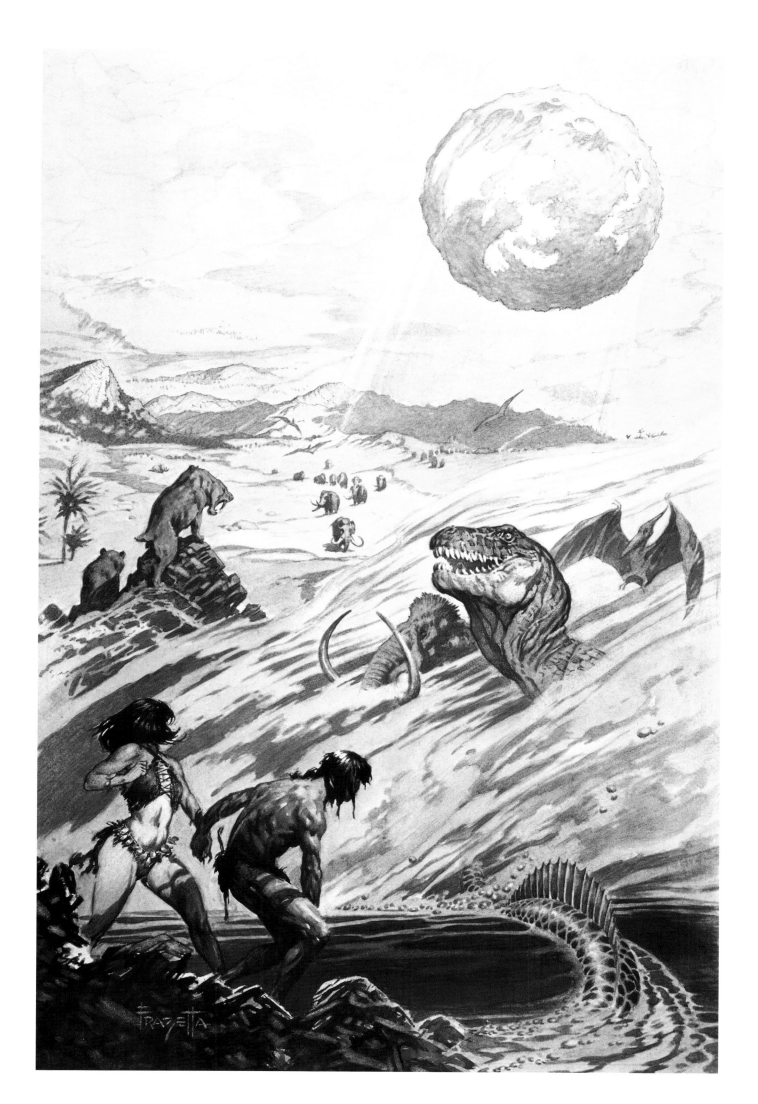

above:
Personal drawing
[1990, 2"x5", pencil on paper]
from the collection of Daren Bader

opposite:
Book cover to
Savage Pellucidar
by Edgar Rice Burroughs
[Ace Books, 1964, 12"x18"
watercolor on board]
Also used as the cover for
the Ace and Tempo editions
of *The Cave Girl.*

"I loved this one," Frazetta says.
"It was a vignette. Roy [Krenkel]
had a thing about a painting that
comes off like a little 'clump'—his
phrase. A very interesting 'clump.'
This worked well as a silhouette:
interesting, simple shape, white
background, but within the area
you've got a lovely design and
movement. It's dramatic, and from
an artistic standpoint I think it
worked pretty well—definitely one
of my better concepts from this
period."

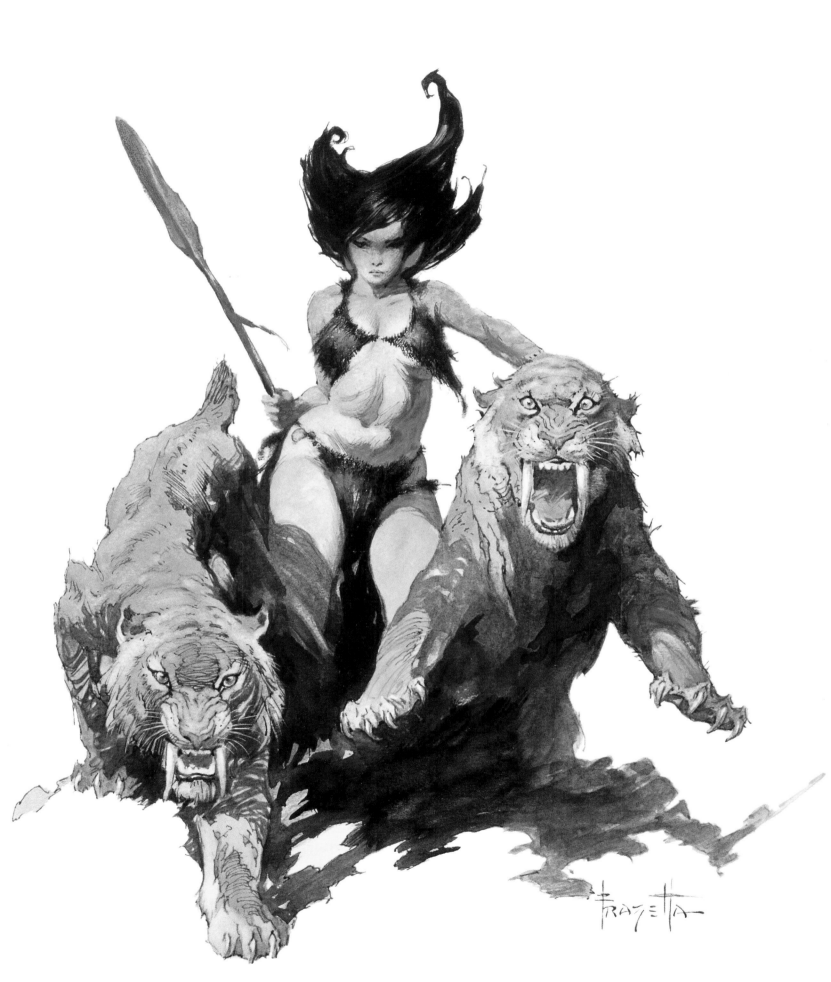

above left:
Preliminary rough for
Beyond the Farthest Star
by Edgar Rice Burroughs
[Ace Books, 1973, 4"x7"
watercolor on paper]

Book cover to
Beyond the Farthest Star
by Edgar Rice Burroughs
[Ace Books, 1973, 11"x16"
oil on board]

opposite:
Book cover to
Beyond the Farthest Star
by Edgar Rice Burroughs
[Ace Books, 1964, 12"x18"
watercolor on board]

Although he certainly did his share of science fiction paintings, Frazetta wasn't a "gadget" artist. His interplanetary travelers and spaceships were more influenced by Flash Gordon and Buck Rogers than by Robert McCall and NASA—which was appropriate, given his source material.

"I was pretty happy with it," Frank says of this cover. "Like most of the paintings, it was done very quickly, but it works well. It has a sort of rich and soupy flavor. This was about the time that I had really started to paint and I think this is better than a lot of my other early Ace covers."

Legacy: Frank Frazetta

above:
Book cover to
The Mucker
by Edgar Rice Burroughs
[Ace Books, 1974, 16"x24"
oil on board]

opposite:
Book cover to
Return of the Mucker
by Edgar Rice Burroughs
[Ace Books, 1974, 16"x24"
oil on board]

When Ace approached Frazetta in the early 1970s to paint new covers for another series of ERB reprints, he was far from the '60s novice scrambling for work and approval. His artistic direction for the second Ace series was much more painterly; he played with color to convey a desired mood rather than rely on minute detail; subtle watercolors were replaced with bold oil glazes. Though Frazetta was flirting with "fine art" with many of these covers, he couldn't resist letting his sense of humor occasionally show through, as with these paintings for *The Mucker* and it's sequel.

Legacy: Frank Frazetta

above:
Preliminary rough for
Swords of Mars
by Edgar Rice Burroughs
[1974, 5"x7" pencil and
gouache on paper]

opposite:
SWORDS OF MARS
Book cover to
*Swords of Mars/
Synthetic Men of Mars*
by Edgar Rice Burroughs
[The Science Fiction Book
Club, 1975, 16"x24"
oil on board]

overleaf:
JOHN CARTER AND
THE SAVAGE APES OF MARS
Book cover to
*The Gods of Mars/
The Warlord of Mars*
by Edgar Rice Burroughs
[The Science Fiction Book
Club, 1971, 32"x20"
oil on board]

How many of you reading this
volume joined the Science Fiction
Book Club in the early 1970s just so
they'd be able to buy hardback
editions of the John Carter of Mars
novels with *new* Frazetta covers and
illustrations? Me, too.

Besides the art done for the ERB
books, Frank provided a variety of
promotional drawings and paintings
for Doubleday's book clubs. "They
were fun jobs," Frazetta says. "The
different book clubs kept me fairly
busy—I did everything from
Westerns to barbarians to some very
surrealistic stuff for them. Doing the
drawings for their books and flyers
kept my black and white art sharp—
some of the Burroughs drawings,
particularly, still stand up pretty
nicely after all these years. Not quite
on a par with my Canaveral Press
ink work, but I'm still pretty happy."

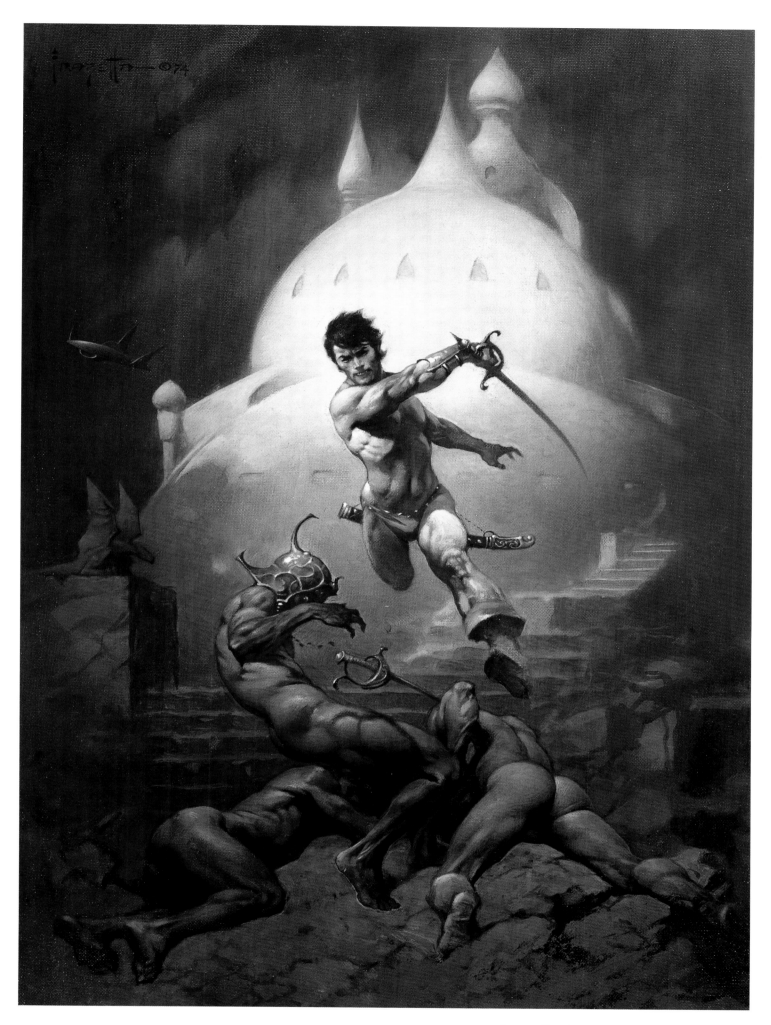

Legacy: Frank Frazetta

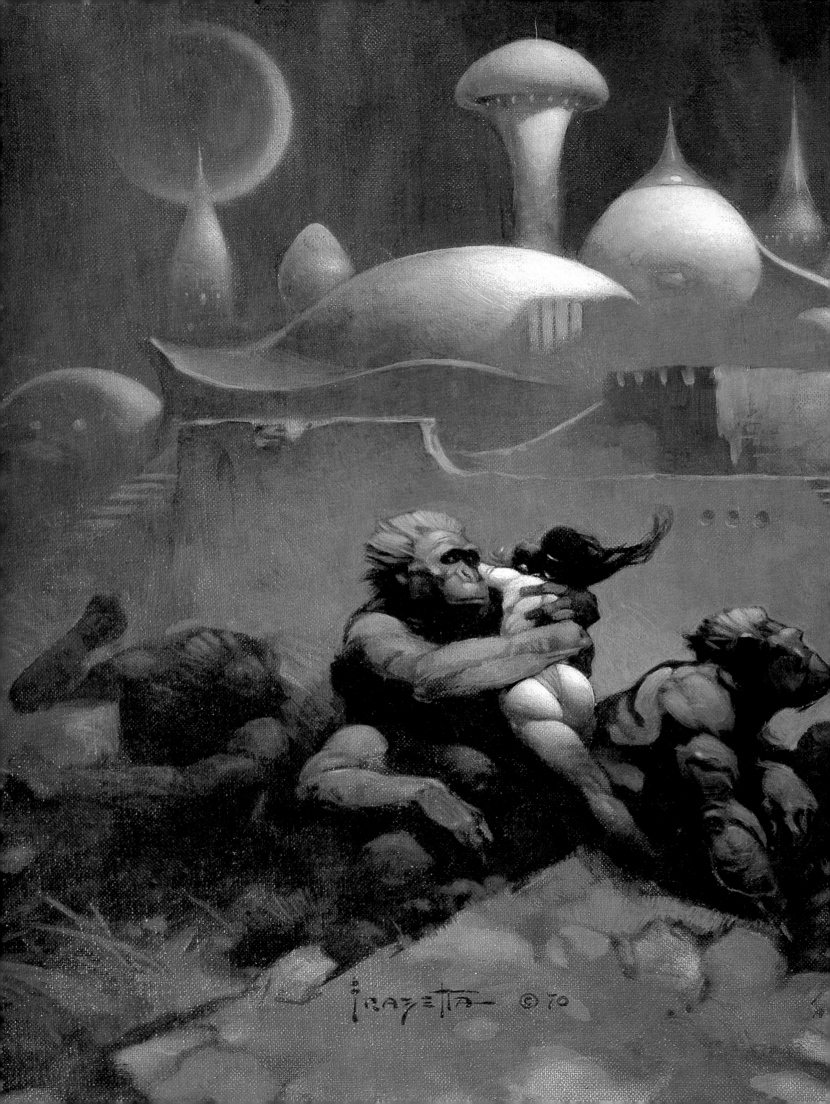

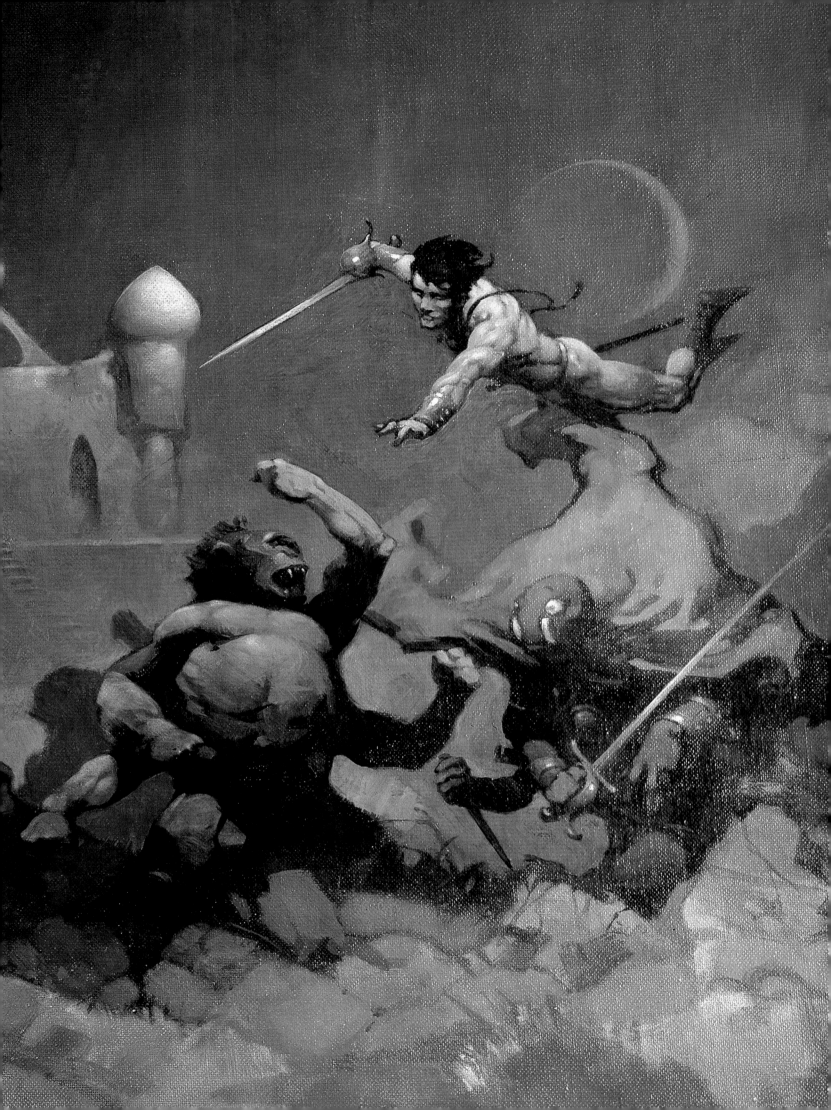

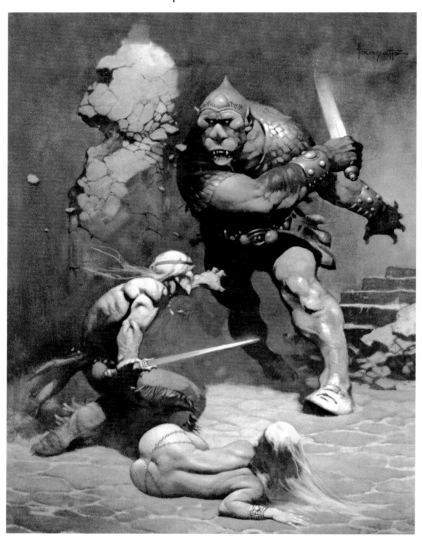

above:
Book cover to
The Moon Men
by Edgar Rice Burroughs
[Ace Books, 1974, 16"x22"
oil on board]

opposite:
ESCAPE ON VENUS
Book cover to
Escape on Venus
by Edgar Rice Burroughs
[Ace Books, 1974, 16"x22"
oil on board]

Lush jungle, beautiful woman in peril, vicious beast being, well, *vicious:* all are icons found repeatedly throughout the body of Frank's art. And yet, all are handled individually, all hold up as vigorous and unique works without creating a sense of *deja vu* within the audience.

"It's no big secret," Frazetta says. "I love big cats and I love beautiful women. And, you know, I think I've captured a cat's movements pretty accurately in some of my stuff, but I don't think I've ever done a piece of work that has captured just how wonderful a *real* woman is. Sure I've done some paintings that might make you stop and go, *'Look out!'*, but what could compare to a flesh and blood woman? *That's* a *real* work of art, pal."

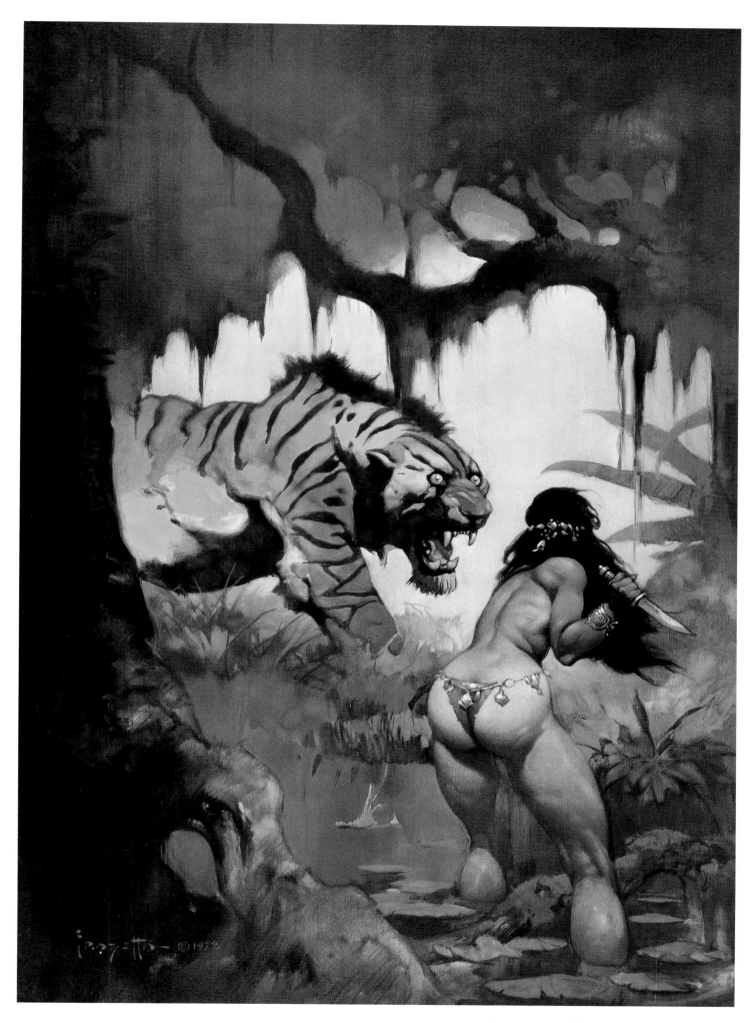

Legacy: Frank Frazetta

above left:
Roy Krenkel's painting for
the book cover to
The Outlaw of Torn
by Edgar Rice Burroughs
[Ace Books, 1968]

above right:
Roy Krenkel

opposite:
OUTLAW OF TORN
Book cover to
The Outlaw of Torn
by Edgar Rice Burroughs
[Ace Books, 1973, 16"x22"
oil on board]
This painting was turned
into a notorious bootleg
poster in 1975 by "The
Alamo Press."

Roy Krenkel was something of an enigma in the commercial art world. His reputation far exceeded his professional output and his staunchest fans acknowledge that even his best paintings can be static and flat.

But Krenkel was beloved by all who knew him and was revered by fans for the voluminous stack of sketches he contributed to numerous fanzines. He was "The Professor" to the artists he mentored and encouraged, a legendary New York collector with encyclopedic art knowledge. Yet at the same time he championed Frazetta to Donald Wollheim, he was also intimidated by his friend's talent. "Frank could always just turn it on or off in a snap," Krenkel said shortly before his death. "Every painting was a real struggle for me and the end results were almost always rigid and dull. Frank, on the other hand, could pull a masterpiece out of thin air—without prior thought—in a matter of hours. And then run out and play ball! How do you compete with something like that?"

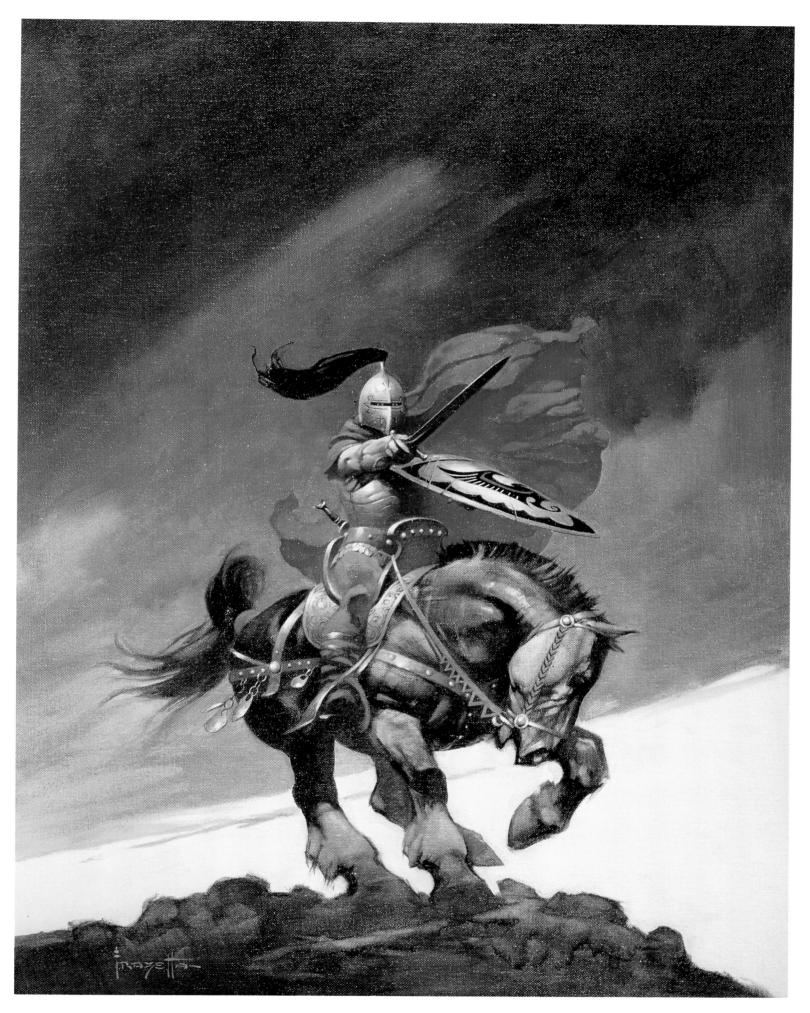

Legacy: Frank Frazetta

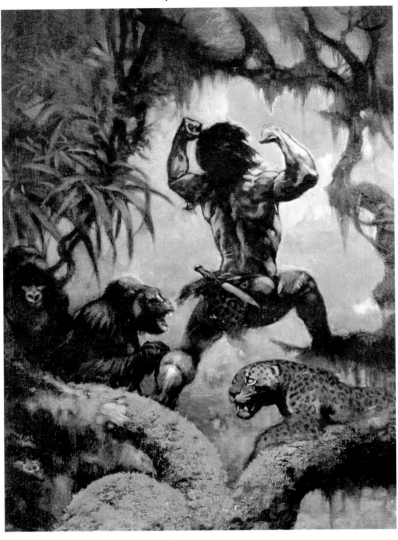

above:
Book cover to
Edgar Rice Burroughs:
Master of Adventure
by Richard A. Lupoff
[Ace Books, 1974, 16"x20"
oil on board]

opposite:
BLACK PANTHER
Book cover to
Land of Hidden Men
by Edgar Rice Burroughs
[Ace Books, 1973, 11"x16"
oil on board]

It's not a secret that Frazetta often continues to work on a painting after it's been published, but his cover for *Edgar Rice Burroughs: Master of Adventure* (above) had more of an extensive revision than most. "I set out to conquer the world with that one," Frank muses, "and I fell on my face. For some reason it didn't pan out, and I don't know why. It was a good idea: Tarzan beating his breast to the moon, and my little rough on it was pretty nice. But when I painted it, half of it was well done and the other half stunk. I was dissatisfied and I couldn't leave it that way."

Tarzan was eventually transformed into a nude woman in the revised painting entitled "The Moon's Rapture" [see *ICON*, p. 163]. "I wish we could talk him into leaving the original paintings alone and into doing his repaints on new canvases," sighs long-time friend Nick Meglin, "but that's Frank."

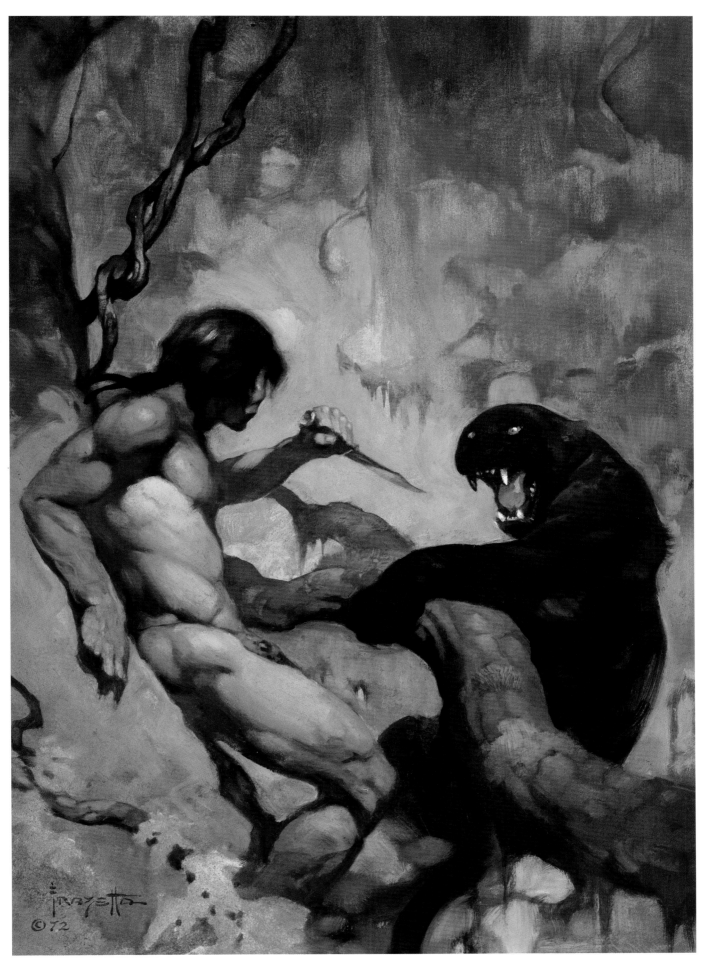

above left:
Preliminary rough
for *Tanar of Pellucidar*
[1972, 5"x7",
watercolor on paper]

above right:
Personal drawing
[9"x11", pencil on paper]

opposite:
TANAR OF PELLUCIDAR
Book cover to
Tanar of Pellucidar
by Edgar Rice Burroughs
[Ace Books, 1973, 13"x19"
oil on board]

Throughout the 1960s and into the early '70s, ERB fandom was in full bloom and one of the topics debated in the various amateur magazines was the merits (or the lack of same) of the various artists illustrating Burroughs' fiction. Inevitably the fans were divided into two camps: those championing J. Allen St. John and those favoring Frazetta. Roy Krenkel once tried to sum up the differnces:

"In St. John's jungles there are no bugs. If a snake bites you it's either completely venomous and you drop dead, or you recover. There's no in between: you never suffer and die a lingering death. His was sort of a *clean* jungle, where the good guys are good and the bad guys are bad. With Frank there are overtones of the reality of the world. His world is more brutal, more sensual. You can get *hurt* in Frank's world. You get bopped on the head and you're in deep trouble. Whereas with St. John, Tarzan would just tap you on the noggin and you'd gently fall asleep, then recuperate and wonder what happened."

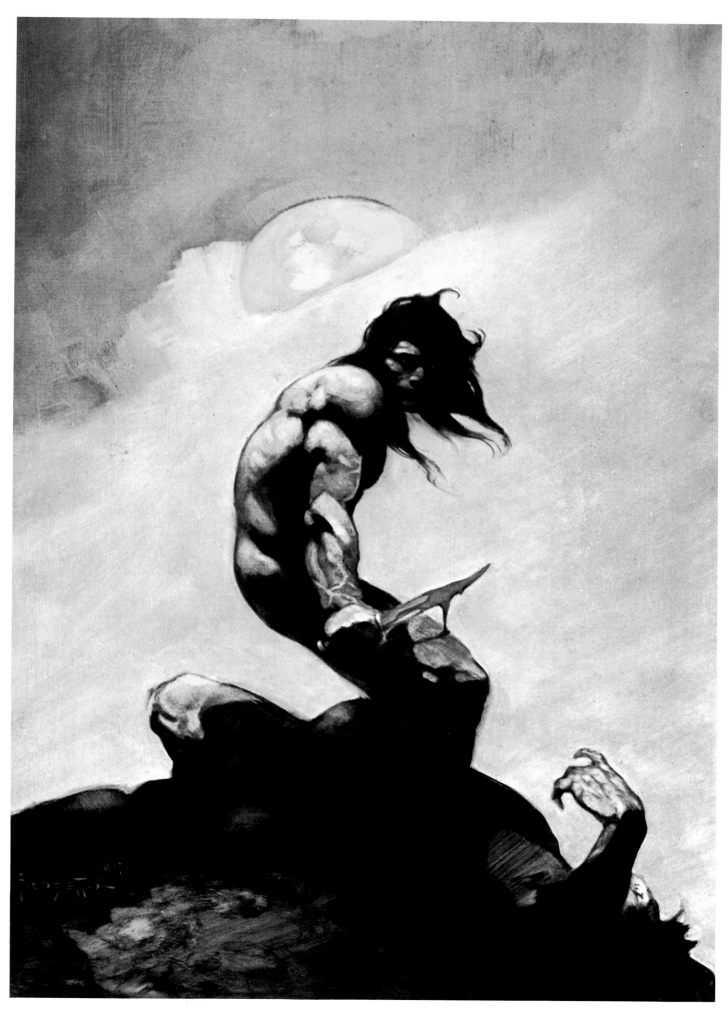

Legacy: Frank Frazetta

above:
A Tarzan sketchbook
drawing [circa 1972,
4" x 6", ink on paper]

opposite:
AT THE EARTH'S CORE
Book cover to
At the Earth's Core
by Edgar Rice Burroughs
[Ace Books, 1974, 18"x24"
oil on masonite]

overleaf:
TARZAN MEETS LA OF OPAR
A previously unpublished
personal work created toward
the end of Frazetta's tenure
with the Al Capp Studio
[1960, watercolor and
ink on paper, 12"x8"]
from the collection of Dr. David Winiewicz

Danton Burroughs observed in his foreword that Frazetta's second series of covers for Ace emphasized the erotic undertone of ERB's fiction. This painting for *At the Earth's Core* leaves the viewer with the tough decision of either keeping an eye on the scantily clad Dian the Beautiful or watching for the deadly Mahar as it emerges from the mist.

While it is true that the Frazetta family has retained many of the works Frank is best known for (and which make up much of the content for both *Legacy* and *Icon*), quite a number of originals reside in private collections. Attempts to seek the cooperation of some of these owners were unsuccessful. However, the previously unpublished watercolor from the collection of Dr. David Winiewicz on the following overleaf is just one example of the generosity we experienced from some collectors while compiling *Legacy*.

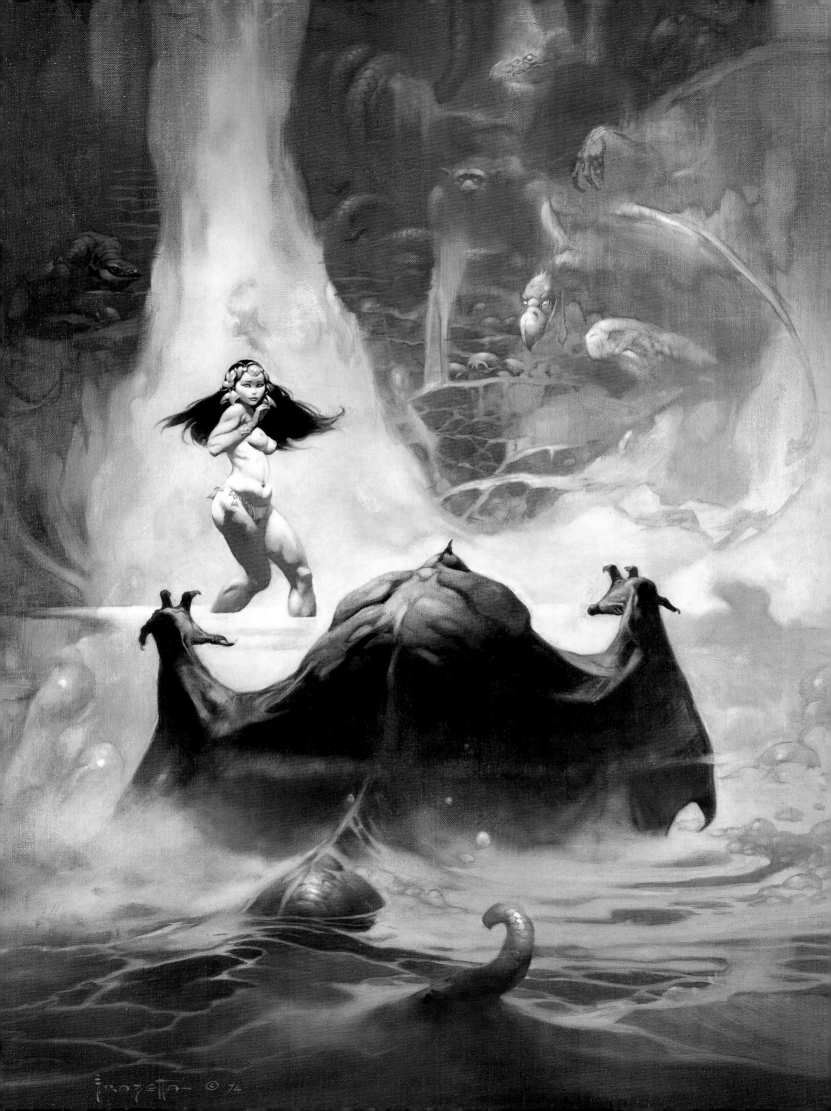

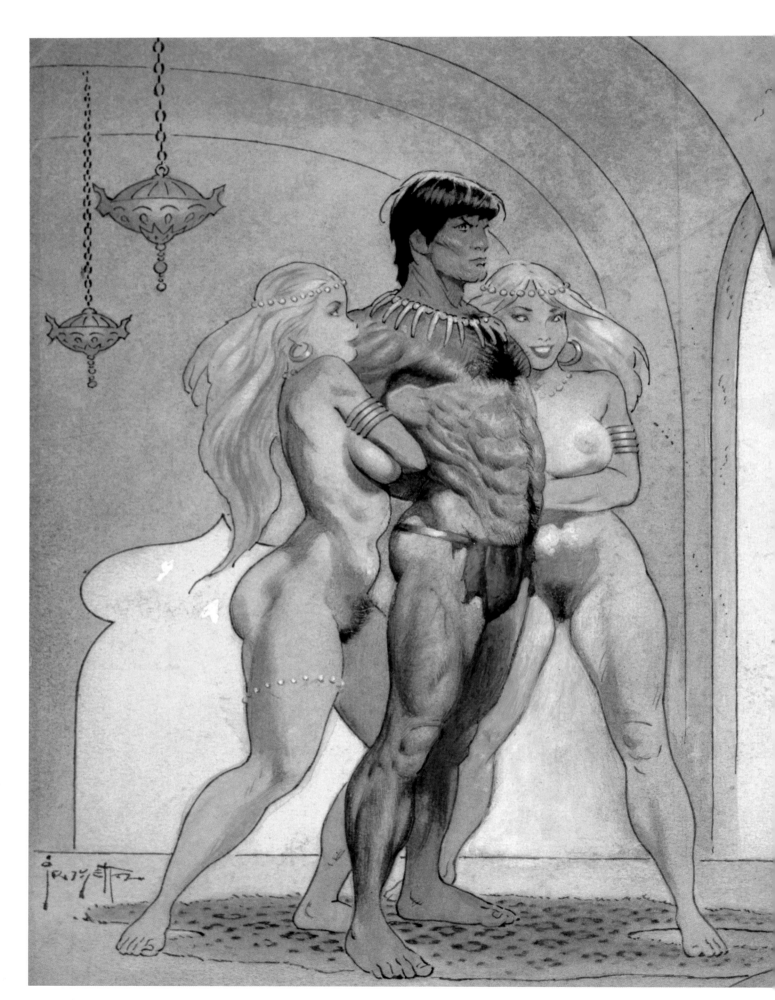

Legacy: Frank Frazetta

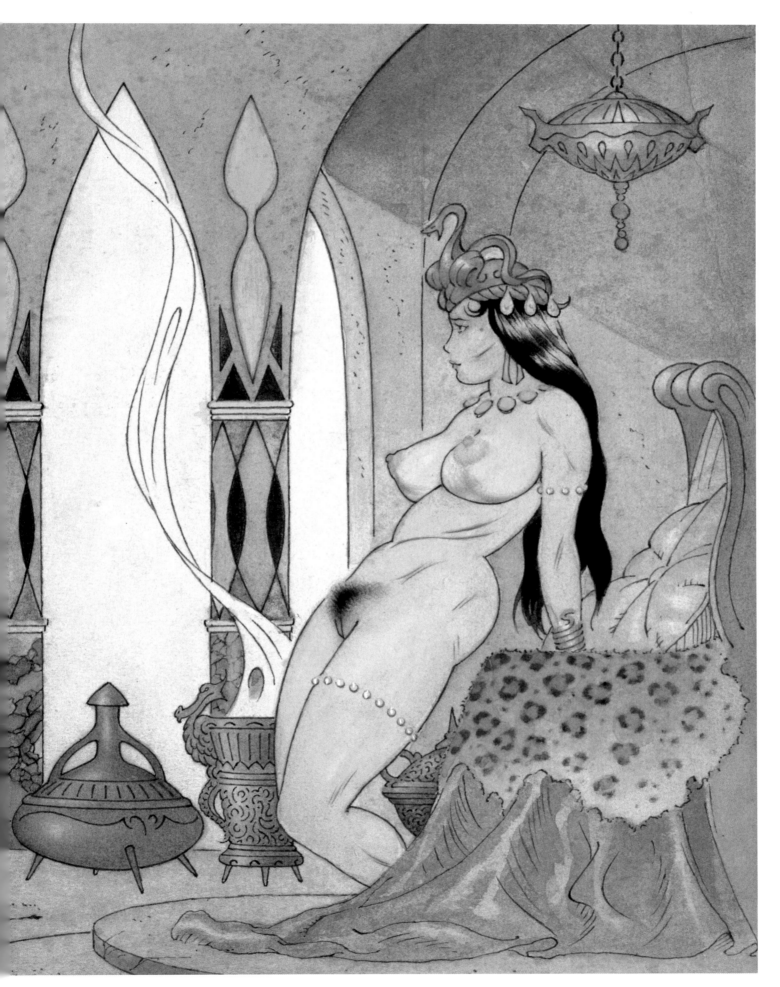

Legacy: Frank Frazetta

above:
Pencil and gouache rough
for *Pellucidar*
[1972, 4"x6"]

opposite:
FLYING REPTILES
Book cover to
Pellucidar
by Edgar Rice Burroughs
[Ace Books, 1972, 15"x23"
oil on board]

Covers and interior illustrations for the works of Burroughs comprise an unusually large percentage of Frazetta's commercial out-put. All told he painted (or drew, in the case of Canaveral Press) well over 40 ERB book covers.

"I usually grow bored with a series after three or four books," Frank confesses. "If you look at the Conans, the first few are the best of the lot—the others I had to go back into much later (like *Conan the Buccaneer*) to bring up to snuff. But with the Burroughs covers there was something there with each job, all of these images that just kept popping out. Maybe I was showing what I would've liked to have done—what I *could've* done—if I'd been given the encouragement my first go around ten years earlier."

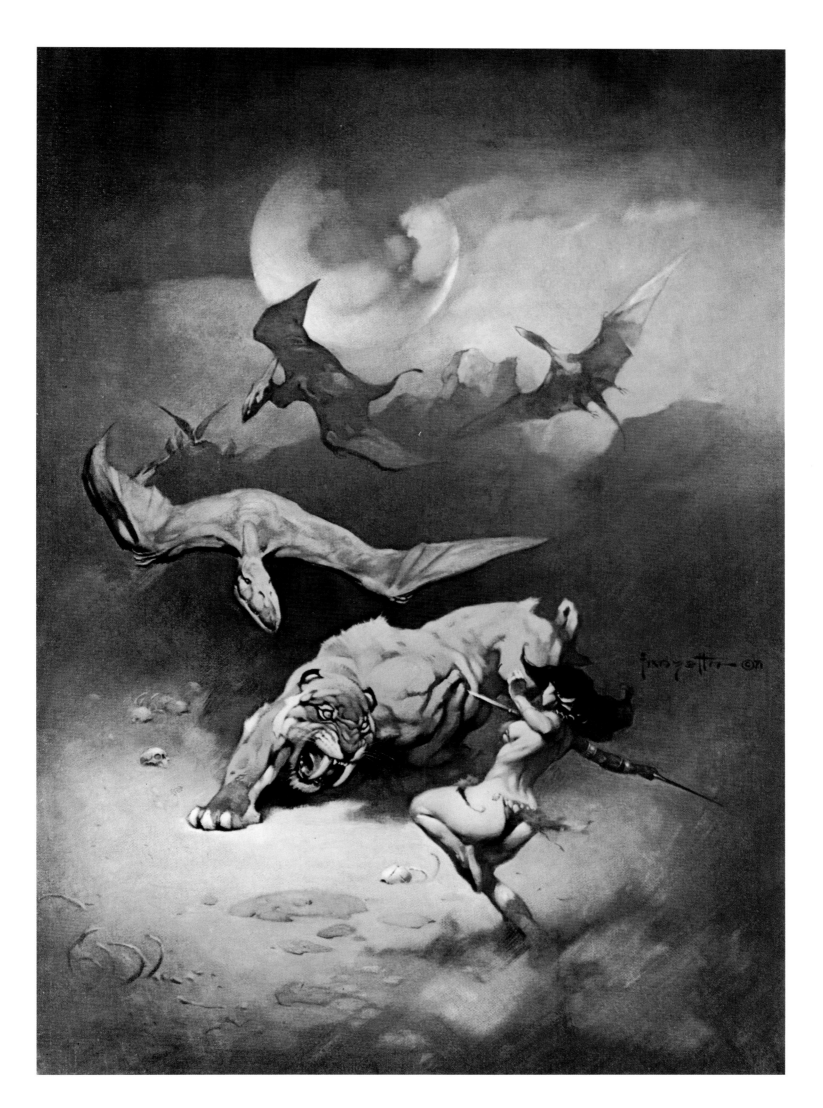

What is unique about Frazetta's Art is Frazetta.

Yeah, he populates his pictures with a lot of cool stuff overflowing with action and atmosphere. His women are the sexiest ever and his men are the very height of barbarian fashion. But it's the way he blends it all together, his own artistic temperament (in part a result of his background—being a NYC boy of Sicilian descent myself, I'm partial), that makes the difference. It's not the style of painting itself that makes his Art scream. When used brilliantly any approach could evoke a powerful reaction—by extreme contrast of nature and execution, look what Leonardo did with Mona (there's a thought, Conan and Mona…maybe that's why she's smiling!). As many have discovered, emulating Frazetta's technique or style is one thing; being unique is quite another.

Joseph DeVito
painter/sculptor/illustrator

opposite: SAVAGE PELLUCIDAR. Book cover to *Savage Pellucidar* by Edgar Rice Burroughs. [Ace Books, 1973, 18"x23", oil on board]

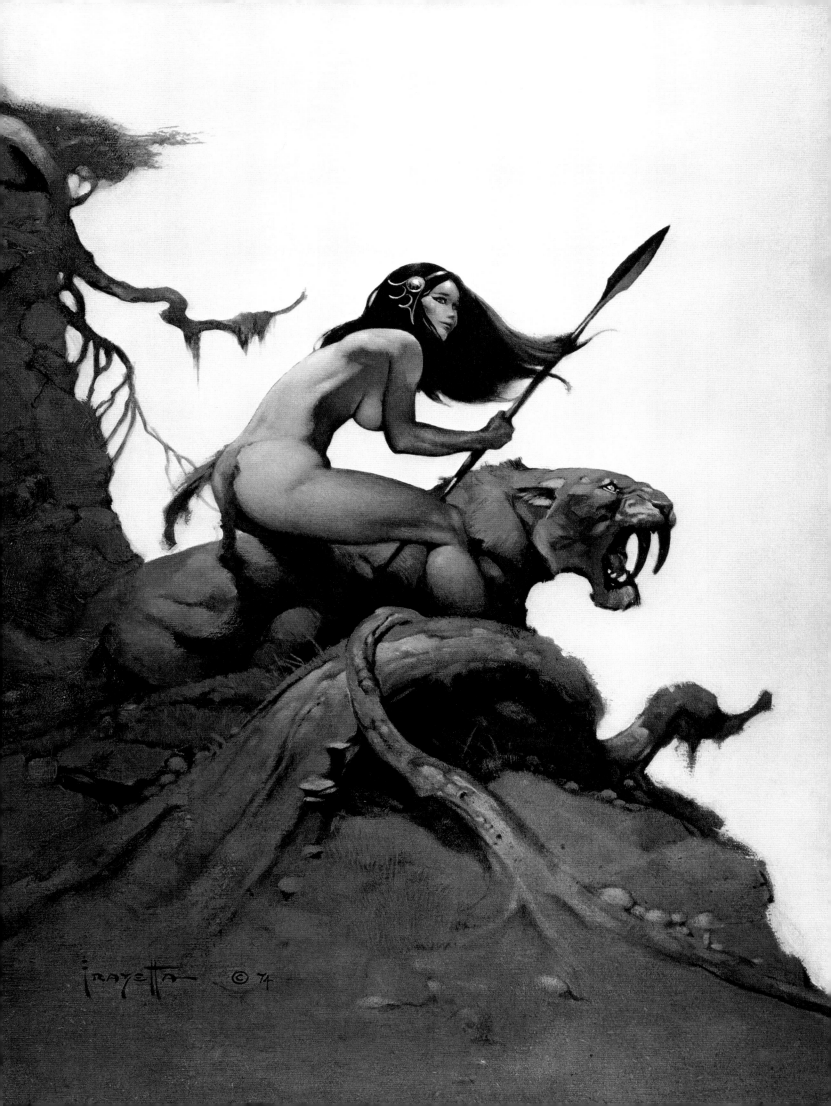

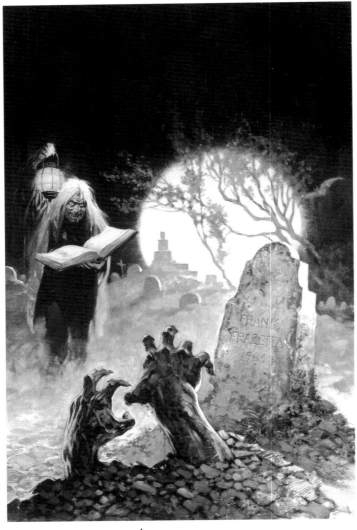

above:
Book cover to
Tales From the Crypt
a paperback compilation
of EC comic stories.
[Ballantine Books, 1964,
12"x16", oil on board]

opposite:
SORCERER
Magazine cover to *Eerie*
[issue #2,
Warren Publishing, NY,
1965, 17"x23"
oil on board]

With the success of *Creepy*, his first magazine-sized horror comic started in 1964, publisher James Warren decided to add a second title, *Eerie*, to his line in 1965. However when he learned that a competitor (who used the same distribution company) was preparing a horror magazine with the same name, the race was on to secure the copyright for the title.

Warren called in editor Archie Goodwin with freelance letterer Gaspar Saladino and cobbled together a 5 1/2"x7 1/4" issue of *Eerie* #1 utilizing inventory from *Creepy*. He had 200 copies printed over night, arranged for the newstand outside his distributor's office to display copies, and announced to his competitor and his distributor in a meeting the following morning that *Eerie* was already on sale. With the title secured, issue #2, full-sized and featuring this stunning Frazetta oil, was published in March, 1966.

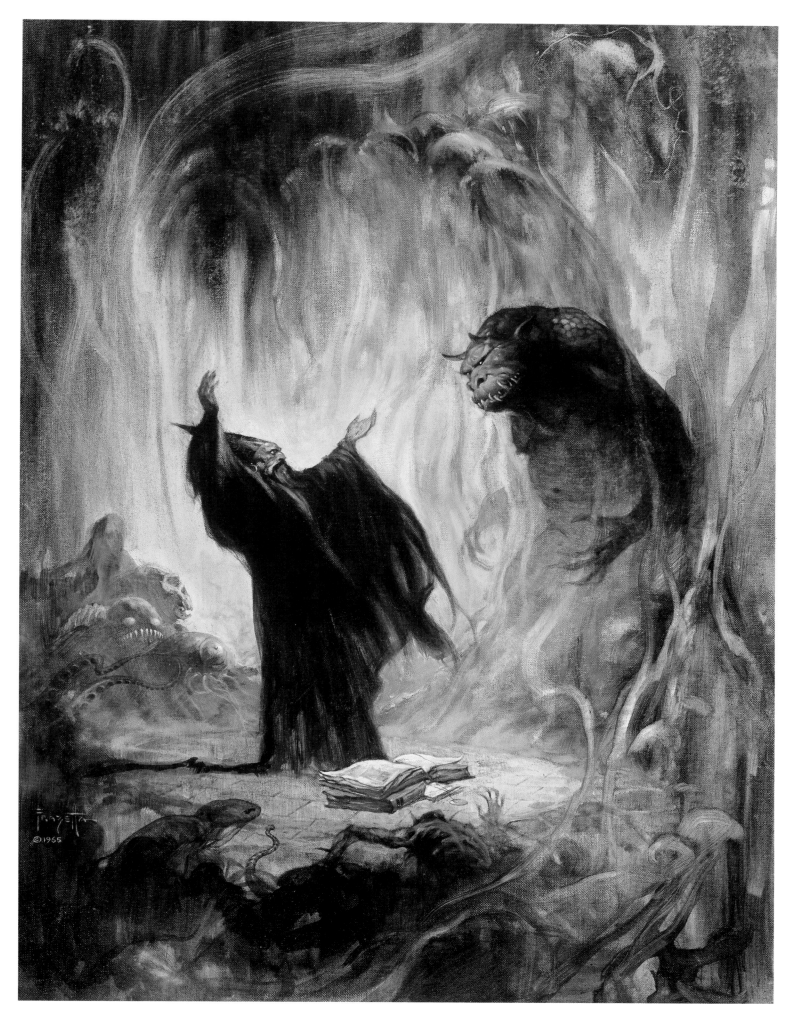

Legacy: Frank Frazetta

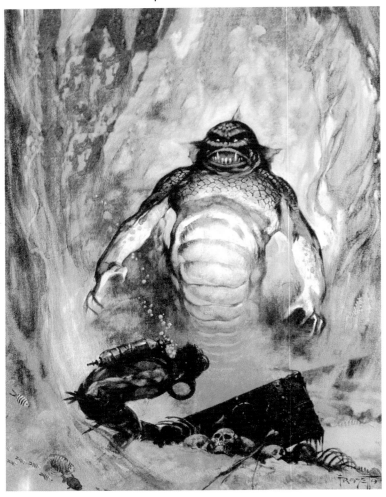

above:
Magazine cover to
Eerie #3 as it was originally
published

opposite:
SEA MONSTER
Magazine cover to *Eerie*
[issue #3,
Warren Publishing, NY,
1966, 17"x23"
oil on board]

Frazetta had a unique relationship with Jim Warren: in return for granting Frank complete artistic freedom Warren got an electrifying string of cover paintings at a bargain price. "I liked Jim," Frazetta says. "He was very amiable and a lot of fun. I mean, he was full of crap up to his eyeballs and if you didn't know that about him you could get suckered. Since I knew that about him we got along pretty well. I wasn't working for him for the money; I did it because I could paint whatever I wanted and see it printed large. *That* was a rush. And you know, I got an awful lot of positive reaction to those *Creepy/Eerie* covers, even years after they were first published."

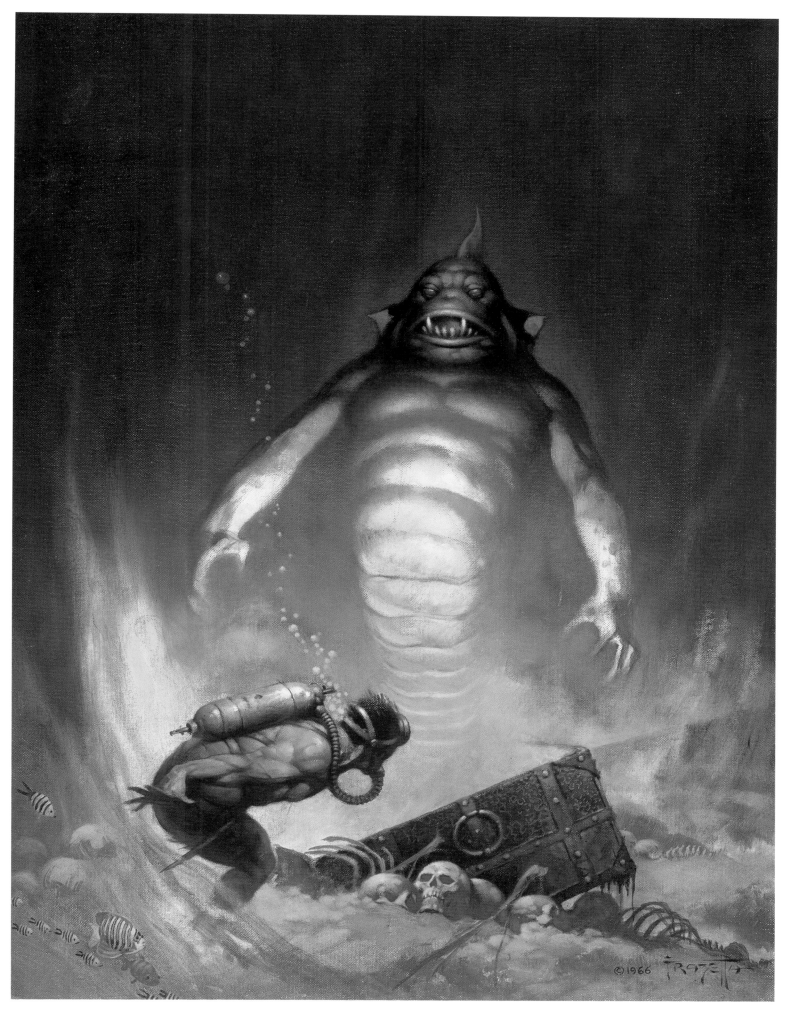

Legacy: Frank Frazetta

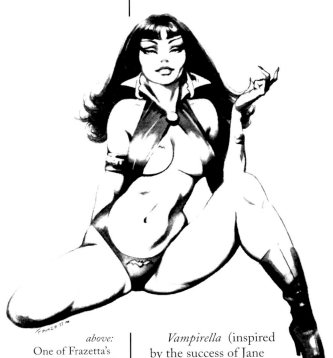

above:
One of Frazetta's
three initial promotional
drawings of the title
character "Vampirella"
[Warren Publishing, NY,
1969, 9"x9" ink on paper]

opposite:
WOMAN WITH SCYTHE
Magazine cover to *Vampirella*
[issue #11,
Warren Publishing, NY,
1971, 19"x20"
oil on masonite]

Vampirella (inspired
by the success of Jane
Fonda's camp film version
of the French comic strip
Barbarella) was the third
title in Warren's line of horror
comics. Whereas *Creepy* and *Eerie*
owed much of their inspiration to
EC comics and the Universal horror
films of the 1930s and '40s,
Vampirella drew its influence from
the sexier Hammer Studio movies
of the 1950s and '60s that were
standard fare at the drive-in theaters
of the time. The heady mixture of
sex and violence made the magazine
an instant success. After Warren
Publishing was forced to liquidate
its assets in bankruptcy proceedings
in 1983, *Vampirella* became even
more popular as a franchise char-
acter for its new owner, Harris
Publishing, throughout the 1990s.
So popular, in fact, that Jim Warren
disputed Harris' claim to the
character in a lawsuit filed in 1998.

For many years Frazetta was the
only illustrator whose work was
routinely returned by Warren Pub-
lishing (though several pieces went
"missing"): everyone else had to
relinquish their originals as part of
the standard work-for-hire practice.

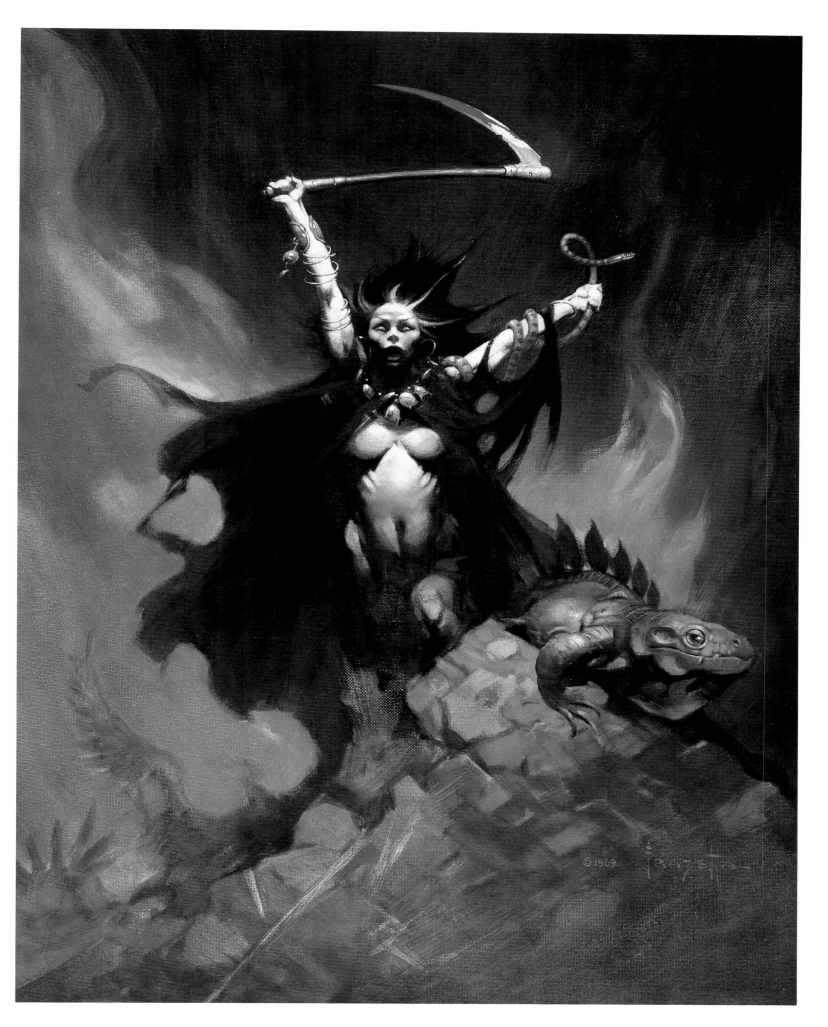

Legacy: Frank Frazetta

above:
A pair of rough sketches
by Roy Krenkel that Frazetta
used as the basis for his
cover to *Creepy* #6.

opposite:
GARGOYLE
Magazine cover to *Creepy*
[issue #6,
Warren Publishing, NY,
1965, 17"x23"
oil on board].

"I think there were a couple of times," Frank relates, "when things were a little tight for Roy. As a way of helping out I'd ask him to do a rough for a *Creepy* cover, then split the fee with him. It wasn't much, but that's what friends do."

As he had during the EC days, Krenkel mostly sat on the sidelines, the dour Eeyore of the Fleagle Gang, as his pals Frazetta, Angelo Torres, Al Williamson, and Wally Wood produced memorable work for Warren. Besides some inking on one of Williamson's stories, he only produced a "Loathsome Lore" page for *Creepy* and three "Monster Gallery" pages for *Eerie*. Krenkel's secret wish was to paint covers (and a large number of roughs exist attesting to that desire), but he was never able to overcome his own lack of initiative and low self-esteem. A large amount of marvelous work remained unfinished at the time of his death from cancer in 1983.

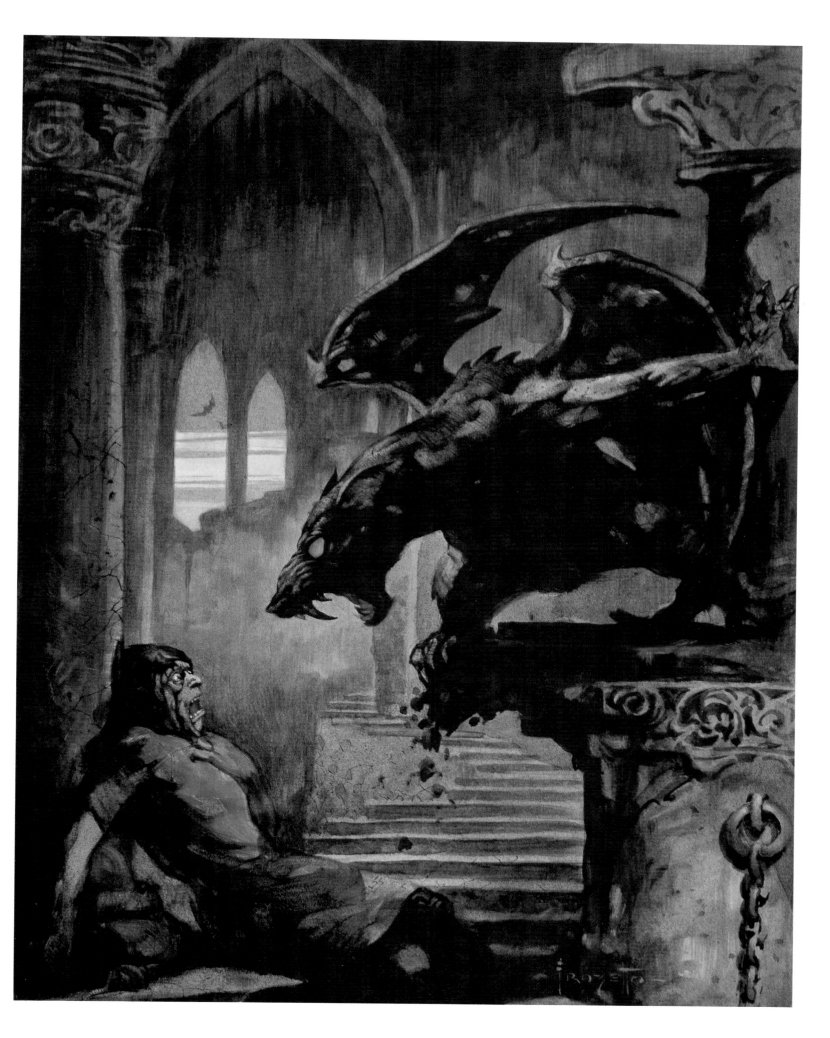

Legacy: Frank Frazetta

above:
The rough drawing
for a plate from
the portfolio *Kubla Khan*
[1975, ink on paper]
The drawings used for
the portfolio were originally
commissioned for a chapbook
of S.T. Coleridge's epic poem,
"Kubla Khan."

opposite:
MONGOL TYRANT
Magazine cover to *Creepy*
[issue #27,
Warren Publishing, NY,
1969, 16"x21"
oil on board]

One of the things that always amazed Frazetta's audience was his legendary speed—the fact that some of his most popular paintings were created in a day or less left many mouths agape. "I'd put everything off to the last minute," Frank says. "One time I had a cover due to Warren on a Monday morning and by late Sunday night I was about ready to start. I didn't have a damn piece of art board to spare anywhere in the house! I went *ape!* Nothing's open, Ellie goes to bed crying, I don't know what I'm going to do. I had given *my word!* All of a sudden, I'm looking down at the floor that we were having repaired. Bingo! I pried up a piece of plywood and painted "Neanderthal" [*ICON*, p. 43] on it—I was so excited I dragged Ellie out of bed to see! Painting on the plywood gave me the idea to start working on masonite. I liked the sturdiness, the heft of it."

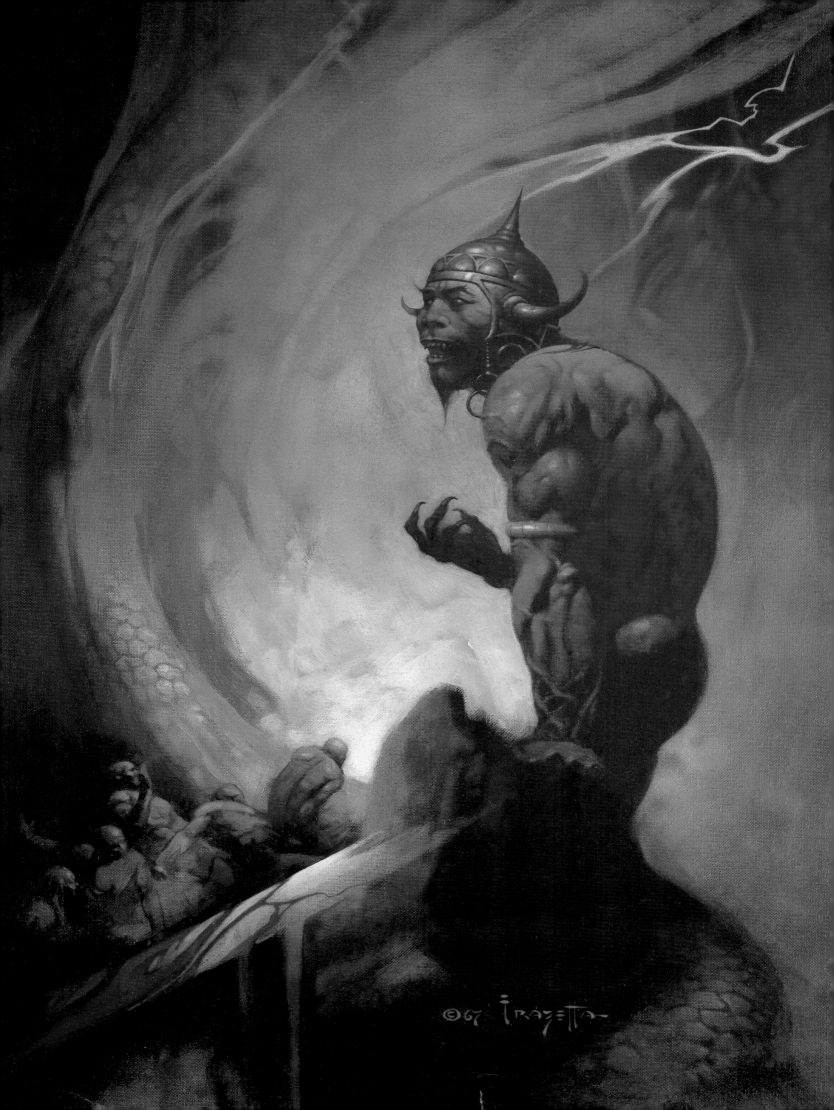

THE STORY BEHIND THE STORY OF
ROCK

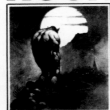

Frank Frazetta, Harlen Ellison, Neal Adams; Anyway you measure it, this trio represents a magnitude of artistic and writing talent. ROCK GOD—starting on the following page—is a showcase of their combined creativity.

Frazetta started it off last summer when he walked into our offices carrying a large manila envelope. We weren't expecting Frank that day, and we certainly weren't expecting him to open that envelope and surprise us with a cover painting (see inset). A few weeks earlier Harlan Ellison, a Hollywood science fiction writer with a highly developed sense of imagination — and a lover of comic art—expressed interest

in writing a story based on the next Frazetta cover. Ellison is also a fan of another Creepy contributor—artist Neal Adams. We asked Neal to illustrate Harlen's story. Neal (his last work for us appeared in VAMPIRELLA #1) enthusiastically agreed to the project.

Ellison was then sent a photocopy of the original Frazetta painting (our cover this issue); soon we received Harlen's short story ROCK GOD—which was sent to Neal for breakdown into comic format and finished art. Another of our top pro's—BEN ODA—did the lettering. Neal Adams did the portraits (including his own) of the 3 contributors, shown below . . .

GOD

Ellison: "My work is writing. It's also my pleasure. I'm 35, and have this portrait on my wall; I keep getting younger, but the portrait is decaying hideously."

Frazetta: "My first love is comic art. Probably always will be. Men who've inspired me. Michael Salanga, Hal Foster—both truly great artists. My second love is drawing the female form. Can't you tell? Altho, some days I'd rather be playing baseball for the Yankees."

Adams: I guess I'm really 3 different people . . . a quiet, serious student of good literature & art; also a guy who loves to draw pictures and convey ideas through the comic medium. The third Adams produces storyboards for television and illustrations for N.Y. ad agencies. Someday "all 3 of us" will work on a project we'll all enjoy."

ART BY NEAL ADAMS/STORY BY HARLAN ELLISON BASED ON A COVER PAINTING BY FRANK FRAZETTA
The story "Rock God" copyright © 1969 by Harlan Ellison

above:
The "set-up" page explaining the evolution of the story "Rock God" from *Creepy* #32 with creator portraits by Neal Adams

opposite:
NIGHTSTALKER Magazine cover to *Creepy* [issue #32, Warren Publishing, NY, 1970, 16"x21" oil on masonite]

Renowned writer Harlan Ellison has never kept his passion for comics a secret. Popular for both his fiction and his television scripts, it was something of a coup for Warren when Harlan approached him with the offer to write a story based on Frazetta's next cover painting. With the agreement that Neal Adams would be commissioned to adapt the story into comic form and the stipulation that Ellison would be able to buy the original pages from Adams upon publication, Harlan wrote "Rock God" for *Creepy* #32. Things didn't work out quite as smoothly as intended, however, and it was nearly fifteen years before Ellison became the owner of the art.

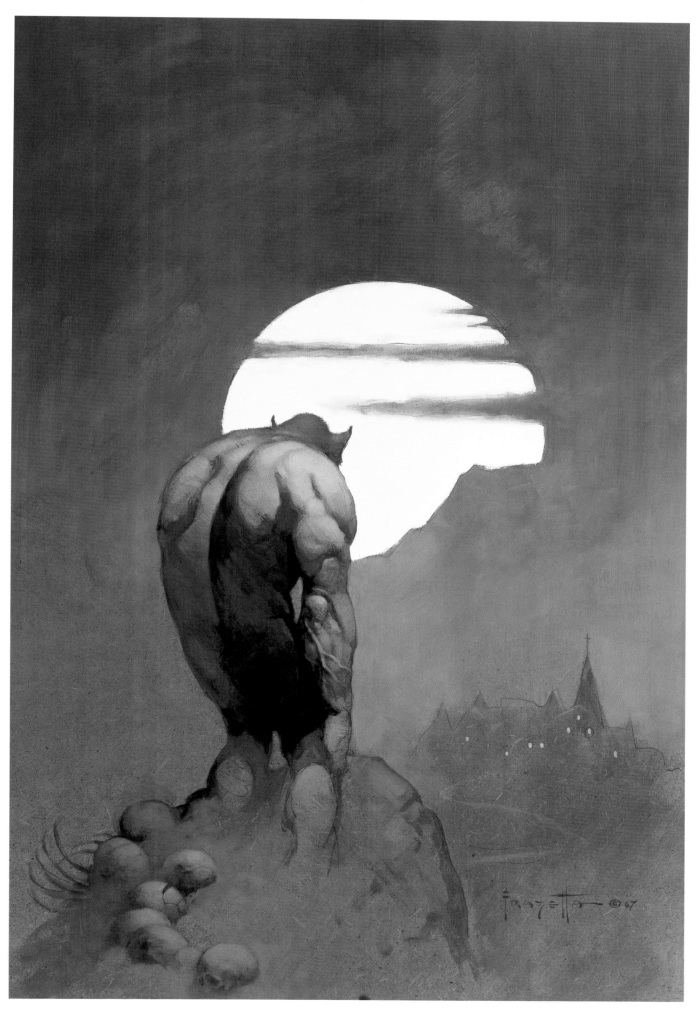

Legacy: Frank Frazetta

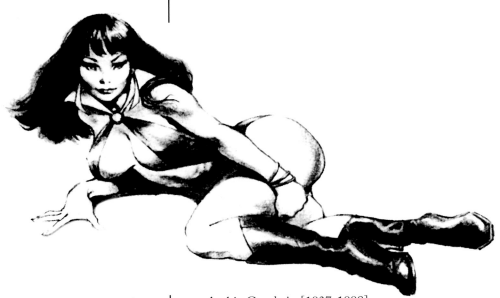

above:
A drawing of Vampirella
that Frazetta created
by request for an auction
at Christie's [11"x9", pencil
on paper]

opposite:
THE BRAIN
Magazine cover to *Eerie*
[issue #8, Warren Publishing,
NY, 1966, 17"x23"
oil on board]

Archie Goodwin [1937-1998] was always considered one of "the good guys" in comics. A talented cartoonist, Goodwin was working at *Redbook* magazine while selling freelance comic stories when he was offered the editorship of *Creepy*. He began with the fourth issue and subsequently became editor of *Eerie* as well in 1965. When Warren went into an economic slump in 1966, Goodwin accepted an editorial position at Marvel Comics.

During his tenure as editor Goodwin wrote the majority of the EC-flavored scripts for Warren's magazines, often creating stories to tie-in with Frazetta's cover paintings. "The Brain" inspired an early sword and sorcery tale, "Demon Sword", drawn by *Spiderman* comic artist Steve Ditko. Interest in R. E. Howard's stories was just beginning and Frank and Archie were savvy enough to explore that genre before everyone else caught on.

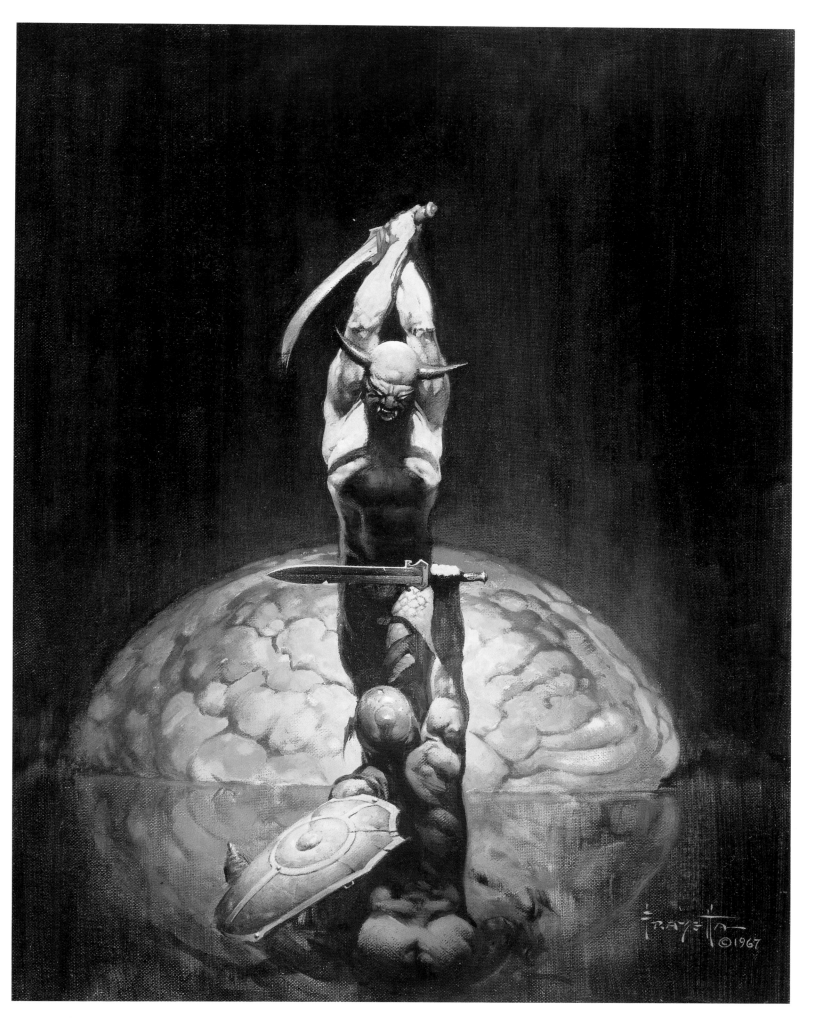

Legacy: Frank Frazetta

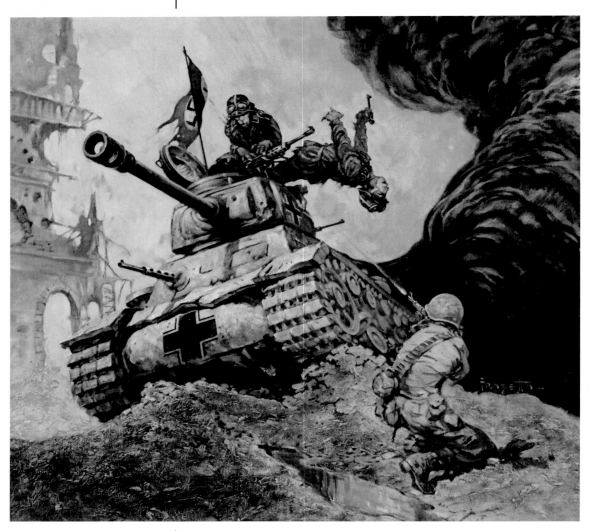

above:
Magazine cover to
Blazing Combat
[issue #4,
Warren Publishing, NY,
1966, 12"x15"
oil on board]

opposite:
COMBAT
Magazine cover to
Blazing Combat
[issue #1,
Warren Publishing, NY,
1966, 12"x15"
oil on board]

War comics of the 1960s were sanitized fantasies in which the soldiers spent more time trading punches than dodging shrapnel.

Warren's *Blazing Combat* was a noble, if short-lived, attempt to revive the sensibility of Harvey Kurtzman's EC war comics. Despite the limitations of his format, editor Archie Goodwin was able to spin compelling and thoughtful stories that stripped war of its "glamour"— all tremendously illustrated by the likes of Alex Toth, Wally Wood, and John Severin. When Warren's distributor received complaints from PX retailers about the anti-war sentiments expressed in some of Goodwin's Vietnam-themed stories, the magazine was canceled.

Frazetta provided each of the covers for *Blazing Combat*'s 4-issue run: all contain a grittiness and horror totally unlike any of the other works in his library of paintings.

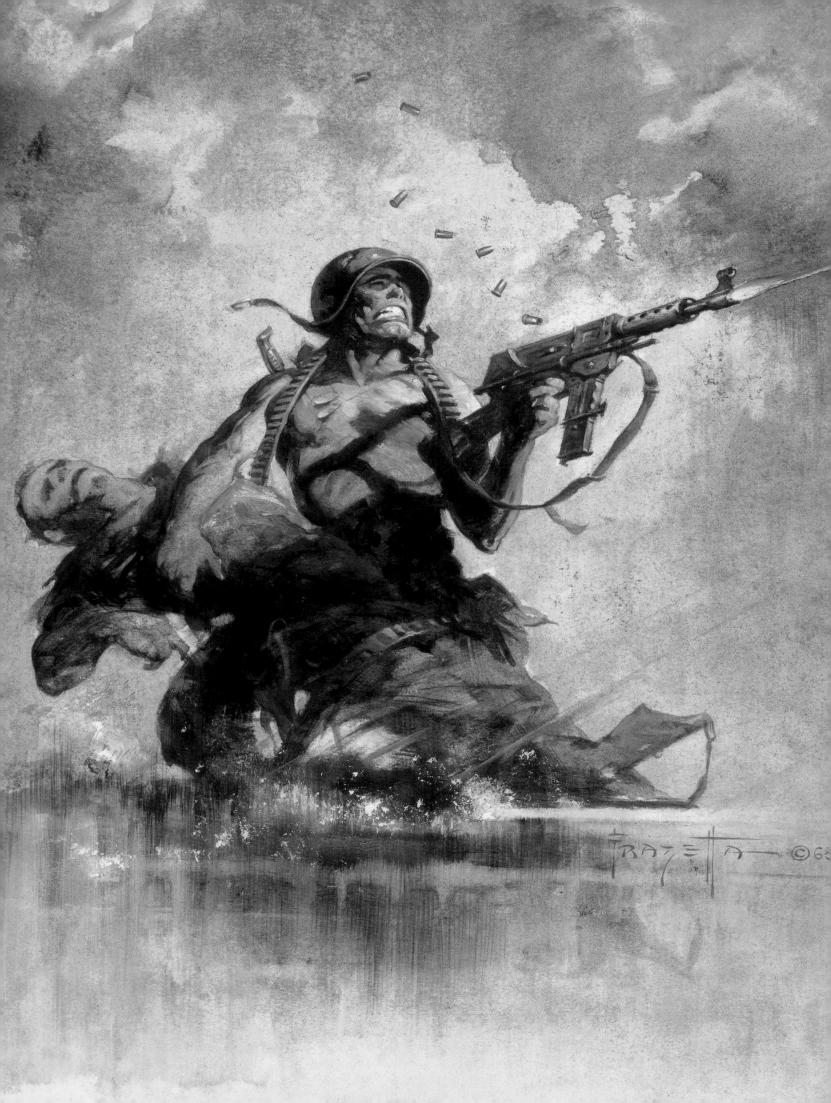

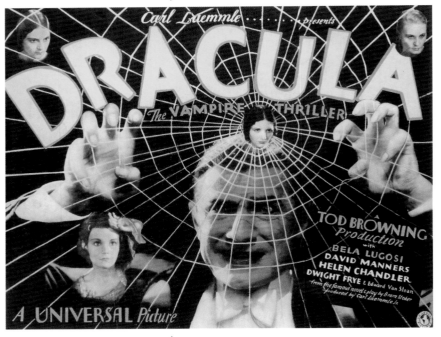

above:
One of the original movie
posters for the first run
of *Dracula*, starring
Bela Lugosi and directed by
Tod Browning
[Universal, 1931]

opposite:
COUNT DRACULA
Magazine cover to *Creepy*
[issue #5,
Warren Publishing, NY,
1965, 15"x19"
oil on board]

"I've always loved movies," Frank says. "When I was younger we'd go all the time. Today they can do a lot more with special effects and, yeah, they can leave you with your mouth hanging open. But I think there's a lot to be said for the mood and atmosphere of some of the older films—a lot of that is missing from movies now. Sure, you can watch *Dracula* or *Frankenstein* and they can seem pretty corny, but if you really watch, if you give them a chance, you'll find yourself getting caught up in the characters and the story and the overall mood."

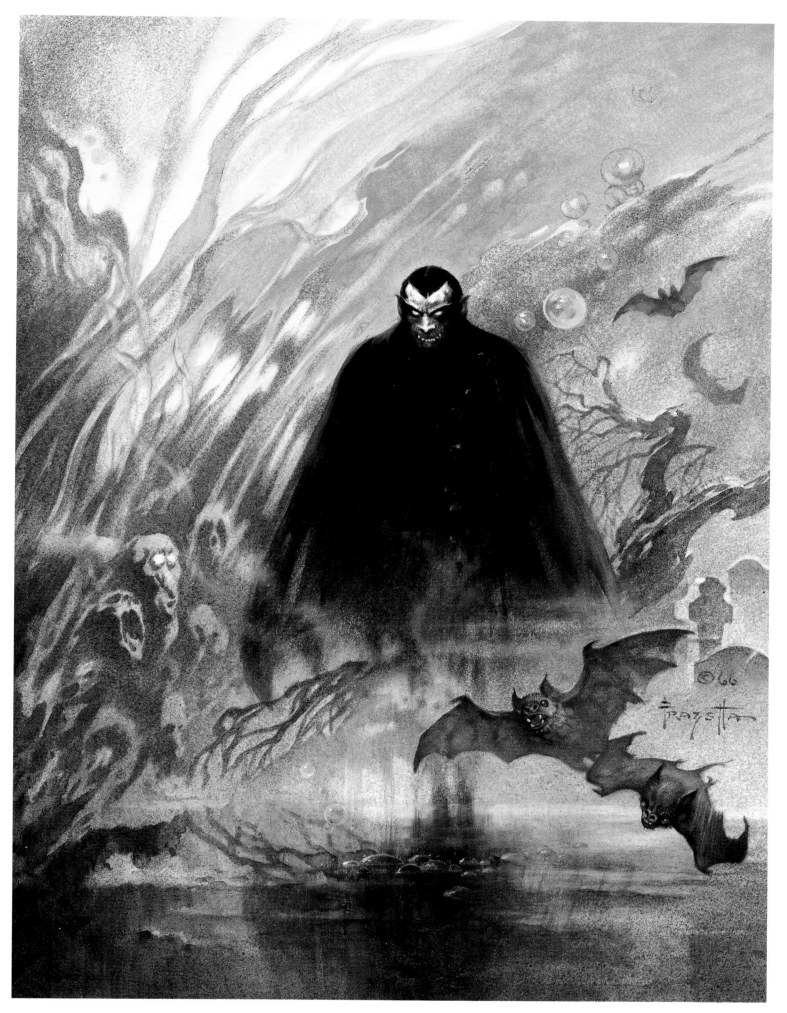

Legacy: Frank Frazetta

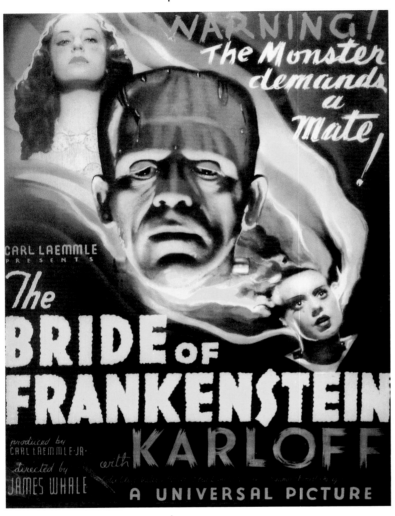

above:
One of the original movie
. posters for
The Bride of Frankenstein,
starring Boris Karloff and
directed by James Whale
[Universal, 1935]

opposite:
BEYOND THE GRAVE
Magazine cover to *Creepy*
[issue #10,
Warren Publishing, NY,
1966, 15"x19", oil on board]

overleaf:
CREATURES OF THE NIGHT
Cover for an omnibus edition
of *Dracula* by Bram Stoker and
Frankenstein by
Mary Wollstonecraft Shelley
[Science Fiction Book Club,
1972, 32"x20", oil on board]

"I think I could direct a horror film and do it well," Frank says. "I mean, it wouldn't be Hitchcock, you know, but I think I could produce a film that would scare the hell out of you. Today film makers go overboard and I don't think it's really necessary. Anything I would do would fit more in the category of the classics, more like the great *Frankenstein* and *The Bride of Frankenstein:* they had a flavor that has never been matched. I'd try to recreate that element of suspense; you'd just sit there and be absorbed by the story, not disgusted by the special effects. If the only way you have to frighten people is by grossing them out, how lame is your story, I ask you?"

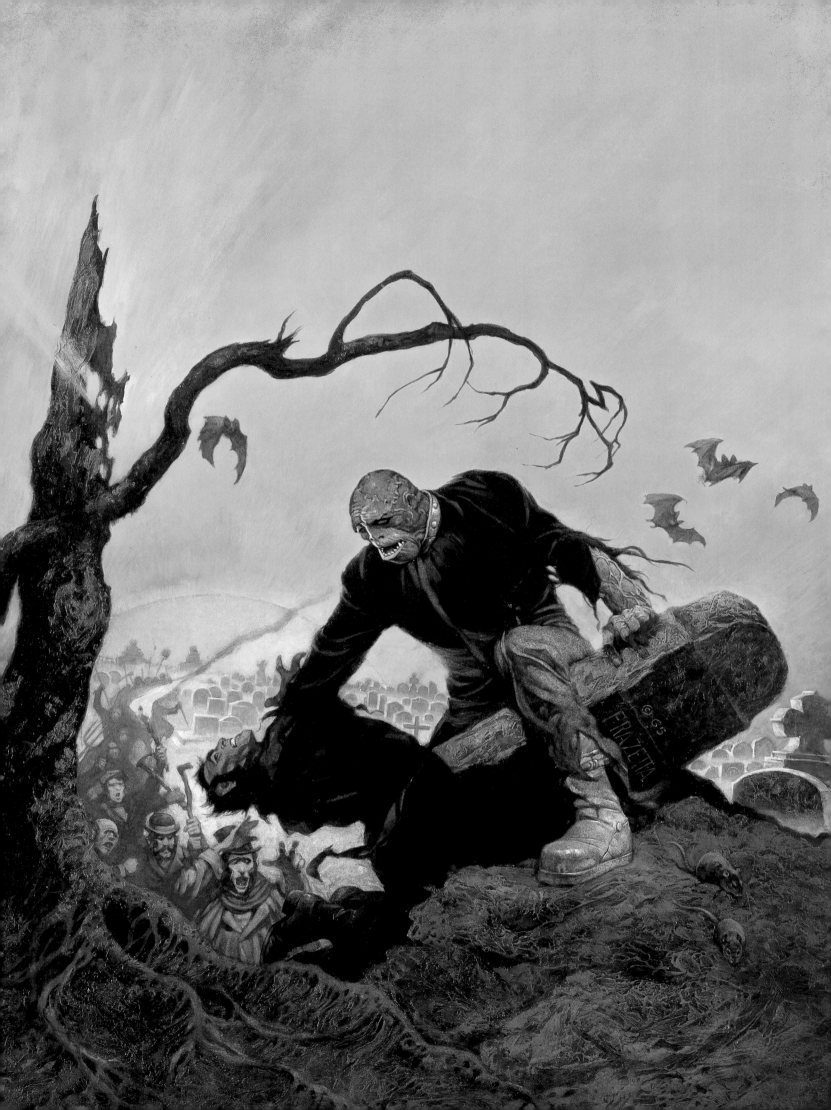

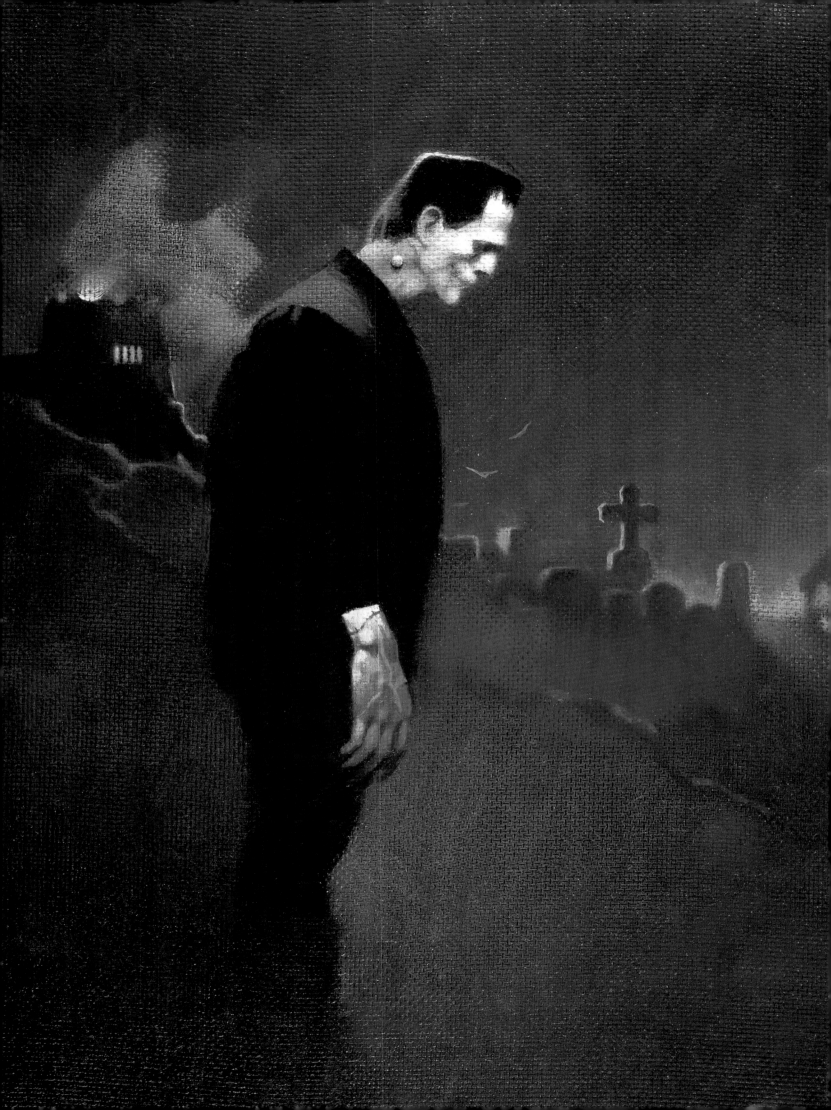

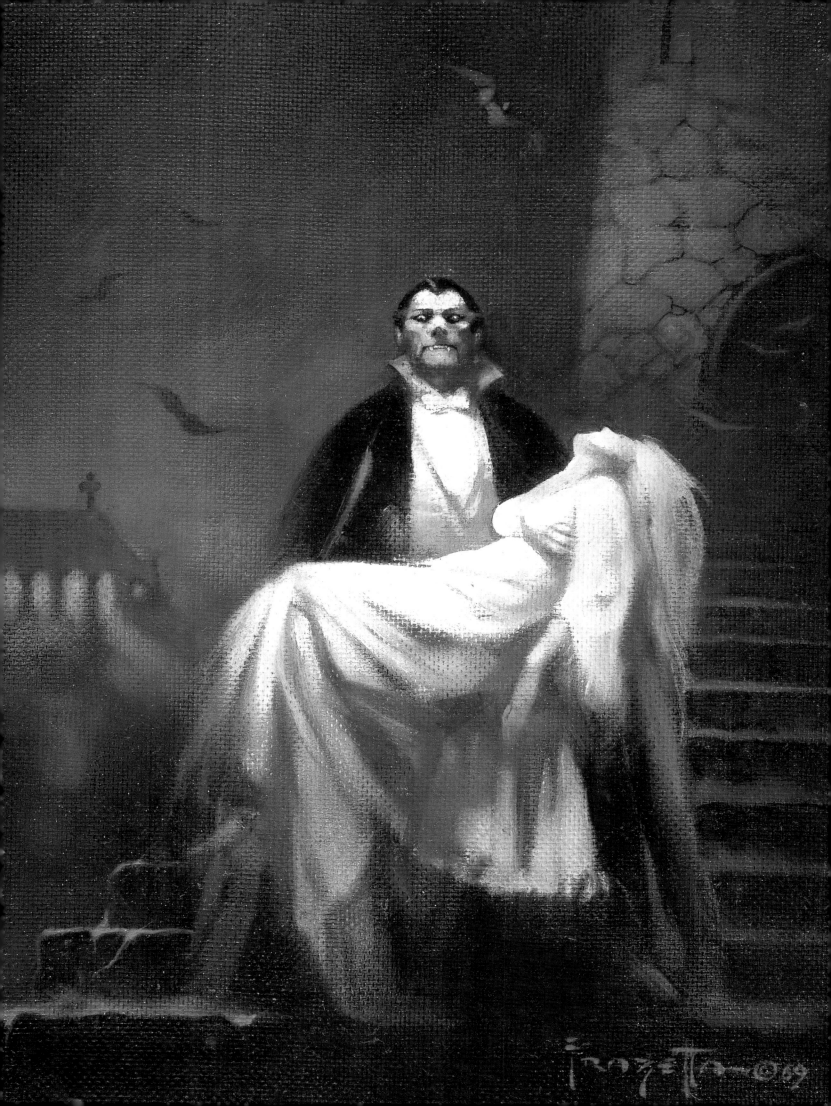

above:
Watercolor and
colored pencil preliminary
rough for *King Kong*
[1977, 6¹/2" x 8"]

opposite:
THE EIGHTH WONDER
Book cover to *King Kong*
by Lorenzo Semple Jr.
[Ace Books, NY, 1977,
16"x22", oil on board]

Fans weren't particularly happy when producer Dino DeLaurentiis announced his plans to remake the granddaddy of all monster movies, *King Kong*, both because he was reworking a beloved classic and he planned to use an actor in a suit rather than utilize stop-motion special effects as in the original. His attempt to convince Frazetta to help him woo some fan support was unsuccessful.

"I've probably seen *Kong* a couple of hundred times," Frank says. "It's not a *great* film, but it has an atmosphere that's hard to beat. I *knew* Dino couldn't do it. Still, I might have gone ahead and painted a poster for him if he would have listened to my ideas; instead he tried to tell me what to do. What that told me was that instead of trying to do something worthwhile, he was just trying to use me to sell a bunch of crap to people. His flying me out to California and his flying out here didn't change my mind. I can't be bought. I agreed to do the cover for Ace just to show him what I could have done if he'd just listened."

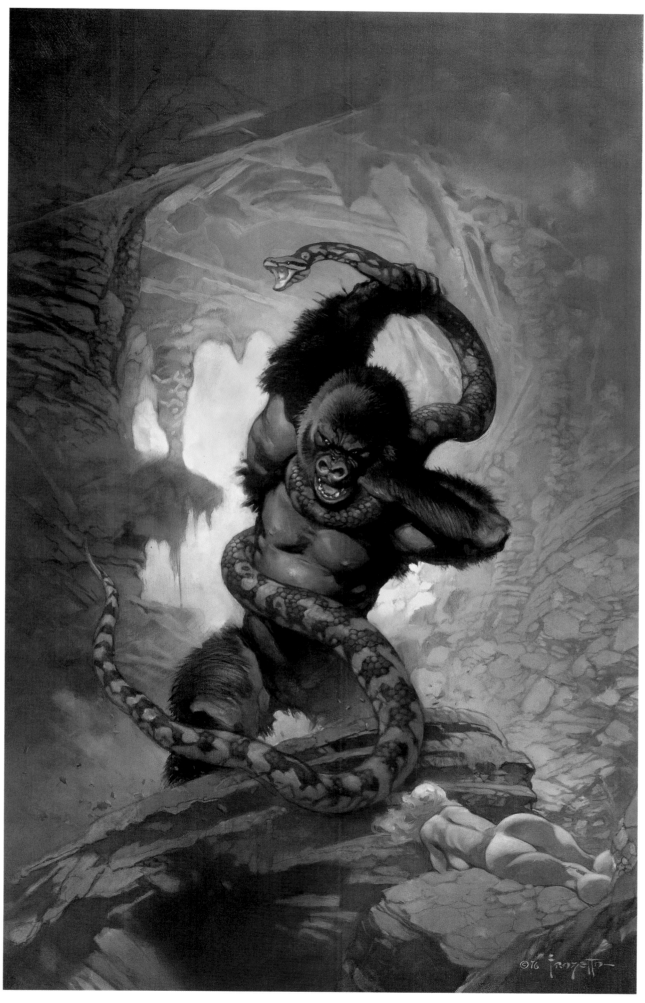

Legacy: Frank Frazetta

above:
Watercolor and
pencil character
study for *Dracula*
[Orsatti Productions,
1975, 7" x 9"]

opposite:
Watercolor character
study for *Dracula*
[Orsatti Productions,
1975, 8" x 10"]

Hollywood is full of stories about people with ideas who want to turn them into a concept that can be transformed into a prospectus with the hope they'll be given a green-light to develop an outline with the goal of making a formal proposal. How movies get made is anyone's guess.

In 1975 Orsatti Productions commissioned Frank to create character designs for a full-length animated adaptation of *Dracula.* The film was postponed almost immediately after Frazetta started work—fortunately his originals didn't follow the movie into limbo. "Guys in Hollywood are real bad about not returning anything," Frank notes, "so I was lucky to have found out the production was canceled before I sent anything off. These pieces would've been gone for good otherwise."

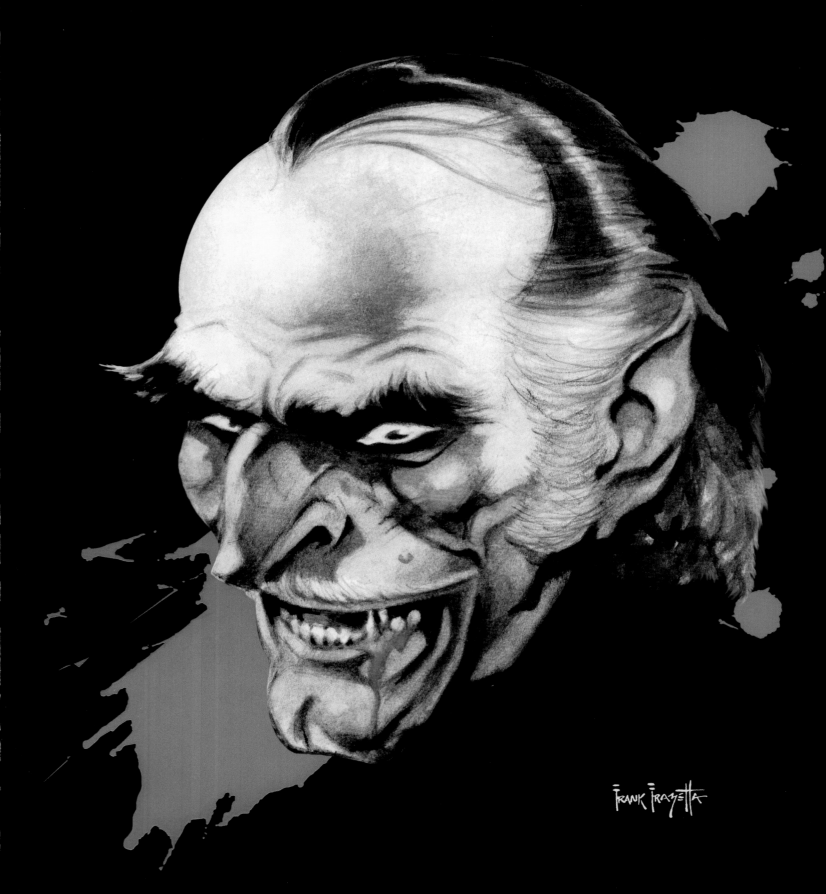

Legacy: Frank Frazetta

The poster shown contains the following text:

It's The
Silliest Party of the Year...
and you're all invited!

SEE FRANKENSTIEN—
the ghoul who never loses his cool!

SEE DRACULA—
the world's original Batman!

SEE THE CREATURE—
the fish you'd like to forget!

SEE THE WEREWOLF—
that sly old dog whose bite is worse than his bark!

SEE DR. JEKYLL AND MR. HYDE—
and get two fiends for the price of one!

SEE THE MUMMY—
135 feet of slithering, slinking bandage!

SEE THE HUNCHBACK OF NOTRE DAME—
college football's "secret weapon"!

SEE THE INVISIBLE MAN—and learn what he has up his sleeves!

A Rankin-Bass Production

Starring the talents of
BORIS KARLOFF in MAD MONSTER PARTY

SAT.-SUN. Matinee Only!

with the talents of Ethel Ennis · Gale Garnett

and also starring the talents of PHYLLIS DILLER

Screenplay by Len Korobkin and Harvey Kurtzman · Produced by Arthur Rankin, Jr.
Directed by Jules Bass · Music and Lyrics by Maury Laws and Jules Bass
In and COLOR · Prints by Pathé · A Videocraft International Ltd. Production · An Embassy Pictures Release

above:
Frazetta's ink on paper conceptual drawing which was used as the poster for the movie *Mad Monster Party* [Embassy Pictures, 1967, 7" x 9"]

opposite:
Ink and marker drawing originally intended to be the movie poster for *Mad Monster Party* [previously unpublished, 1967, 9" x 12"]

Both Frazetta and veteran comic and film artist Jack Davis were commissioned by the producers at Rankin/Bass to create poster art for their stop-motion animation film, *Mad Monster Party*. Davis provided a poster (similar in basic concept to Frazetta's art shown opposite) as well as some character designs: Frank turned in two conceptual posters drawn in ink and the full color design shown here. The situation got confusing after that. Frank heard nothing further from the producers until he saw the poster using one of his drawings displayed at a local theater. He promptly billed Embassy Pictures—and received payment—but the circumstances surrounding the final decision to use his art for the poster and pressbook ads remains something of a mystery. "Ultimately, they had to pay me my full fee for a few roughs," Frazetta notes. "Crazy."

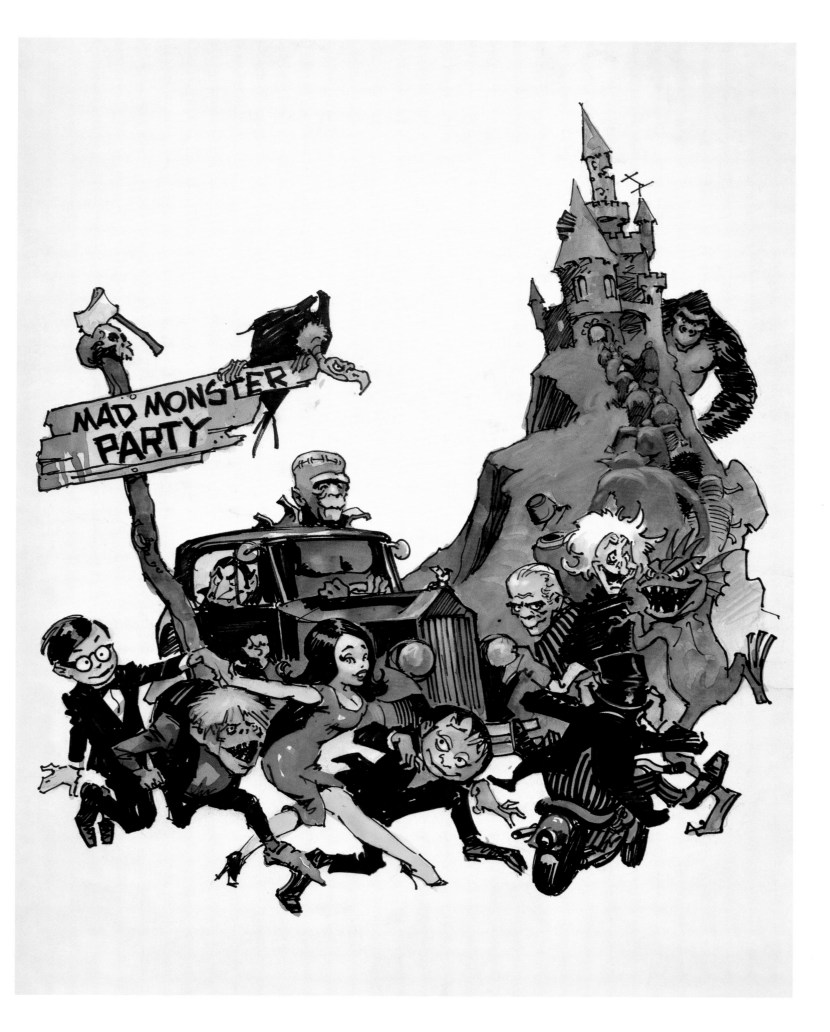

above:
The "B" sheet movie poster
for *After the Fox*
[United Artists, 1966,
32" x 26", watercolor on board]

opposite:
3000 AD
Movie poster for an
unreleased film,
previously unpublished
[Client studio unknown, 1985,
24" x 30", oil on masonite]

"For the life of me," Frazetta notes bemusedly, "I can't remember the name of this movie or even who it was done for. It was some crummy thing that probably went straight to late night cable. Around the same time I also did a painting for some film starring these body-builder twin guys—I think they were known as the 'Barbarian Brothers,' or something equally dumb. The original had them standing in front of one of my monster wolf-bears; I painted them out leaving just the wolf and the background. One of these days I'll get around to turning it into a decent piece of art."

Legacy: Frank Frazetta

Legacy: Frank Frazetta

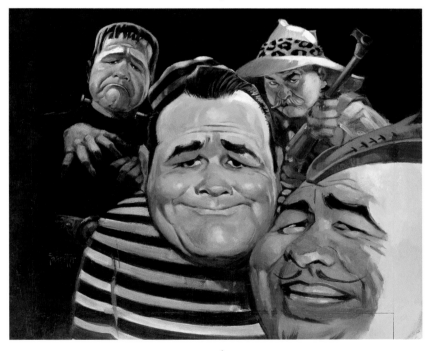

Dorothy Gilman's grandma gumshoe, Mrs. Emily Pollifax, has experienced periodic spells of popularity since she first appeared in a series of novels beginning in 1966. Rosalind Russell's interpretation of the character (she wrote the screenplay as well as starred in the title role) for the 1971 film *Mrs. Pollifax—Spy,* co-starred Darren McGavin as a CIA operative and amplified the book's comedic appeal. In 1999 CBS Television produced the first in a projected series of films entitled *The Unexpected Mrs. Pollifax,* starring the popular actress Angela Landsbury.

above:
Frazetta's painting for the comedy record album *Movies Are Better Than Ever* by Jonathan Winters [MGM Records, 1967, 20" x 16", oil on board]

opposite:
MRS. POLLIFAX—SPY Movie poster for *Mrs. Pollifax: Spy* [United Artists, 1971, 32" x 24", watercolor on board]

The taped voices you hear on this album are the actual voices of the people being interviewed...and at some time they gave these answers—but <u>never ever ever</u> to these questions!

above:
Frazetta's illustration
for the comedy record album,
Welcome to the LBJ Ranch
[Capitol Records, 1966,
various sizes,
watercolor on board]

opposite:
Movie poster for
The Secret of My Success
[United Artists, 1965,
24" x 32",
watercolor on board]

Absurdist British comedies were a popular stable for moviegoers in the early 1960s. *The Secret of My Success* starred James Booth, Lionel Jeffries, Honor Blackman (best remembered as Pussy Galore from the James Bond classic *Goldfinger*) and Shirley Jones.

This was Frazetta's second movie poster and came at a time when his other advertising commissions had started to increase. His caricatures of the various politicians for the comedy album *Welcome to the LBJ Ranch* exhibit a skill that might have appealed to higher-profile (and paying) editorial markets like *Time* or *Life* if Frank had chosen to pursue that career path. "I didn't think about going after those types of clients," Frazetta says. "I didn't consciously think about going after *anyone* by that point, really. People were giving me jobs pretty fast and furious and I doubt if I ever had the time to think, 'Yeah, I'd like to work for so and so.'"

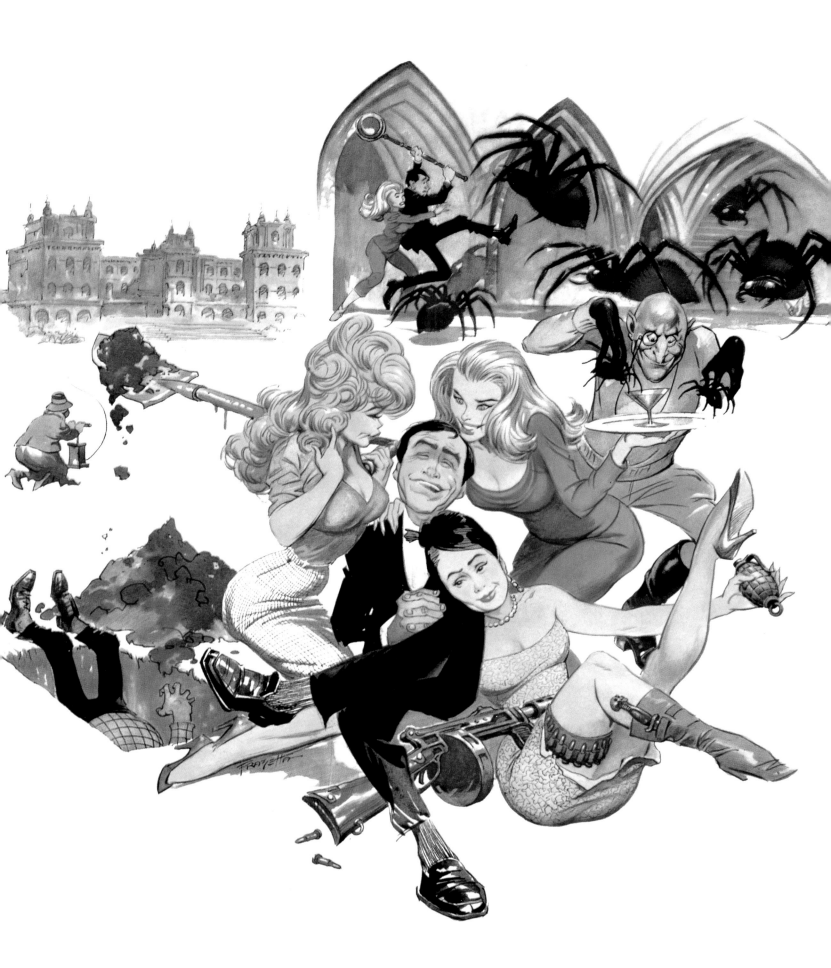

Legacy: Frank Frazetta

above:
Frazetta's sculpted
busts of the characters
Teegra (left) and a nameless
Neanderthal for the film
Fire & Ice
[1982, approximately
6" tall, painted plaster]

opposite:
Frank's sculpted
bust of the main
character Darkwolf for
the film *Fire & Ice*
[1982, approximately
6" tall, painted plaster]

A unique item for Frazetta collectors are the busts shown on these pages: they were created as a guide for the animators working on the Bakshi/Frazetta 1982 film, *Fire & Ice*. "A lot of the animators were having a hard time keeping the characters consistent," Frank says. "We had forty or fifty artists working on the production: some of them were really good and some of them weren't, but all of them seemed to be doing their own versions of the characters. So I worked up these clay heads, had them cast, and gave a set to each animator—they had them at their drawing tables and could turn them in different directions and play with the light source. It helped them a lot. Plus the animators each got a little souvenir of the film."

The remaining busts have been quietly offered to collectors through Frazetta Prints over the years.

George MacDonald Fraser
Flash for Freedom!

above:
Arthur Barbosa's cover for
the hardcover edition of
Flash for Freedom by
George MacDonald Fraser
[Alfred A. Knof & Co., 1971]

opposite:
Frazetta's cover for
the paperback edition of
Flash for Freedom by
George MacDonald Fraser
[Signet, 1973,
20" x 32", oil on board]

The Flashman Papers, a series of comedic novels "edited" by George MacDonald Fraser, purport to be the diaries of Harry Flashman, the notorious bully from the classic English novel *Tom Brown's School Days*. Coward, bounder, and lecher, Flashman becomes an undeserved hero of the Victorian Age through no fault of his own.

Flash for Freedom details the character's involvement on both sides of the American slave trade during the mid-1800s. Arthur Barbosa's covers for the series took on a classical approach that mimicked tinted engraving, whereas Frank's dramatic, almost James Bond-flavored oils grabbed the paperback readers with their contemporary lushness.

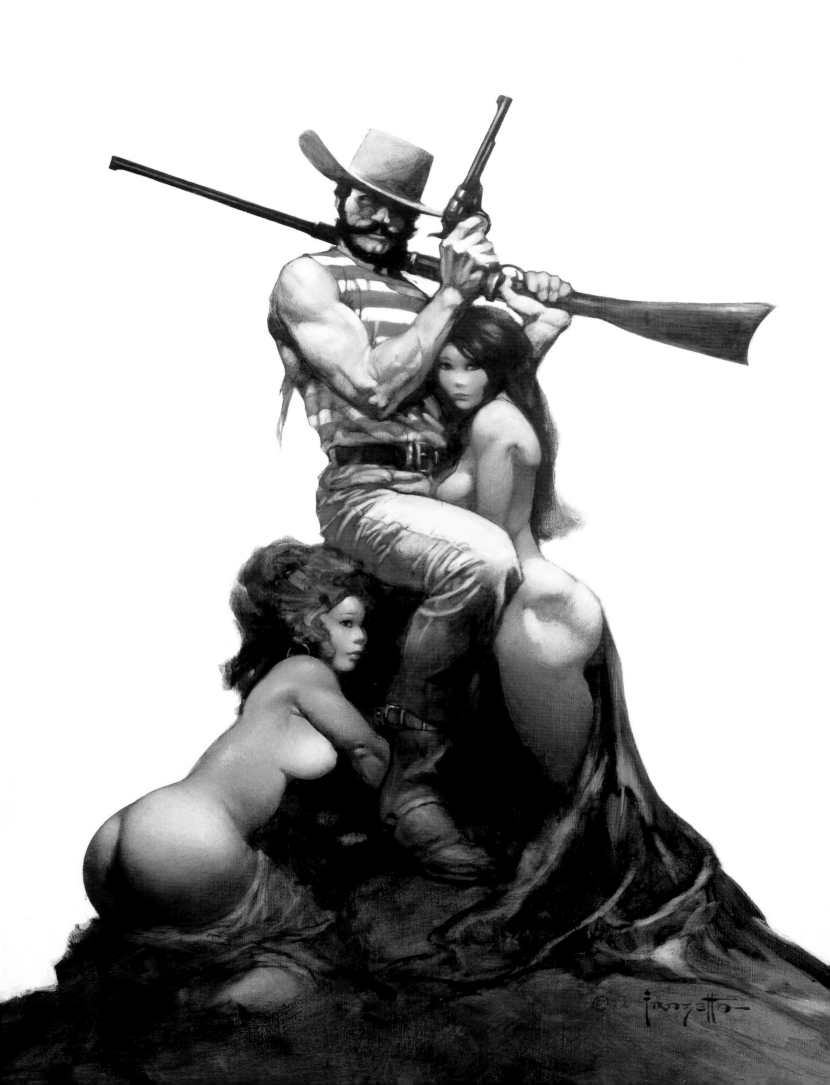

SIGNET·451-Y6094·$1.25

GEORGE MACDONALD FRASER

Flashman at the Charge

WINNER OF THE PLAYBOY AWARD FOR THE BEST NOVEL OF THE YEAR!

The all-time ace of boudoir Olympics is back in action!

above:
Frazetta's original cover for *Flashman at the Charge* by George MacDonald Fraser [Signet, 1974, 15" x 23", oil on board]

opposite:
FLASHMAN ON THE CHARGE Frank's revised painting of *Flashman at the Charge* by George MacDonald Fraser [circa 1976, 15" x 23", oil on board]

Frazetta's cover painting for *Flashman at the Charge* perfectly captured the essence of Fraser's roguish character: Flashman spends half the novel in stark terror (as one of the "noble 600" at the infamous charge of the Light Brigade and, subsequently, as a prisoner of the Russians), and the other half chasing anything remotely female.

As was his habit, Frank reworked the painting slightly after publication. "Pleasing the art director was one thing," Frazetta notes, "but I didn't think anything of scrapping the whole thing when I got it back. I've got to live with it, not them. If something doesn't look right to me, like the girl's face in the Flashman painting, I'm going to change it."

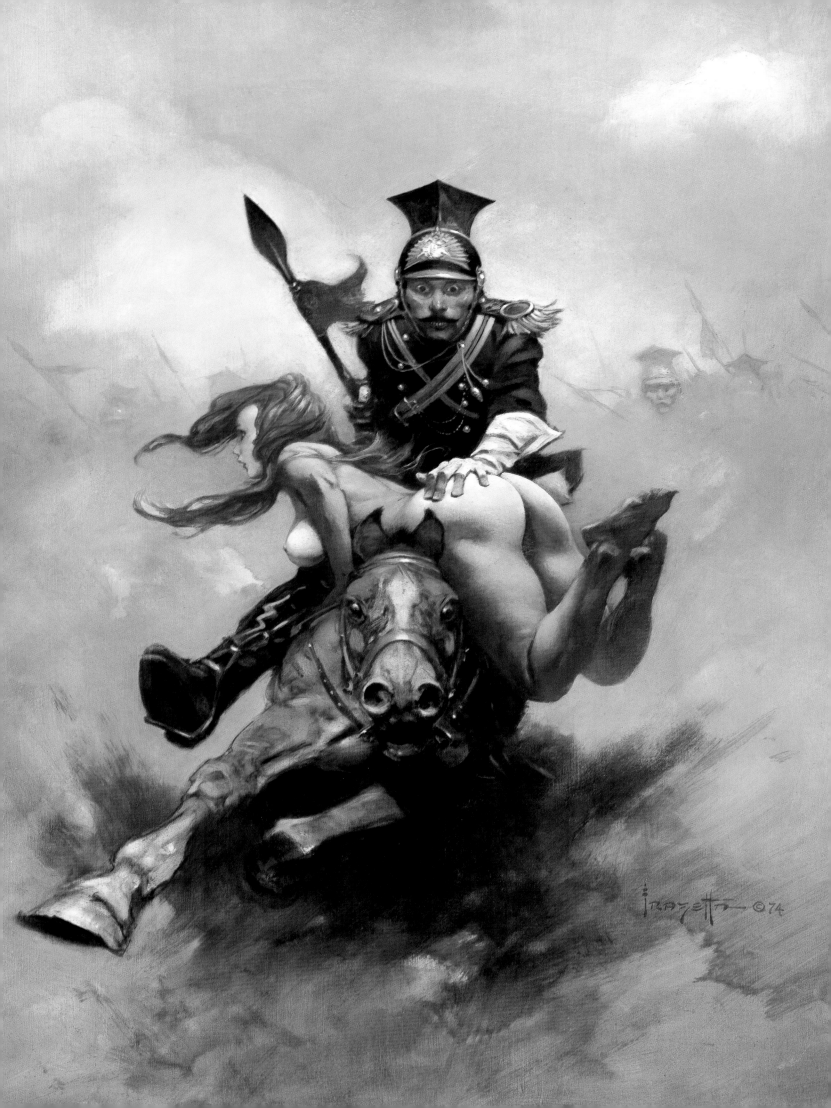

above:
A page of sketchbook
drawings [circa 1964,
8" x 10", ink on paper]

opposite:
PONY TALE
Book cover to
The Tritonian Ring
by L. Sprague de Camp
[Paperback Library, 1968,
16" x 20", oil on board]

"I never really gave the publishers a hard time about the way they used my art," Frazetta says, "but this cover really tested my patience. I always prided myself on the design and balance of my work—they stood up as paintings, but also served their function as commercial art. I thought I was being pretty clever by leaving them a space above the girl for their titles: you'd see the girl, the barbarian, the castle in the distance, everything. So of course they had to slap the title on there in a big white box and cover up the castle. I credited them with having brains enough to follow my lead— big mistake."

The Tritonian Ring was written by L. Sprague de Camp [b. 1907], a respected science fiction writer who devoted the greater part of his later career to the role of "editor" of Robert E. Howard's Conan stories.

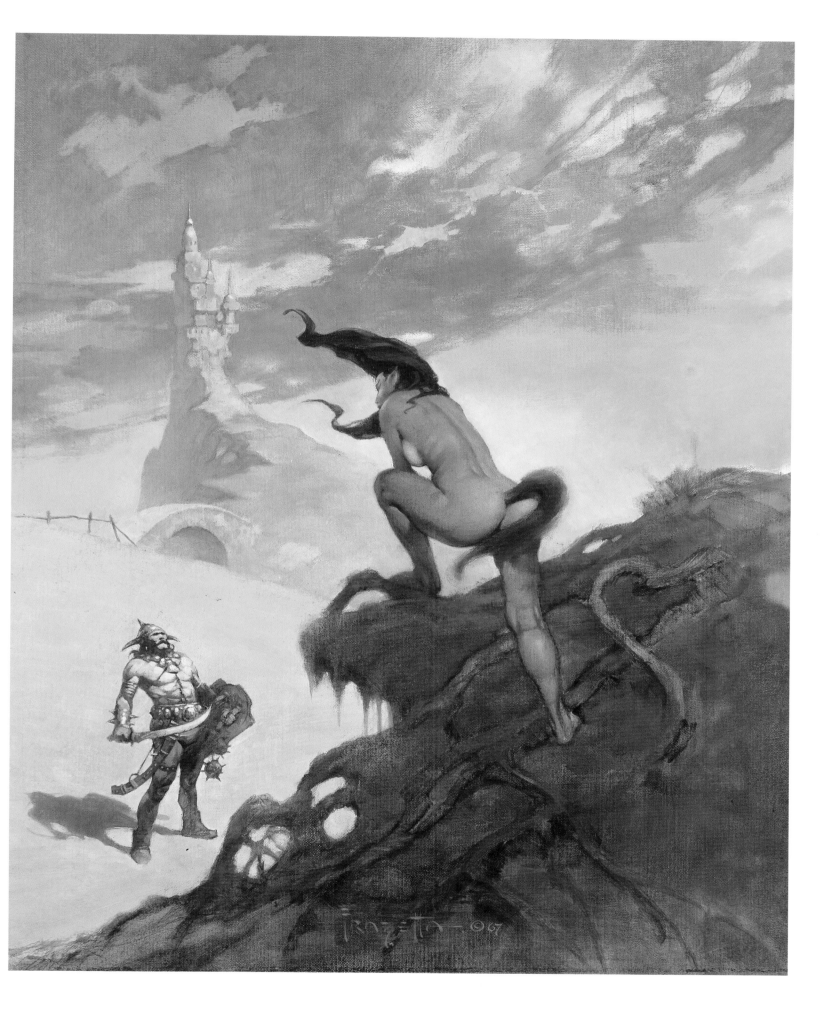

Legacy: Frank Frazetta

above left:
The artist at home
[New York, circa 1967]

above right:
The cover of the
special Frazetta issue of
The Burroughs Bulletin
[issue #29,
House of Greystoke, 1973]

opposite:
MASAI WARRIOR
Personal painting,
previously unpublished
[circa 1960, 22" x 45",
oil on stretched canvas]

overleaf:
PREDATORS
Personal painting,
previously unpublished
[circa 1987,
20" x 16", oil on masonite]

"Masai Warrior" was the first in a mini-series of paintings Frank created involving African warriors over a period of several decades. It and the even larger "Lion Hunt" (approximately 4'x3') pictured on the cover of the *Burroughs Bulletin* above, are among his largest canvases. Originally created as an anniversary present for his wife Ellie, it was eventually sold—and subsequently repainted by Frazetta. It hung for many years in the family room.

"Shortly after his first stroke, he took 'Masai Warrior' down to his studio and told me he was going to work on it," Ellie says. "Frank was having trouble with his right hand and wanted to try painting with his left. I got so worried when he scraped the face off, I couldn't watch anymore and went to bed. I was afraid to look at it in the morning— and it was *better!* He had improved the face 100%! He had *never* painted left handed before! I was so excited I had to call the kids over to see. Frank's just sitting there with this look on his face, like, 'What's the big deal?' That's my husband!"

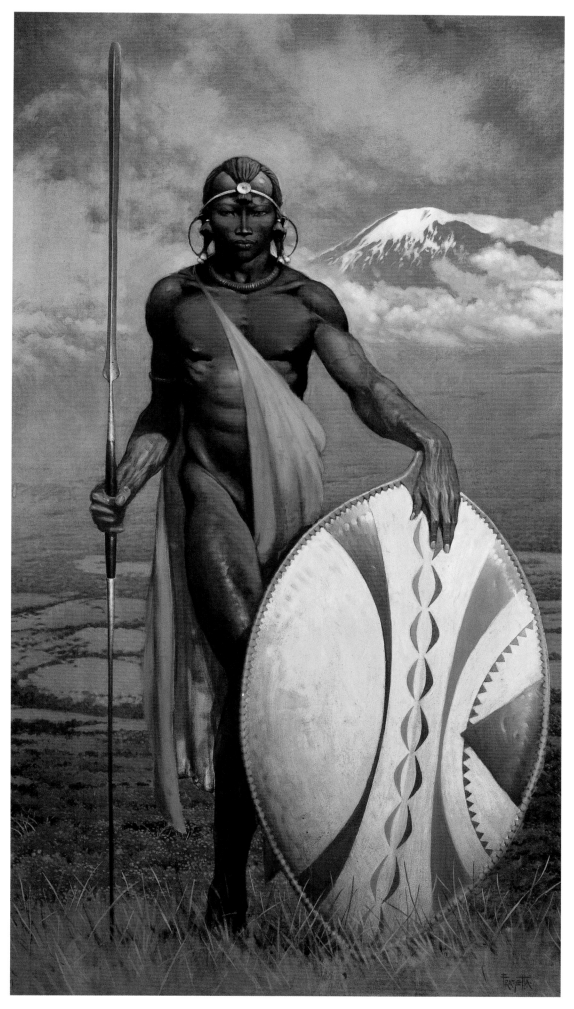

Legacy: Frank Frazetta

131

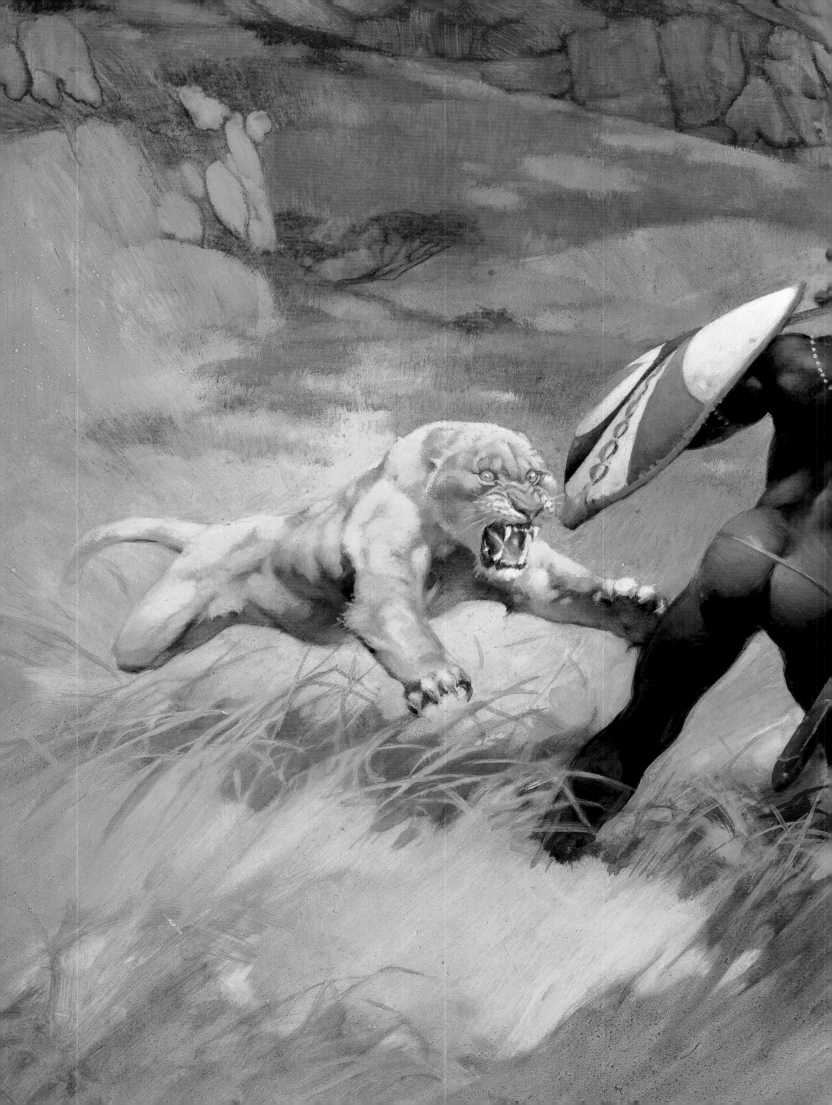

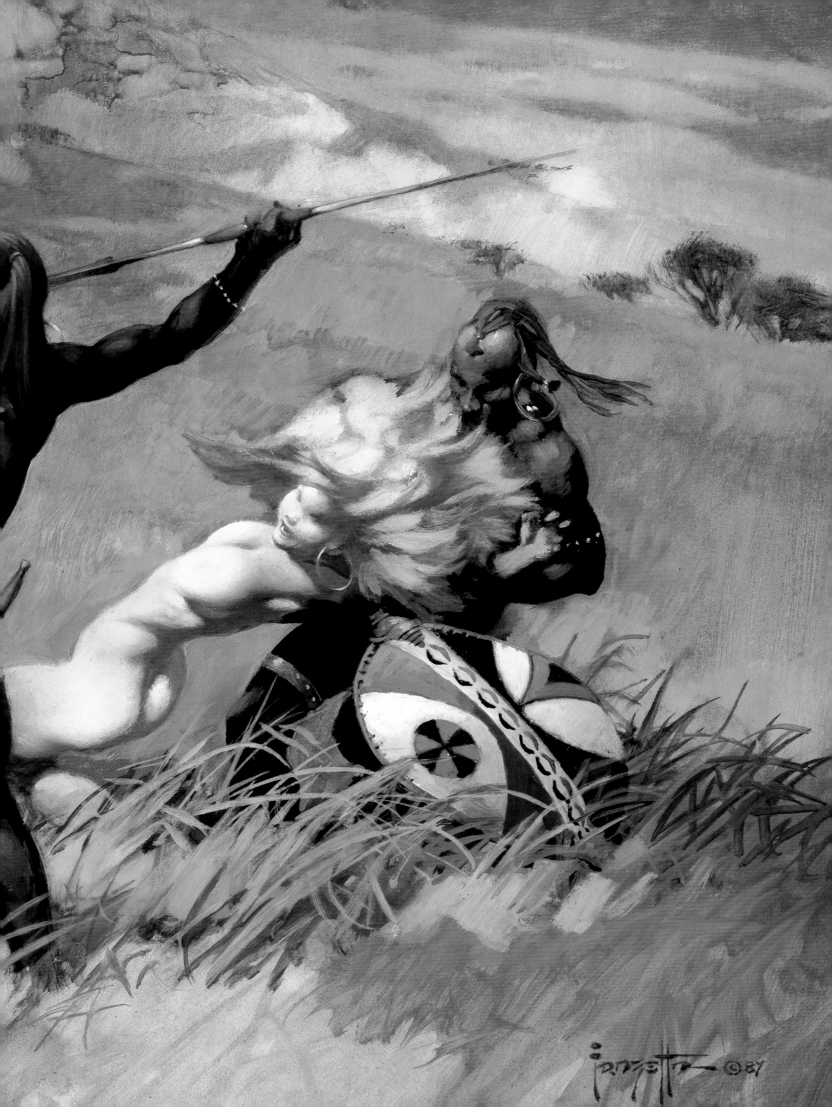

above:
An untitled sketchbook
color rough [circa 1981,
3" x 5", watercolor on paper]

opposite:
WOLF PACK
Book cover to
Atlan by Jane Gaskell
[Paperback Library, 1968,
15" x 23", oil on board]

Just like Frazetta, British writer Jane Gaskell [b. 1941] was something of a child prodigy. Frank's first professional work appeared when he was sixteen years old (in *Tally Ho* #1, 1944): Gaskell's first novel, *Strange Evil*, was published when she was fourteen. *Atlan* was the first in a somewhat confusing sf/romance series. Frank also painted the cover for the second volume, *The Serpent*.

Atlan gave Frazetta another opportunity to paint his wonderfully animated wildlife. "Everybody knows I love big cats, but I love to draw all kinds of animals. I regret never getting around to doing a full-blown painting of my rough [above]. I really think it could've been one of the best things I'd ever done. I love that rough. I had another idea about a wolf pack on the Kansas prairie— I just never found the time to put it on board. I still might."

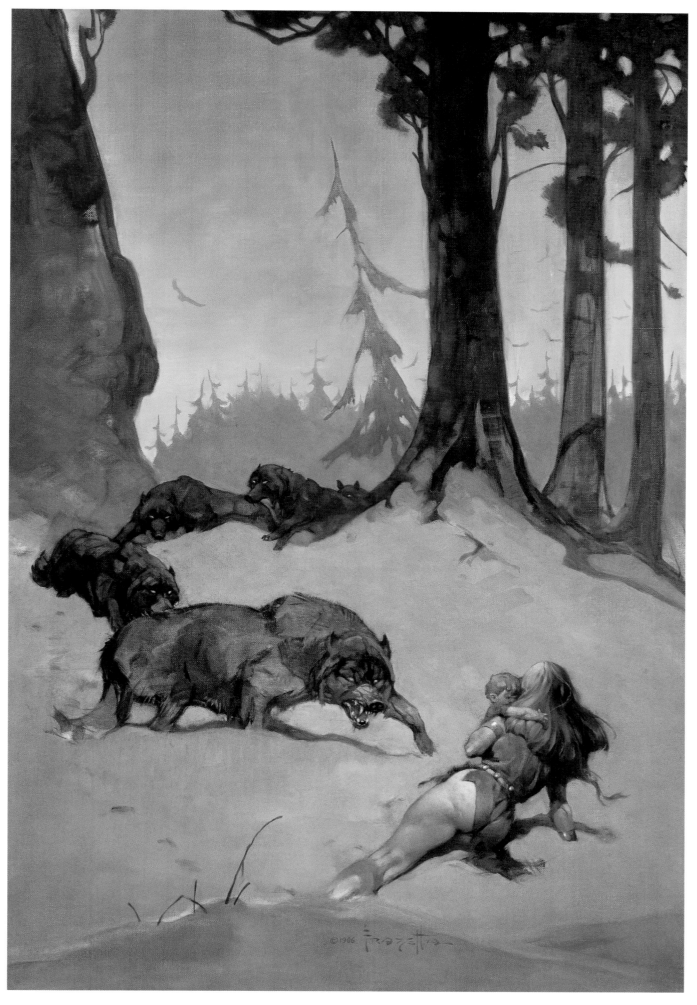

Legacy: Frank Frazetta

above:
An untitled sketchbook
drawing [circa 1977,
4" x 6", ink on paper]

opposite:
TREE OF DEATH
Book cover to
Flashing Swords #2
edited by Lin Carter
[Science Fiction Book Club,
1973, 15" x 19", oil on board]

The phenomenal success of the
books and comics based upon
Robert E. Howard's stories sparked
a stampede of publishers eager to
cash in on the sword and sorcery
gold mine. Lin Carter [1930-1988],
one of the original co-editors of the
Lancer Conan series, attempted to
duplicate Howard's popularity with
several original contemporary
anthologies with mixed results.
Frank's four covers for both the hard
and softback editions of *Flashing
Swords 1 & 2* are some of his most
dramatic art. Though the "Death
Dealer" [see *Icon*, p. 153] featured on
the Dell paperback of *Volume 2*
became one of his most recognizable
works, *all* of the paintings, including
"Tree of Death" shown here, are
intense and memorable additions to
the Frazetta canon.

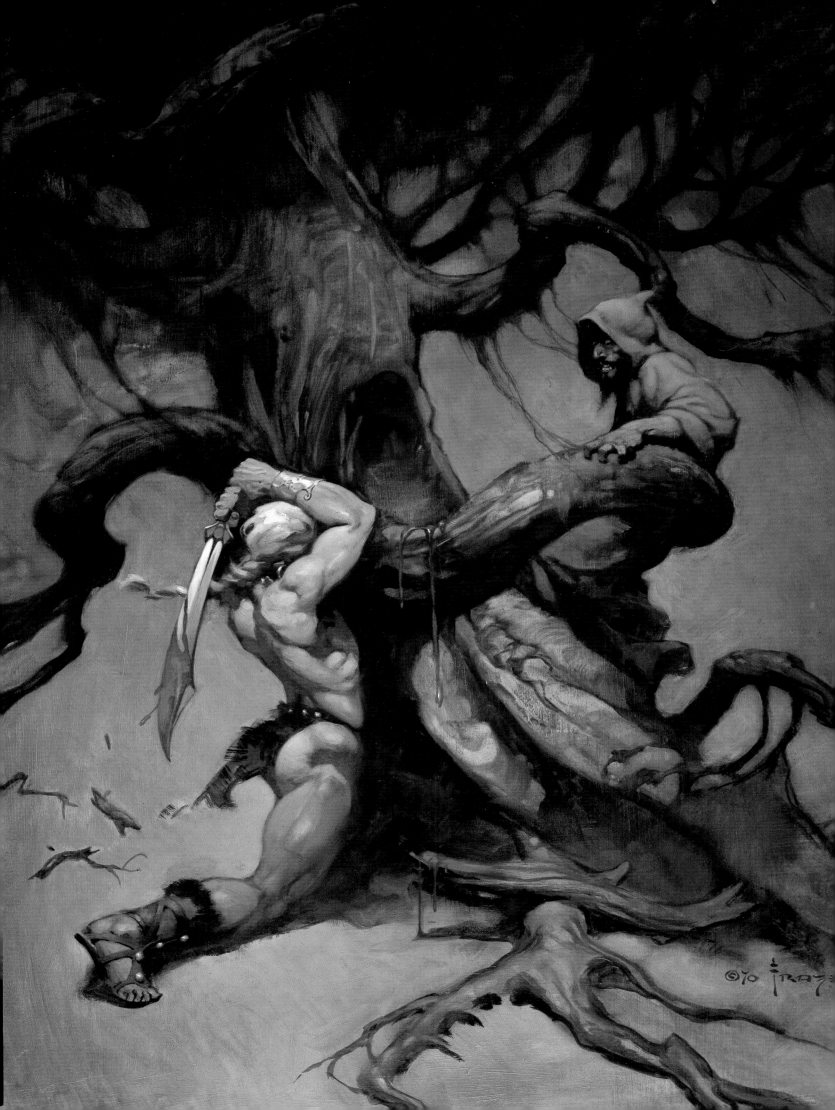

above left:
The cover to
Jaguar God #0
retouched by Simon Bisley
[Verotik, 1997, from a
work circa 1982,
16" x 23", oil on masonite]

above right:
A rough of
the character Darkwolf
[circa 1981, 8"x10",
gouache on paper]

opposite:
VICTORIOUS
Previously unpublished
[from a work circa 1982,
16" x 23", oil on masonite]

"Glenn Danzig wanted to start a comic line and wanted me to create characters and paint some covers and I said, sure, why not?" Frazetta says.

Danzig's publishing company, Verotik, licensed the Death Dealer and Jaguar God characters and Frank provided both pre-existing and brand new paintings for some of their covers. The art used for *Jaguar God #0* (above) was originally created as a character study of Dark-wolf, the hero of Frazetta's 1982 animated feature *Fire & Ice*. Simon Bisley retouched the art to make the costume match that of the comic character. Sometime around 1997 Frank reworked the painting into its present form, as seen opposite.

Legacy: Frank Frazetta

above:
An untitled sketchbook
drawing [circa 1974,
5" x 7", ink on paper]

opposite:
BLACK STAR
Book cover for *The Black Star*
by Lin Carter
[Dell Books, 1973,
16" x 22", oil on masonite]

Lin Carter was highly regarded
as the editor of the *Ballantine Adult
Fantasy* series from 1969-72. His
rescue of such authors as Lord
Dunsany and Clark Ashton Smith
from obscurity has been justifiably
lauded.

Conversely, Carter was widely
considered a "hack" writer by the
science fiction community during
his lifetime. His entry in *The
Encyclopedia of Fantasy* was very
charitable: "Most of his fiction
deliberately pastiched the work of
earlier fantasy writers like Edgar
Rice Burroughs and Robert E.
Howard, but did so both openly and
with the clear intent of popularizing
modes less well understood in the
1960s than they are now." However,
since REH, ERB, and Tolkien were
all climbing the bestseller lists by
the time Lin's fiction started to be
published, it seems more likely that
he was riding on others' coat tails
rather than leading the charge.

Covers by Frazetta, Krenkel, Jeff
Jones, and Tim Kirk were often the
best things about Carter's novels.
Frank's gorgeous painting for *The
Black Star* told a story better than
Lin unfortunately ever could.

Legacy: Frank Frazetta

above:
An untitled sketchbook
drawing [circa 1973,
7" x 6", ink on paper]

opposite:
WOLF MOON
Book cover for *Phoenix Prime*
by Ted White
[Lancer Books, 1966,
16" x 20", oil on board]

"I like to build tension in the viewer," Frazetta says. "I want to suck the audience into the painting: I want it to stop them in their tracks and make them go, 'Hey! What's going on here?!' I want them to ask questions; I want them to wonder what happened *before* the scene they're looking at. 'How'd that guy get into a mess like that?' And I want them to make up their own stories of what happens after. *Art* gets you involved, gets you thinking, makes you remember it. A *pretty picture* can be forgotten in a minute, but a work of *art* can be carried in your head forever."

Legacy: Frank Frazetta

above:
An untitled sketchbook
drawing [circa 1973,
4" x 6", ink on paper]

opposite:
REASSEMBLED MAN
Book cover for
The Reassembled Man
by Herbert Kastle
[Gold Medal Books, 1964,
14" x 19", oil on board]

"I obviously like women who
have got some meat on their bones,"
Frazetta admits. "I'm not against a
very slender, shapely woman at all.
But I found that when I'm putting it
on canvas or paper it doesn't read as
real. I have to exaggerate in order
for it to look like you might imagine
it should. The audience isn't going
to buy the idea of a ninety pound
girl swinging a thirty pound sword:
she's got to have some muscle to
make her movement believable."

Legacy: Frank Frazetta

above:
A drawing from the
"Gent Zodiac"
[Gent magazine, 1962,
6" x 6", ink on paper]

opposite:
PINUP
Previously unpublished
[circa 1961,
11" x 26", oil on board]

Frank experienced some lean
times after he quit ghosting the *Li'l
Abner* newspaper strip. As has been
noted elsewhere, his first break after
a long dry period came from the
softcore pornography publisher
Tower Books. The painting on the
facing page was completed as a
portfolio sample. "I didn't have a
choice," Frazetta says. "I had no
work and I was at the point of
taking whatever was offered. But
even then I took it pretty easy. The
girls are beautiful and sexy, but the
art is still pretty innocent. If you
read those books, boy, you'd see I
took the high road!"

Legacy: Frank Frazetta

above:
A personal painting, originally published as the cover of the unauthorized book, *The Rare Frazetta* circa 1977

opposite:
LAS VEGAS
Personal work
[circa 1979,
17" x 23", oil on board]

"I've been accused of being sexist and I think it's pretty damn silly," Frank says. "Ridiculous. I paint beautiful women: sometimes they look vulnerable and sometimes they look like the deadliest things on two legs. I love women. I don't think that I suggest that they're weak or wimpy or that they're being taken advantage of. And when did painting the body become sexist? I could sit around painting bowls of fruit or people mowing the yard, you know, the most boring crap that would challenge no one—and who would want to see it? Nobody."

Legacy: Frank Frazetta

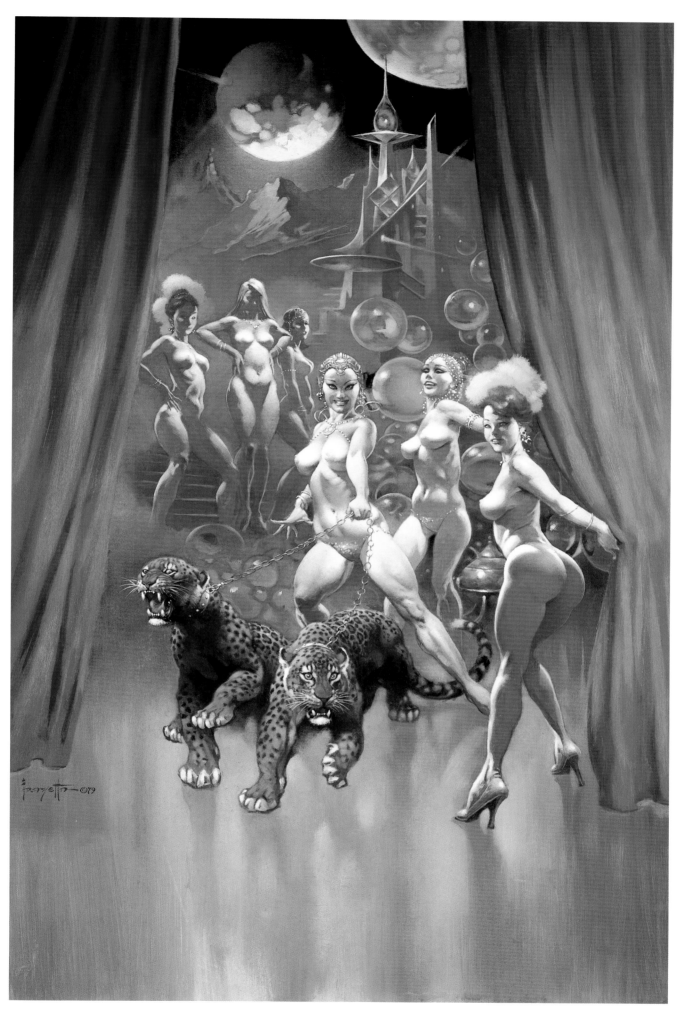

above:
A personal drawing of
Ellie Frazetta
[circa 1964,
9" x 12", pencil on paper]

opposite:
NUDE
Personal work
[circa 1964,
16" x 20", oil on board]

"A group of us would rent a hall every so often and chip in for a model to do life drawing," Frazetta recalls. "Al Williamson, Krenkel, Angelo Torres, maybe a dozen altogether. And the idea was that you'd spend a couple of minutes on each pose, then the model would shift, and you'd start a new piece. And pretty soon there were all these guys standing behind me watching me sketch. 'How'd you do that, Frank? How'd you get so fast, Frank? How'd you get so much detail in a couple of minutes?' The answer was obvious and is maybe one of the reasons for my success: I didn't *care* what *they* were doing, I was concentrating on *my* art."

The popular painting on the opposite page was printed much smaller in Frank's previous collection. Its inclusion here is in response to numerous reader requests that it be reprinted larger.

Legacy: Frank Frazetta

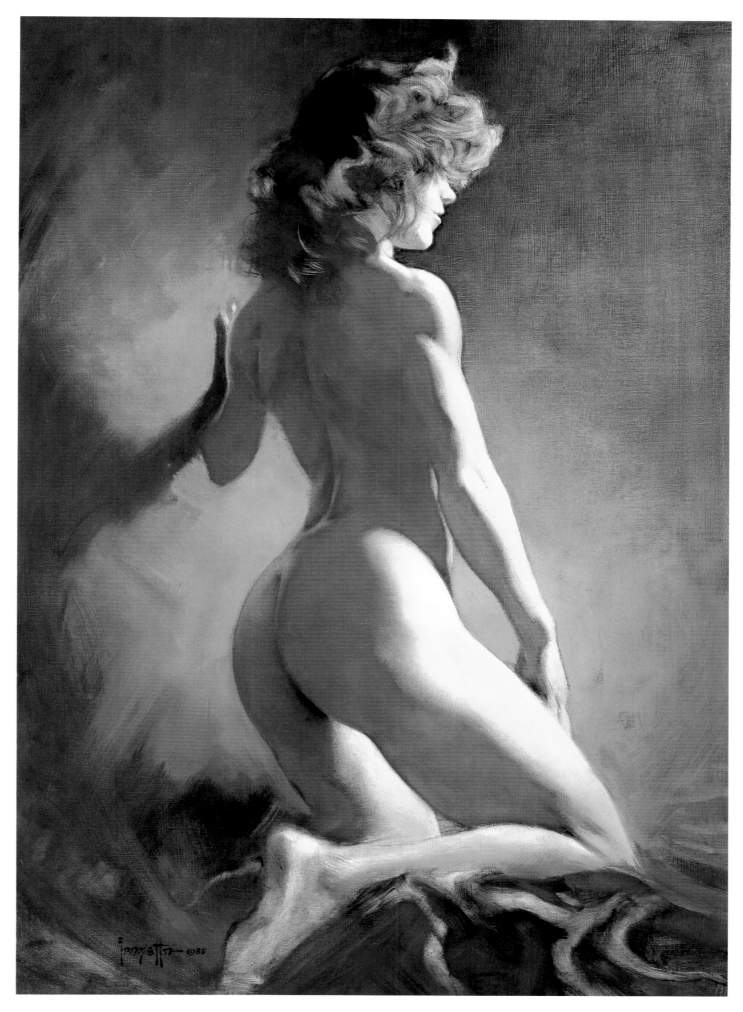

Legacy: Frank Frazetta

above:
An initial oil rough
for the book *Wolfshead*
by Robert E. Howard
[1968, 12"x12"]

opposite:
GREEN DEATH
Book cover to
Wolfshead
by Robert E. Howard
[Lancer Books, 1968,
16"x20", oil on board]

The importance of Frazetta's cover paintings to the success of books throughout the 1960s can't be emphasized too strongly. If a collection today sells 10,000 copies it's considered a bestseller: the various Howard compilations like *Bran Mak Morn* (Dell Books, 1969) and *Wolfshead* both featured Frazetta covers and both sold in excess of 85,000 copies. "I put my heart and soul into a lot of those early Howard books," Frank says. "I liked the publisher, I liked the energy of the stories, and I think I just really cut loose. I'm not saying Howard was a great writer, but he was very illustratable. The pictures just came pouring out: that doesn't happen too often."

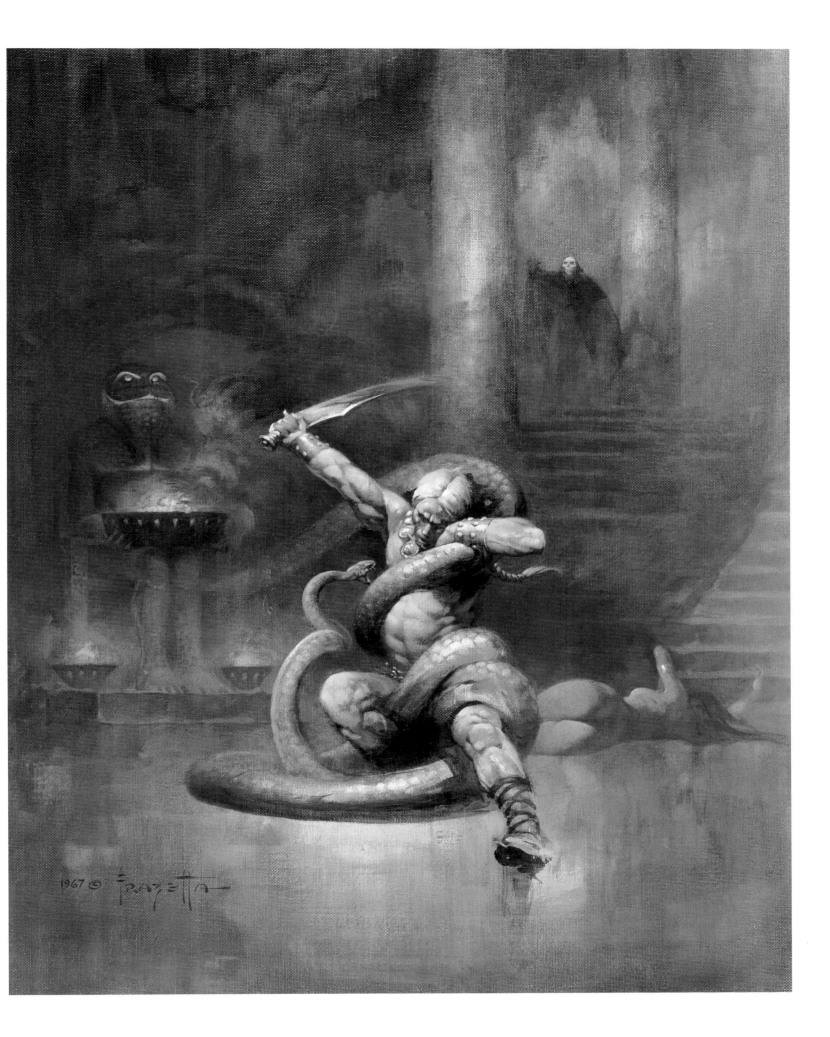

1967 © Frazetta

above:
Book cover to
The Eternal Champion
by Michael Moorcock
as it was originally published
[Dell Books, 1970, 15"x19"
oil on masonite]

opposite:
ETERNAL CHAMPION
Revised version of cover to
The Eternal Champion
by Michael Moorcock
[Personal work, circa 1994,
15"x19", oil on masonite]

A trademark of Frazetta's art is a strong central focal point, as exemplified by this wonderful cover for Michael Moorcock's novel. "As much as I'd like to sit there and render a lot of detail in the foreground, I know it will affect the way a viewer looks at the painting," Frank explains. "I have to wrestle with my convictions sometimes, because I have to make sure that I don't lose my sense of direction. I want the viewer's eye to go right where I want it to—then I want it to move around and take in everything else. I want to lead you into the picture, take you directly to a certain point, and send you on from there to find all the neat little things that I've done."

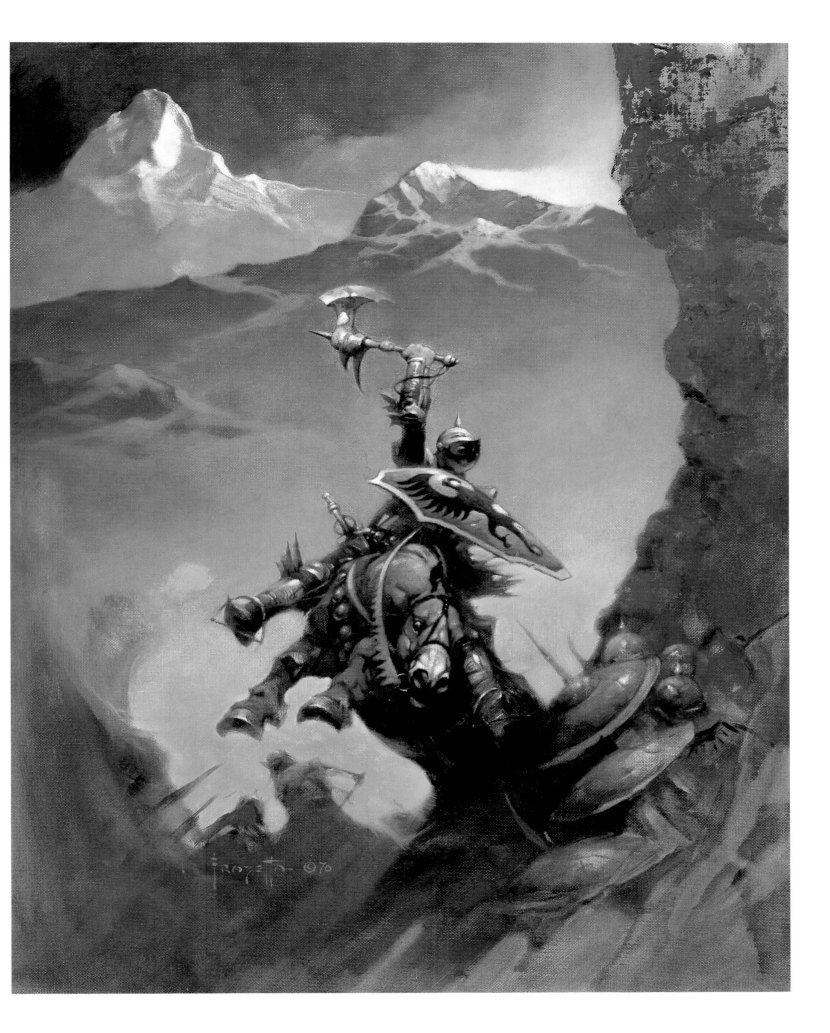

Legacy: Frank Frazetta

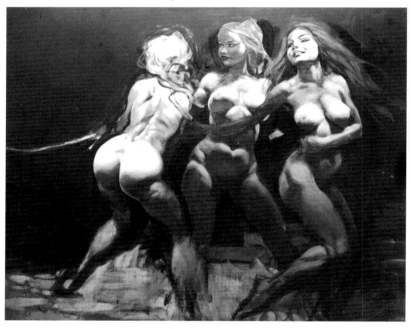

above:
Oil preliminary rough for
Arthur Rex
by Thomas Berger
[1978, 81/2" x 6"]

opposite:
PARADOX
Book cover to
The Book of Paradox
by Louise Cooper
[Dell Books, 1975,
15"x23", oil on board]

overleaf:
CASTLE OF SIN
Illustration for the
novel excerpt *Arthur Rex*
by Thomas Berger
[*Playboy* magazine,
September 1978,
24"x15", oil on masonite]

"I think that I was unfair in my feelings toward *Playboy* for a long time, " Frazetta admits. "Toward the end of my time with Al Capp I had been working up a batch of painted cartoons that I thought were just perfect for *Playboy*. Capp's brother took them and told me he'd run them by Hugh Hefner 'as a favor'. I waited and waited and finally I asked and he told me *Playboy* wasn't interested. I took that pretty hard. I was really bitter. Years later I found out that my stuff had never been shown—it was just Capp's way of keeping me in line: '*We're* paying you, Frankie, but boy would you have it hard otherwise,' you know, that sort of thing. So when *Playboy* asked me to do something I was more than happy to oblige."

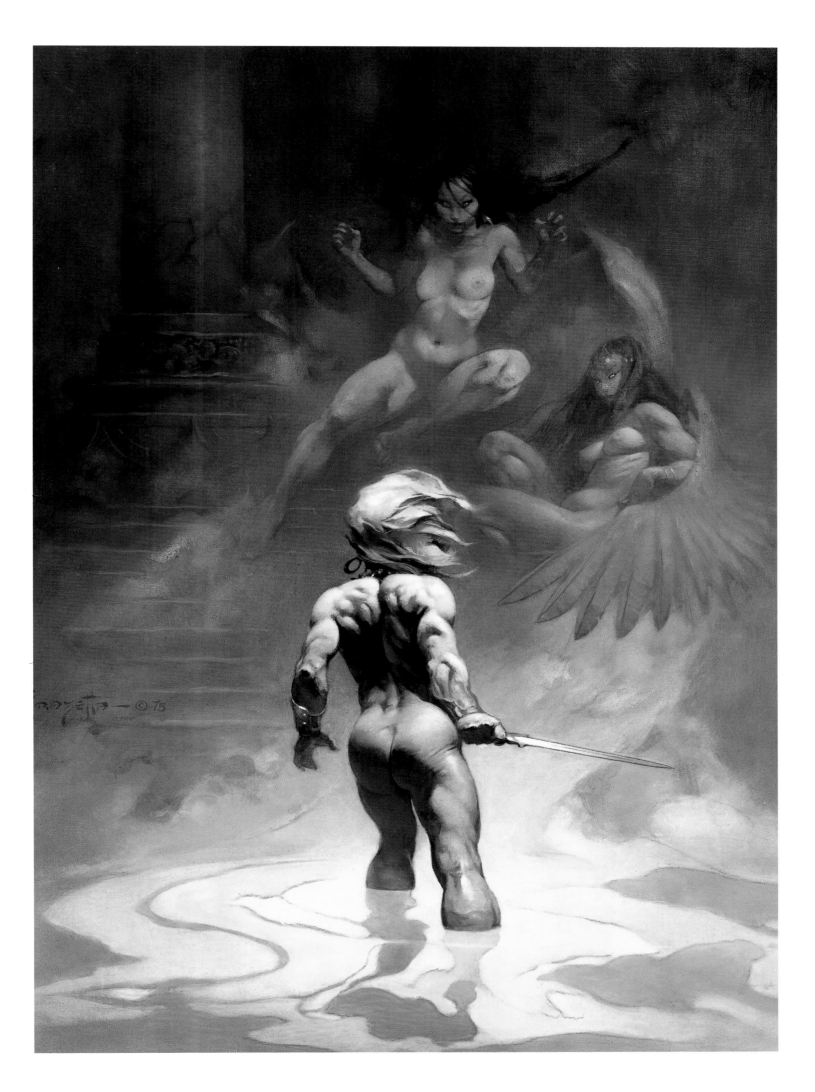

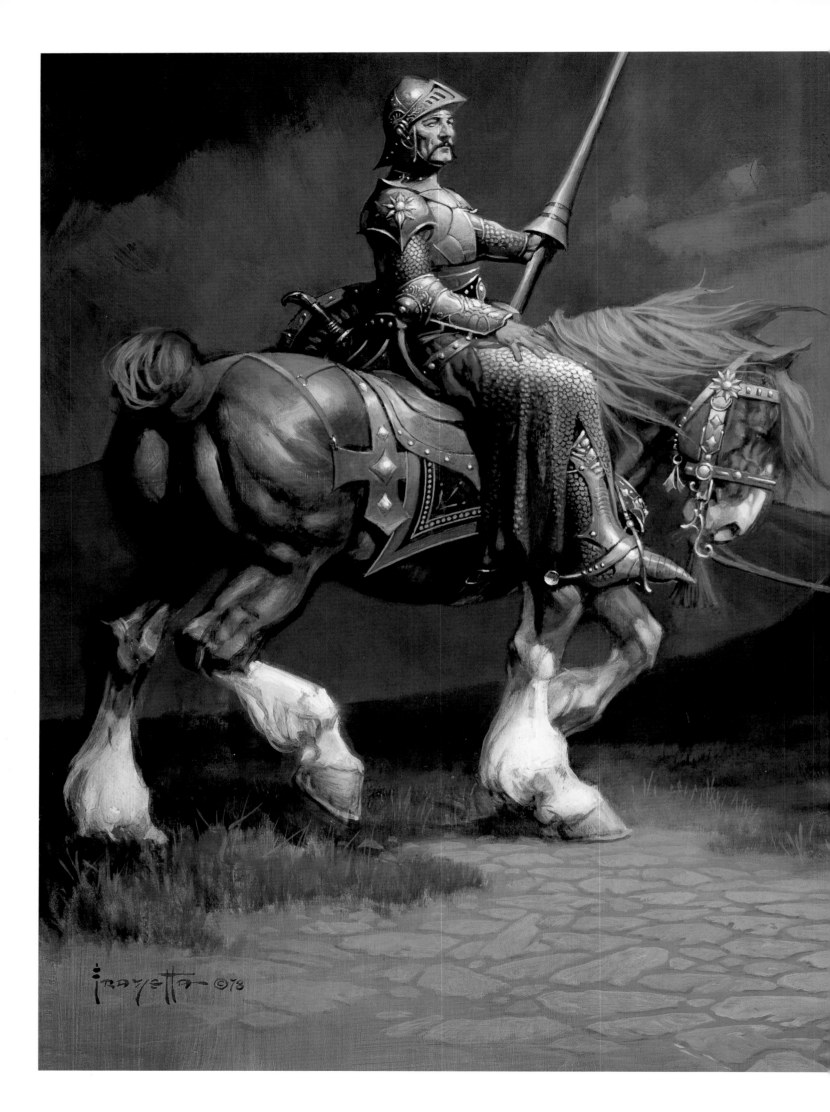

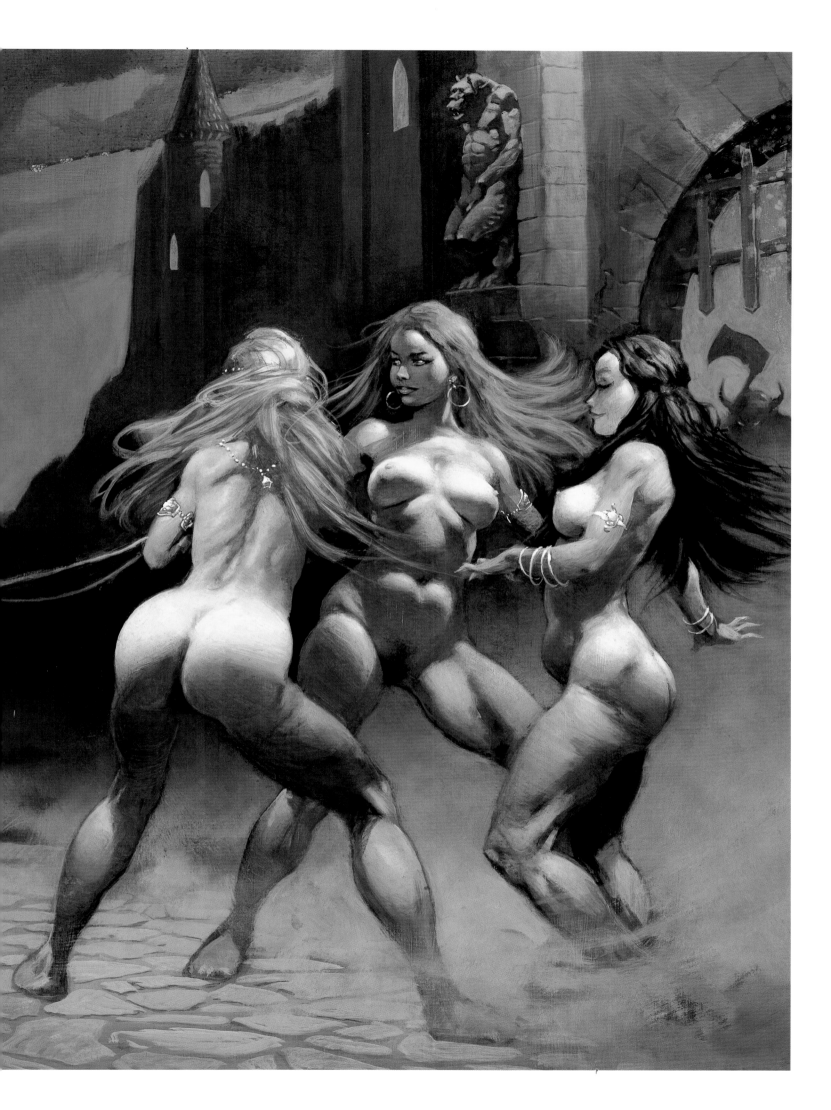

above:
An untitled sketchbook drawing [circa 1969, 9" x 7", ink on paper]

opposite:
FIRE DEMON
Book cover to *Swords Against Darkness* edited by Andrew J. Offutt [Zebra Books, 1977, 16"x23", oil on masonite]

"I enjoy drawing," Frazetta says, "but painting can be a bit of a drag. I like the early stages of a painting, when you've got nothing on the board, and you just start whacking stuff in and in a matter of hours the painting is practically there. And then I start polishing it up and getting the details and I kind of slow down. That's when it's not as much fun. When I start slashing away from scratch I'm having a pretty good time because I'm watching this thing materialize. But when I get to being about 85% done is when things slow down to a crawl. Working on the edges, pulling the whole picture together, can take longer than I like."

Legacy: Frank Frazetta

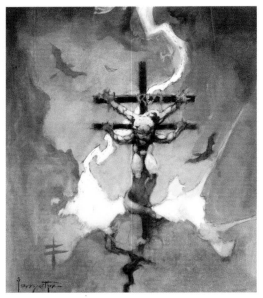

above left:
Magazine cover to
National Lampoon
[June 1972,
16"x23", oil on masonite]

above right:
Conceptual rough for
the *National Lampoon*
cover [5"x7",
gouache on paper]

opposite:
GHOUL QUEEN
Magazine cover to
National Lampoon
[August 1973,
16"x21", oil on board]

Publishers were able to get away with a lot more in the 1970s than they can today. If the *National Lampoon* were still publishing regularly it's doubtful the distributors and book superstore chains would agree to handle their "Tits & Lizards" issue with Frazetta's cover as seen on the facing page. Times and tastes change.

"One of the very few paintings Frank has done that I really didn't care for was the alien crucifixion," Ellie says. "It wasn't his idea; it's what the *Lampoon* people wanted. Having fun is one thing, but when you start messing with people's core beliefs, that's when the joke's gone way too far."

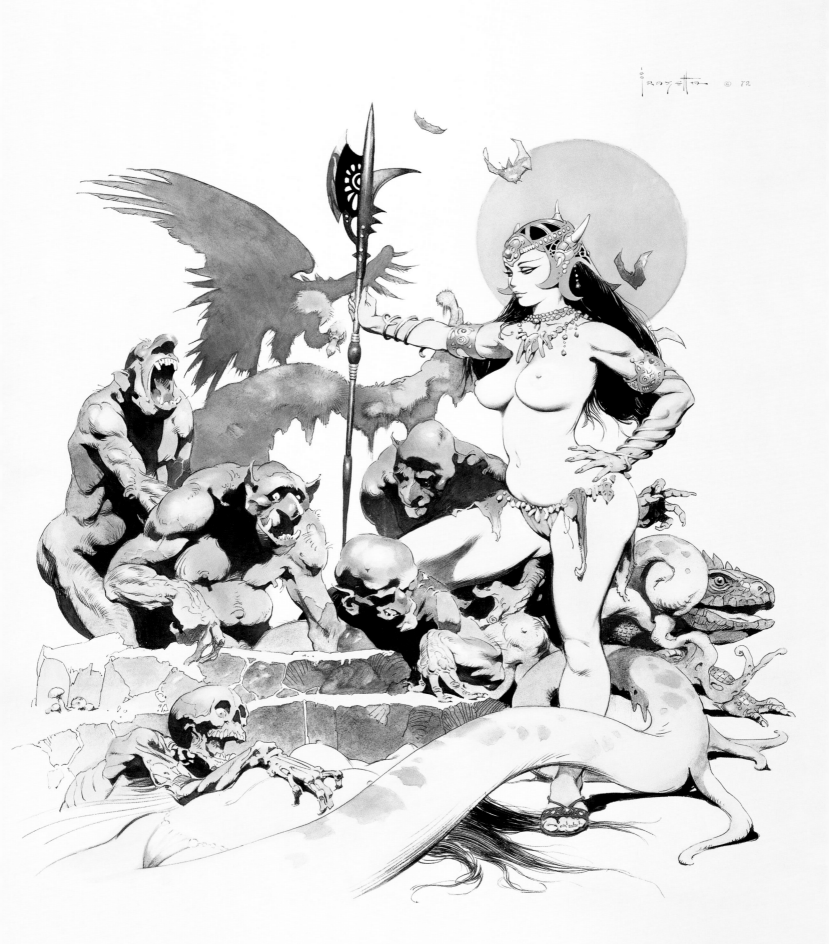

above:
An untitled sketchbook
drawing [circa 1957,
4" x 6", ink on paper]

opposite:
SEVEN ROMANS
Magazine cover to
Epic Illustrated
[Marvel Comics, issue #1,
1980, 16"x21", oil on board]

This moody painting of a squad of Roman soldiers guarding the battlements was Frazetta's only work for Marvel Comics. Magazine-sized and printed in full color, *Epic Illustrated* was edited by Archie Goodwin and was Marvel's attempt to compete with *National Lampoon's* much edgier *Heavy Metal* for the young adult comics consumer. "I always liked Archie," Frank says, "but I never cared that much for Marvel or their policies toward the ownership of an artist's originals or characters. They swung a deal where I didn't have to give anything up, so it offered a chance to do something for Archie again."

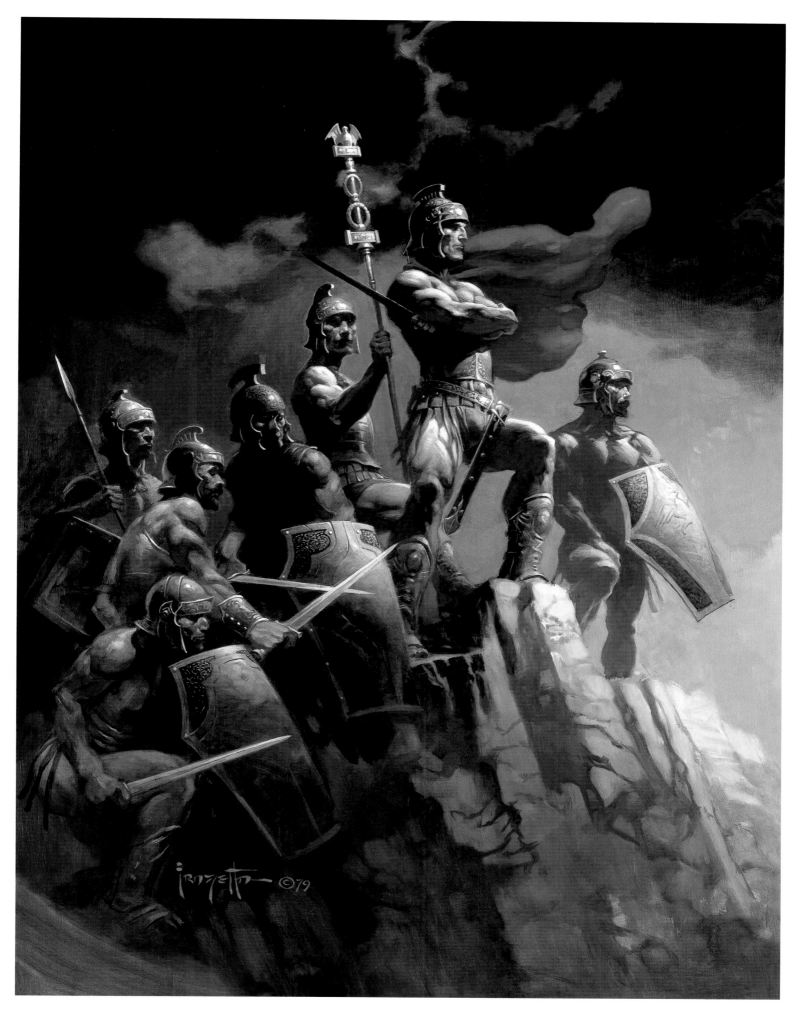

Legacy: Frank Frazetta

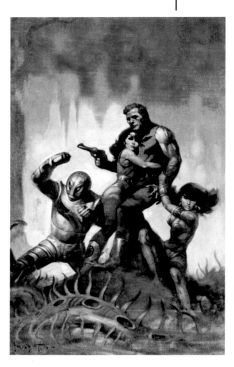

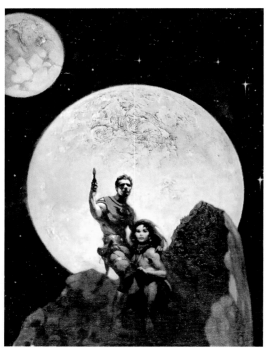

above left:
Book cover to
The Solar Invasion
by Manly Wade Wellman
[Popular Library, 1968]

above right:
Book cover to *Danger Planet*
by Brett Sterling
[Popular Library, 1968]

opposite:
INVADERS
Revised book cover to
Time War by Lin Carter
[Dell Books, 1977,
16"x21", oil on board]

overleaf:
MASTODON
Book cover to *The Creature
From Beyond Infinity*
by Henry Kuttner
[Popular Library, 1970,
24"x18", oil on board]

"I love technology," Frazetta says. "I love gadgets. But I don't like to paint them. I'm more concerned with the people, the human drama. It's a trap when an artist has no room to interpret. Yeah, I could sit here and paint super accurate space suits or machines or guns—and that's what the viewer would focus on, not the people or the situation. That's where a lot of these young guys begin to lose their way. They're not reinterpreting the world through their art, they're not bringing anything original to it, they're trying to make everything so real that the audience is no longer involved. It's take it or leave it and leave your imagination at home. Without that involvement from the viewer, what have you got? I don't think you've got very much at all."

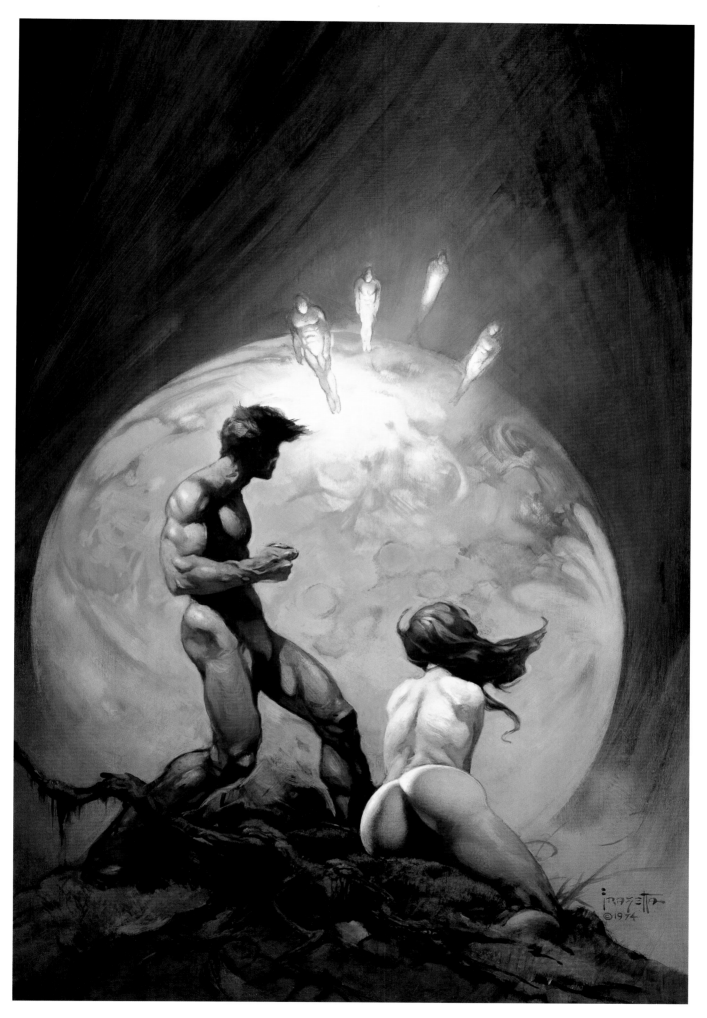

Legacy: Frank Frazetta

167

above:
An untitled sketchbook
drawing [circa 1977,
4" x 6", ink on paper]

BLOODSTONE
Book cover to *Bloodstone*
by Karl Edward Wagner
[Warner Books, 1975,
12"x19", oil on board]

Most of the sword and sorcery fiction that was rushed into print in an attempt to climb aboard the Robert E. Howard/Conan bandwagon was poorly conceived and derivative.

Not so with Karl Edward Wagner's [1945-1994] Kane series. Using as his central character a fantasy interpretation of the Biblical Cain and employing contemporary speech patterns instead of attempting to mimic medieval dialogue, Wagner's stories and novels, though extremely dark and brooding, were a breath of fresh air in an otherwise stagnant field.

Frazetta's paintings for the five Kane books [the cover for *Dark Kingdom* was included in *ICON*, p. 133] are some of his most dramatic works and effectively capture the cynicism and horror of Wagner's monstrous antihero.

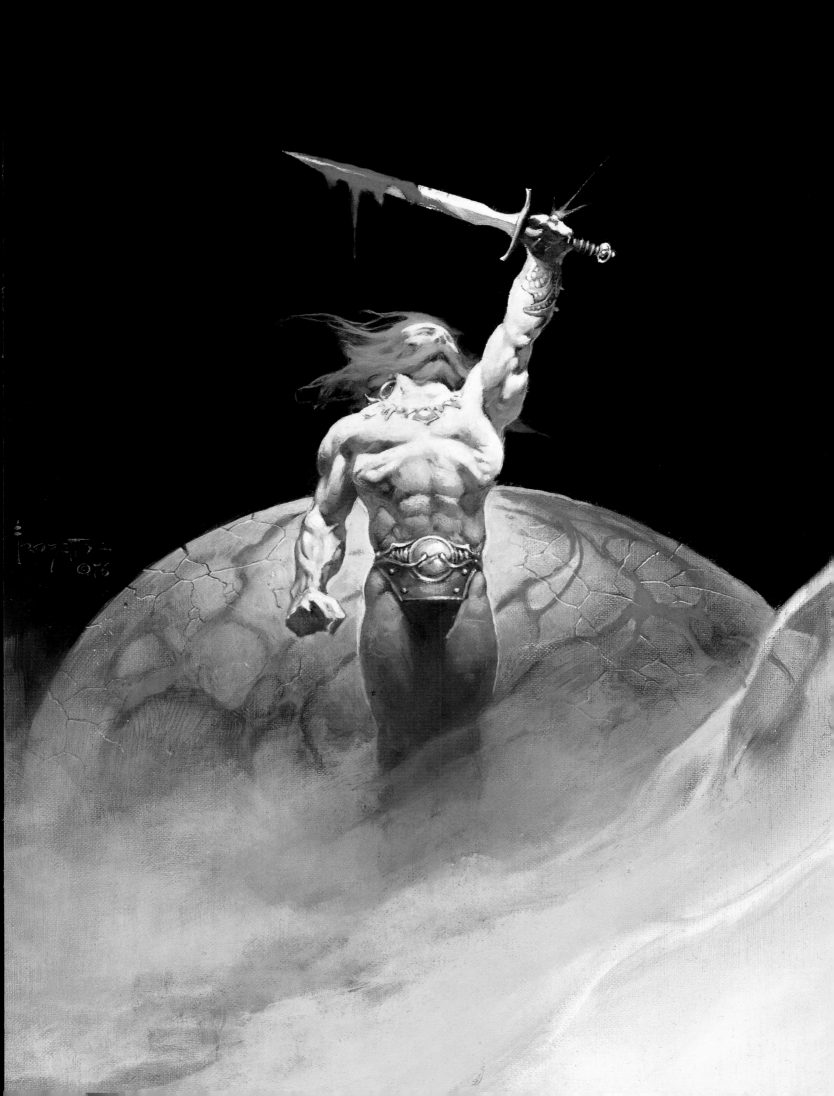

above:
An untitled sketchbook
drawing [circa 1973,
4" x 6", ink on paper]

NIGHT WINDS
Book cover to *Night Winds*
by Karl Edward Wagner
[Warner Books, 1978,
16"x20", oil on board]

Karl Wagner was hardly a prolific writer: each manuscript was laboriously tapped out with one finger. His writing career was further hampered by self-destructive tendencies that ultimately led to his premature death from liver failure. "I like my living *hard*," he told me once. Wagner looked and partied like a biker, but at his core was a kind man who couldn't contend with his own depression.

He was *very* appreciative of having Frazetta as his cover artist. "How lucky can I get?" Wagner asked in 1978. "I've loved Frazetta since the '50s. He put Bob Howard on the map after everyone else had failed. Frazetta is the hottest cover artist going and far from the cheapest: to have Warner hire him to paint my covers after the terrible treatment other publishers had given my books thrilled the kid in me. But it also sent a message to the adult in me that said that Warner was taking me seriously as a writer."

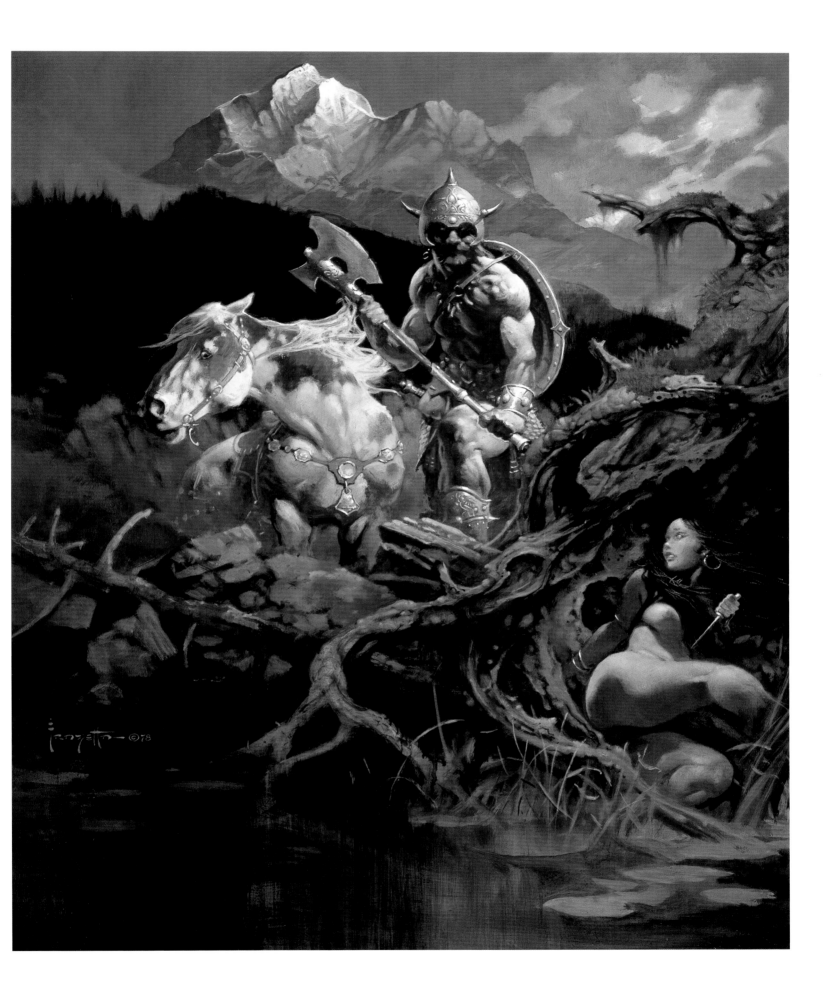

Legacy: Frank Frazetta

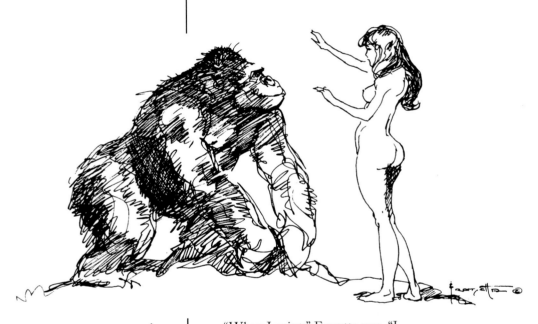

above:
An untitled sketchbook
drawing [circa 1973,
6" x 4", ink on paper]

opposite:
CAVE DEMON
Book cover to
Death Angel's Shadow
by Karl Edward Wagener
[Warner Books, 1978,
16"x21", oil on board]

"When I paint," Frazetta says, "I compose these wonderful shapes that are almost abstract. I'm more concerned with achieving a balance and rhythm than I am with subject matter. Once I've acheived that balance I start in on the details. The rhythm and balance of the shapes make the subject matter acceptable. My paintings can have a lot of action but they aren't especially violent: there's the suggestion of mayhem without being explicit. Violence can be handled completely wrong if you're not careful and I'm always aware that I'm on a tight-rope. If I wanted to I could paint something so brutal and violent that it would make you sick—I don't need that. Balance makes for beauty and that's what I aim for."

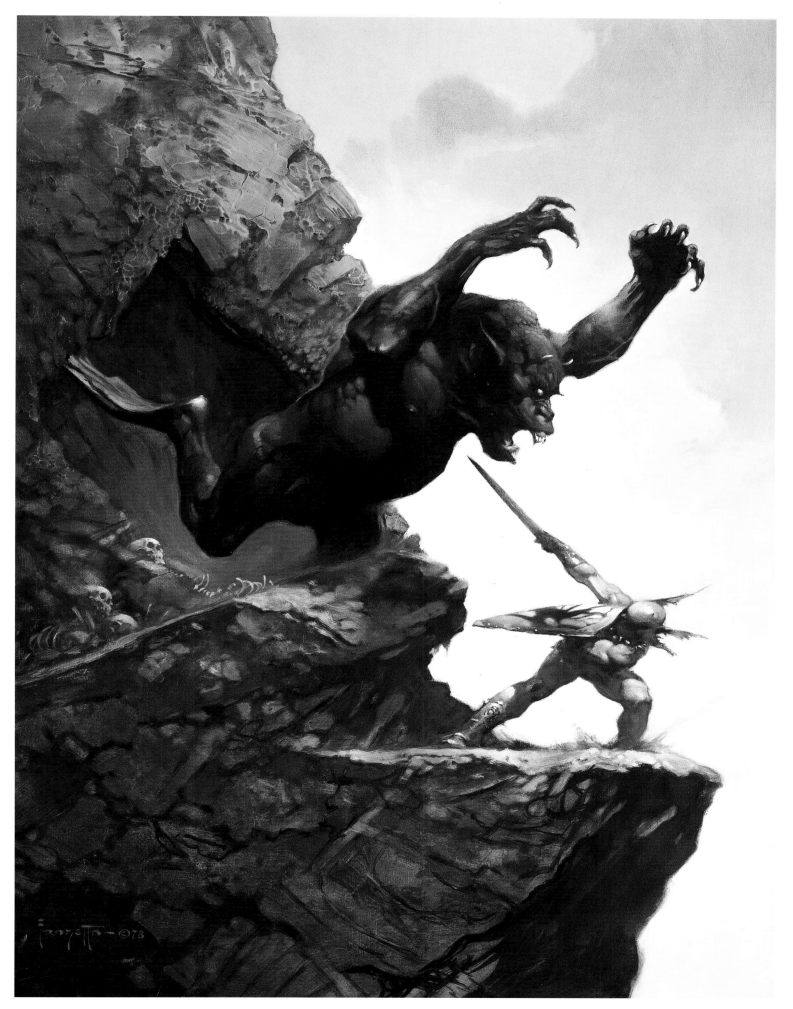

Legacy: Frank Frazetta

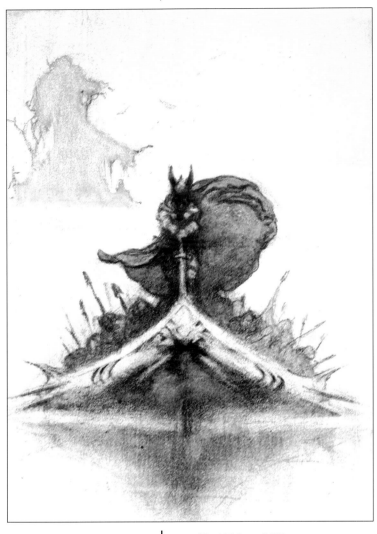

above:
A conceptual rough for
Darkness Weaves
[1978, 4" x 6",
gouache on paper]

opposite:
KANE ON THE GOLDEN SEA
Book cover to
Darkness Weaves
by Karl Edward Wagner
[Warner Books, 1978,
16"x21", oil on board]

Karl Edward Wagner was a respected editor as well as a writer. He compiled fifteen volumes of *Year's Best Horror*, several fantasy anthologies under the title of *Echoes of Valor*, and restored the preferred original text to Robert E. Howard's Conan stories in a series for Berkley Books.

In the latter part of his career Wagner turned to writing horror fiction and he was the recipient of both the World Fantasy and British Fantasy awards.

"I liked doing the Kane series," Frazetta notes. "There's a dark mood going on: you don't know whether to root for this guy or hope he gets taken out. Which would you prefer? That's the question I want going through the viewer's head when they look at these paintings."

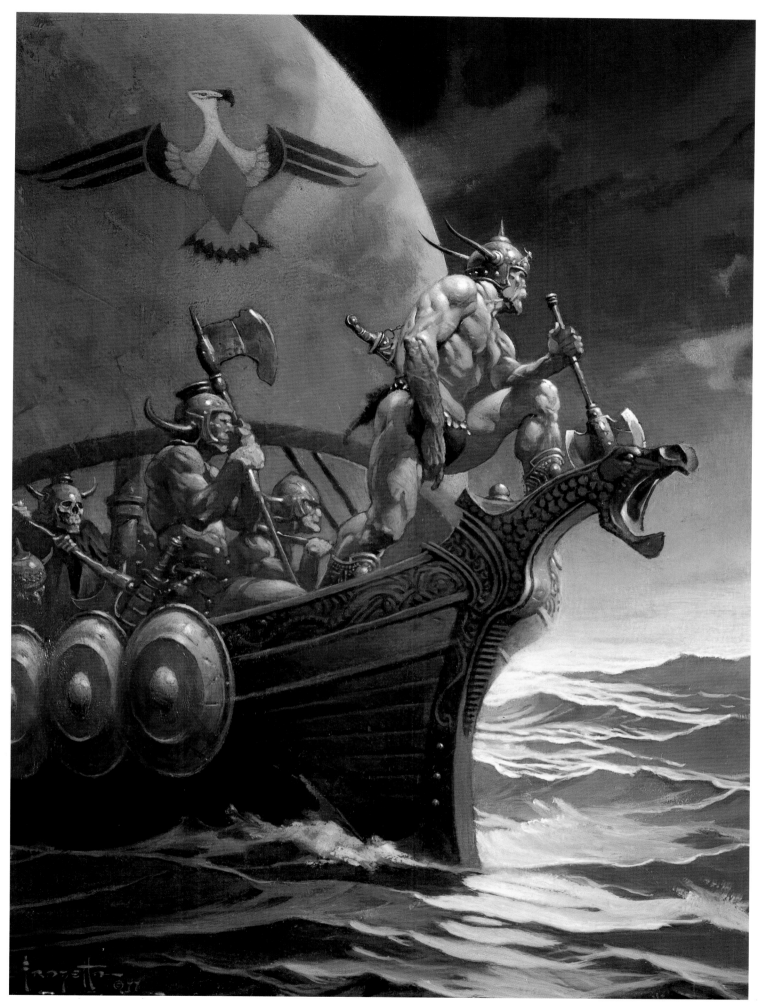

Legacy: Frank Frazetta

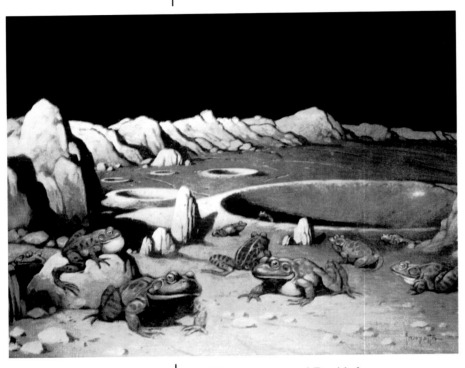

above:
FROGS ON THE MOON
A promotional painting for the
Science Fiction Book Club
[circa 1973, 16" x 12",
oil on canvas board]

opposite:
A REQUIEM FOR SHARKS
A promotional painting
for the Mystery Book Club
[circa 1973 (revised to its
present form sometime in
the 1980s), 16"x20",
oil on board]

Name a genre and Doubleday probably has a book club devoted to it. At the same time that Frazetta was painting new covers for the SF Book Club's Burroughs novels he was also providing promotional material for the Western and Mystery club mailings. The humor of "Frogs on the Moon" (above) is contrasted by the horror of "A Requiem for Sharks" (facing page), which suited Frank just fine. "One of the reasons I stopped doing movie posters regularly," he says, "is because I just got bored. Usually what they wanted was what they'd seen someone else do—originality meant nothing. I like variety. I like all kinds of things. They couldn't understand why money wasn't enough of a reason to take on a job. The book club stuff was fun: no one told me what to do. They were happy to have me and I was happy for the variety."

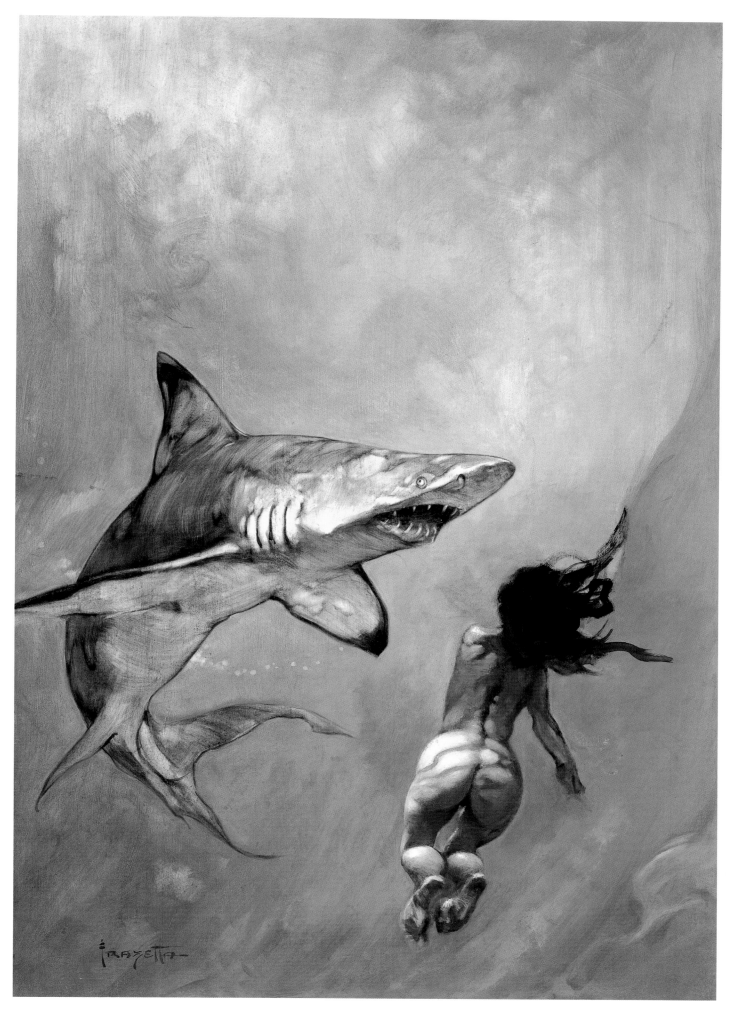

Legacy: Frank Frazetta

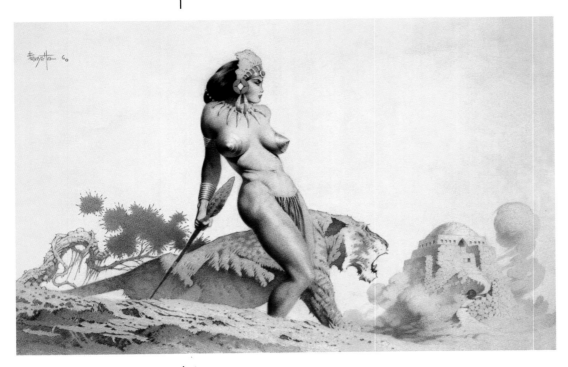

above:
LOST CITY
A personal work
published in color here
for the first time [circa 1964,
12"x9", watercolor on board]
transparency courtesy Illustration House

opposite:
A detail from "Lost City"

Joe Orlando was highly regarded as an editor and as a comics artist. He and Frazetta worked for EC comics and Warren Publishing during the same time periods and both had mutual friends. Shortly before his death in 1998 Orlando related the following story:

"Frank was in the studio, I guess around 1961 or '62, and he was showing the guys a little watercolor drawing and I heard him say, 'I'm painting now.' So I went over and said, 'Painting? Nooo, Frankie. A painting has depth and composition and shapes emerging from and blending into the color. This is just a colored comic book panel.' I proceeded to explain the differences and how he had failed miserably. Frank was standing there nodding, listening to this art lesson I was giving him. He reached down, pulled something from between a couple of pieces of cardboard, and handed me a canvas that made my jaw drop. I think it was one of his Tarzan covers: it was a *painting* by God. It was a true work of art. I'm standing there making noises like Porky Pig: 'b-duh, b-duh, that's all folks.' Frank gave me his best s.o.b. smile and said, 'I'm painting now.' I think I responded with something clever like, 'Yes you are.'"

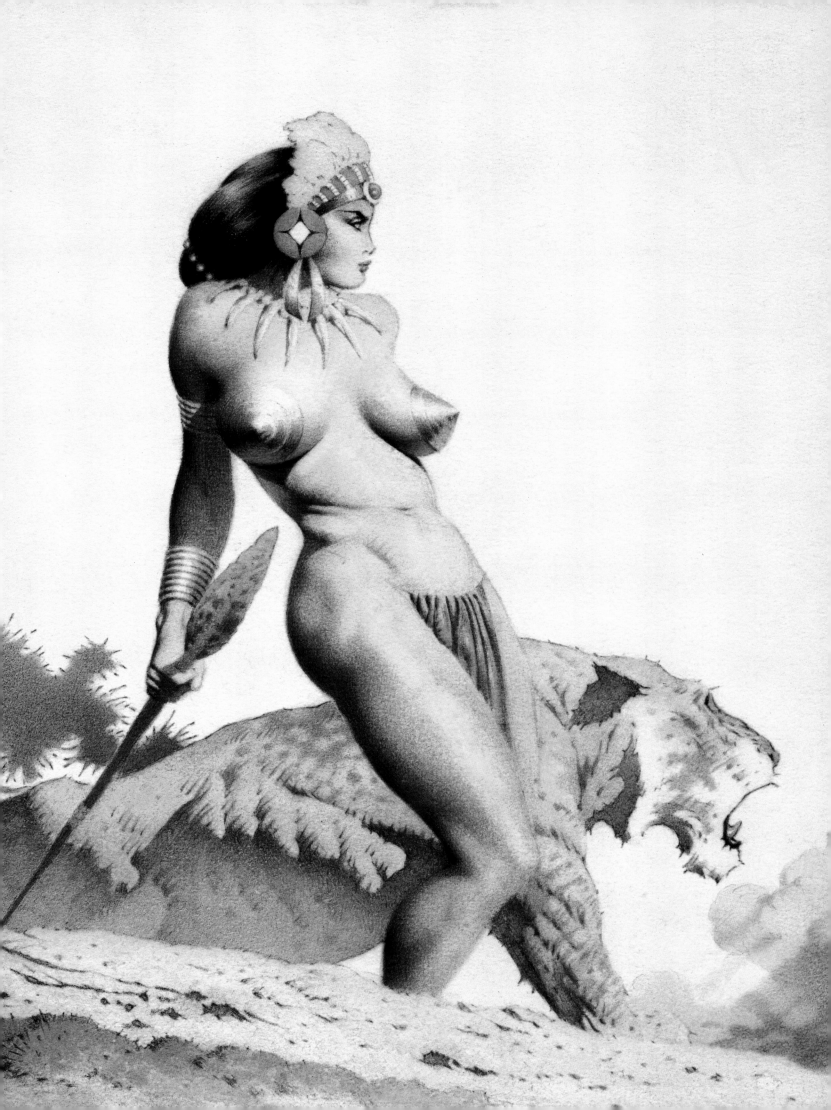

above:
Watercolor and colored pencil
preliminary rough for
Flashing Swords #1
edited by Lin Carter
[1973, 4¹/2" x 6"]

opposite:
THE NORSEMAN
Book cover to
Flashing Swords #1
edited by Lin Carter
[Science Fiction Book Club,
1973, 17"x23" oil on board]

"Everything I set out to do," Frazetta confides, "I try to do it to the extreme, and sometimes I've been criticized for that. They'll say, 'No, slow down.' Sinatra for example. You can see the type of guy he was: hyper-sensitive, at least when he was a young man. There was such a magic about his voice, and it was only because he was so sensitive. What happened to him was that he let Holloywood affect him. His ego took over. I never really let my ego take over and screw me up. I'm *confident,* but don't get that confused with having a big ego. I'm confident only because of the results. I can step back from a painting when it's finished and wonder, 'How the hell did I do that?' Sometimes I fail and sometimes I succeed—and, believe me, I can tell the difference. But there have been times when my hands were going literally without me. I was as surprised as everyone else at the results. It really *is* like magic."

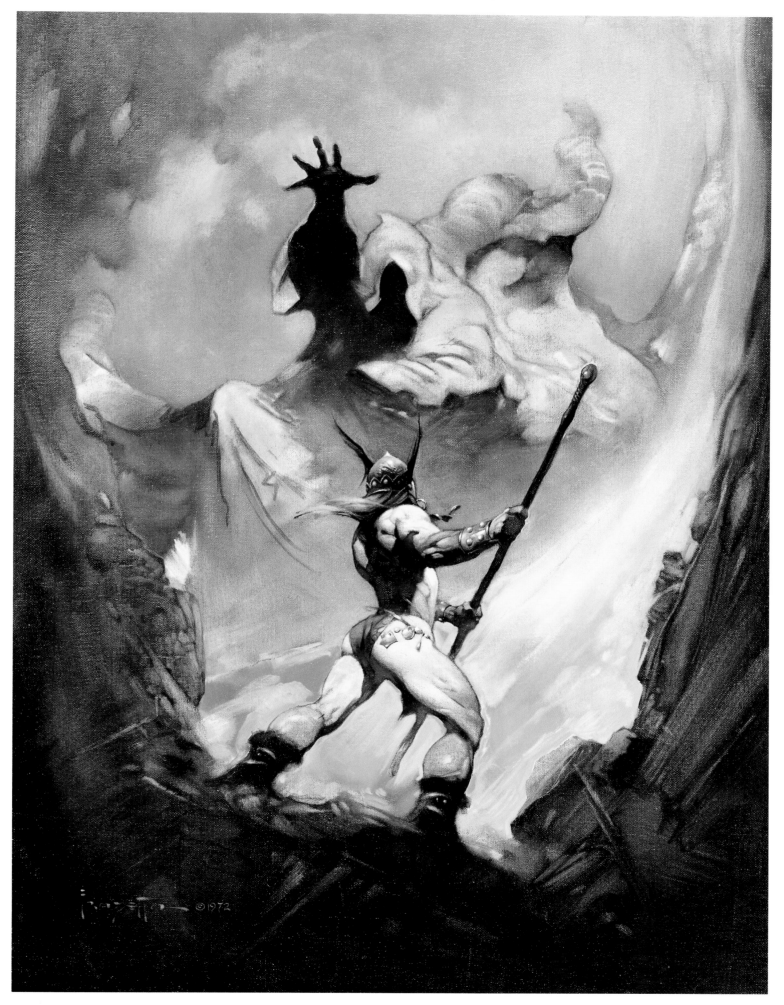

Legacy: Frank Frazetta

above:
Sketch used as the cover
to *Nostalgia Journal #27,*
the precursor to the
Comics Journal [1976,
8" x 10", ink on paper]

opposite:
WARRIOR WITH
BALL & CHAIN
Book cover to
Flashing Swords #2
edited by Lin Carter
[Dell Books, 1974,
16"x19" oil on board]

Throughout his career people have tried to analyze Frazetta through his work: rarely have they hit the mark. Frank seems to take it all in stride, but the friends who know him best sometimes get fed up with the distortions and half-truths. Nick Meglin recently wrote:

"No one wants to hear that Frank Frazetta is a family man who is deeply devoted to his wife and kids, not when there's a painting on the wall showing some primitive warlord wielding a golden sword. Why print that the artist, in his own real world, wields only a baseball bat, and not to crush a band of wild apes, but to send a benign baseball over the left field fence?

"Better to suggest that the craggy rocks and gnarled trees depicted in a Frazetta painting represent a dark outlook on a chaotic world; barbarians portray violence as a method of dealing with violence in a violent world; the sword...well, anyone who took Psych 101 or reads Ann Landers religiously knows what *that* means! Forget the inconsequential detail that Frazetta was illustrating a Conan adventure at the time."

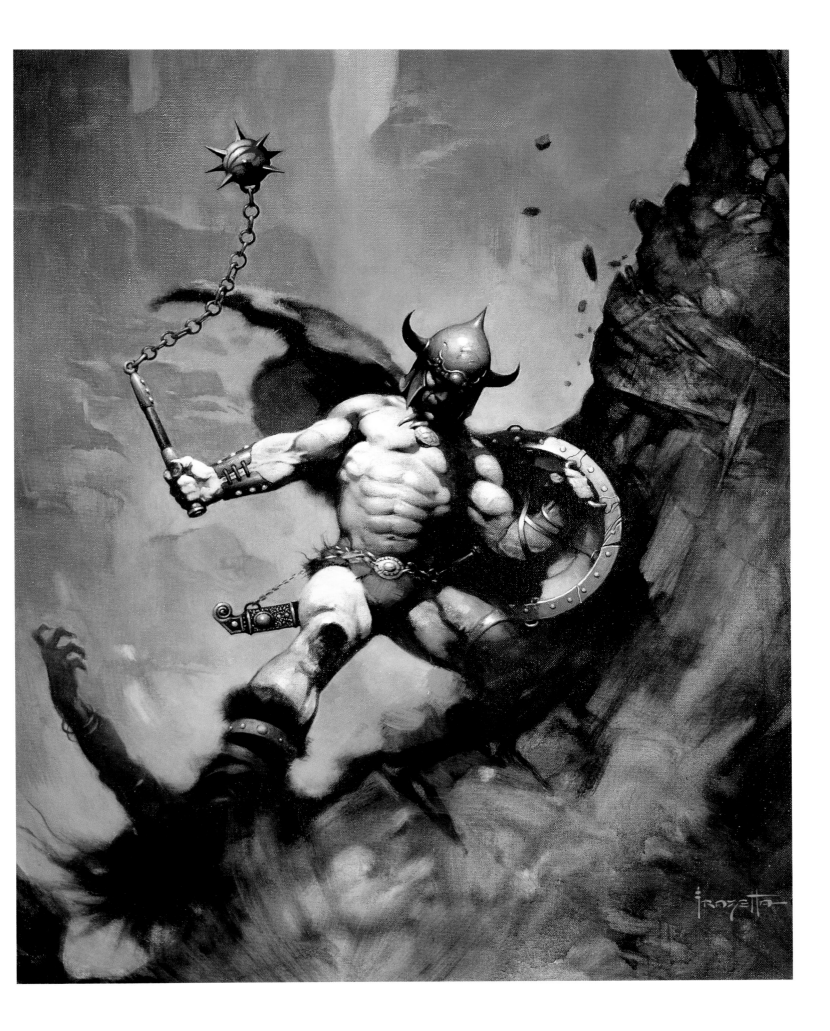

Legacy: Frank Frazetta

top:
The Frazetta Museum under
construction. March, 1999.

above:
Book cover to
Jongor of Lost Land
by Robert Moore Williams
[Popular Library, 1970,
16"x20", oil on board]

THE RETURN OF JONGOR
Book cover to
The Return of Jongor
by Robert Moore Williams
[Popular Library, 1970,
17"x22", oil on board]

Frank Frazetta's semi-retirement has given him time to think about his legacy. "When people come to the new museum I want them to be able to look at my work strictly within the context of art, not its association with Burroughs or Howard, but on its own merits. I don't want someone to look at a painting and think, 'Hey, it's Jongor!' That's the last thought I want to pop into their heads! I want people to get past all of these preconceived ideas of me and my work and look at it for what it is. I'm not a comic book artist, I'm not a fantasy artist, I'm not happy with any label people want to stick on me except 'artist.' Period. People who dismiss my work because of the subject matter haven't looked at it. I'm not pretending that I am a great painter: I don't think I am. I think there are plenty of people that paint better than I do. What I think I'll be remembered for is my imagination, for my sense of drama, and for not being afraid to take a chance."

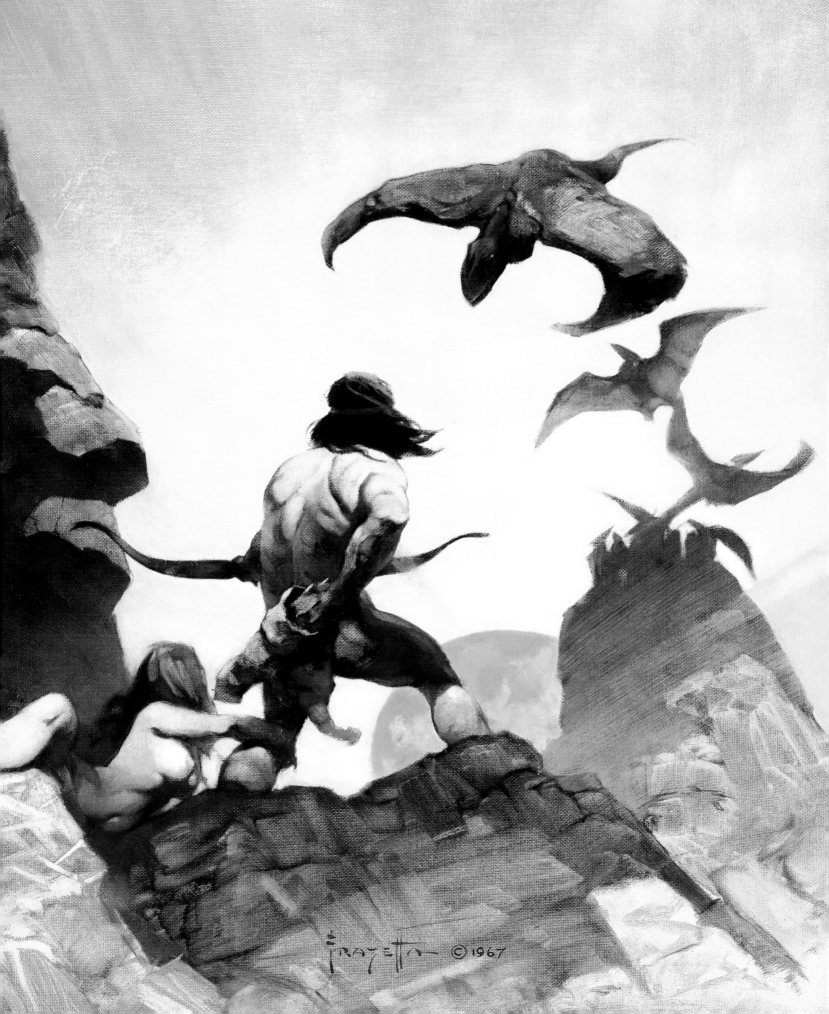

The one you've been waiting for!

BLACK EMPEROR

Third book in the
Black Lord, Black Master
trilogy
Stuart Jason
The saga of Royal—
born emperor—made slave!

Never before published!

above:
Book cover to
Black Emperor
by Stuart James
[Lancer Books, 1973,
14"x18", oil on masonite]

BLACK EMPEROR
Revised painting of the
cover to *Black Emperor*
by Stuart James
[Personal work, 1998,
14"x18", oil on masonite]

Many artists working today cite Frazetta as a source of inspiration: Frank's paintings continue to strike the same chord in a new generation that it struck in viewers fifty years ago. As artist Phil Hale points out, "I don't think Frank had a lot of questions. I don't think Frank felt guilty. His pictures are frankly unencumbered by the old rope of self-examination."

It is that instinctive quaility of Frazetta's paintings that set him apart from his peers, an originality that distinguishes him from even his most careful imitators. He has always gone his own way, for good or for bad, and never worried about the consequences. He's the tough guy that doodles pixies, the cartoonist who creates works of fine art, an *artiste* with a portfolio of Popeye drawings. He's an enigma and a contradiction, hard to explain and impossible to forget. He's Frank Frazetta.

And there is only one.

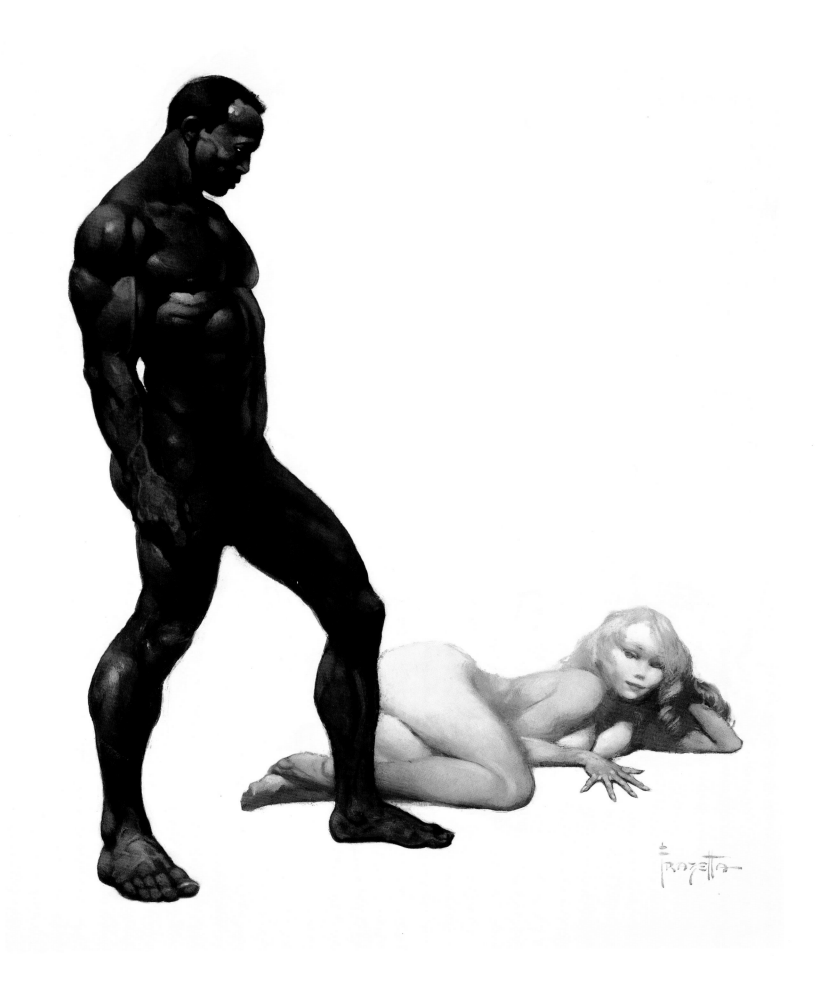

Legacy: Frank Frazetta
189

Art For the Collector.

For the first time Frazetta's masterpiece, "The Silver Warrior," will be offered as an extremely limited ed[
[o]n of 500 impressions. This is as close as you will ever come to owning the original: the art will hang in the per[
[ma]nent collection of the Frazetta Museum to be viewed by the world.

This edition is virtually undistinguishable from the original painting; a stunningly framed replica printe[
[on] artist-grade canvas and stamp-signed. This replica captures the ethereal quality of the original by preserving[
[the] wonderful depth of color, subtle textures, and mysterious artistic presence. The reproduction is a joy to beho[ld]
[an]d captures much of the thrill of standing before a Frazetta original.

Other features include an imported ornate hardwood frame which contains a solid brass museum plate [
[etc]hed with the title and the individual number of the limited edition. This limited print is also ready to hang a[nd]
[in]cludes a pre-attached museum grade picture wire on the reverse. Take it out of the box and hang it on the wall[.]

Each print includes a certificate of authenticity that is signed and numbered in accordance with your edi[tio]
[o]n.

Please remember that this is a very small edition with a focus on value and quality. The discriminating [co]
[co]llector wants only the best, and this edition of "The Silver Warrior" satisfies that demand for quality by em[-]
[plo]ying only the highest possible state-of-the-art production values. Once you see it, you will want it. This edi[-]
[tio]n is guaranteed to sell out quickly: do not delay. Why deny yourself the pleasure?

Frank Frazetta S[

Frank Frazetta Art Galle[ry

$499 @ *plus $20 shipping and insurance*

please add state sales tax as applicable.

To Order call toll free 888-299-0323 Visit our Website: www.frazettaartgallery.com

Art For Everyone.

Frazetta Book 1 features an exciting selection of rare and previously unpublished art reproduced in gorgeous full color. Softcover, 8¹/₂x 11, 72pp. $29.95

Frank Frazetta: The Living Legend features a stunning variety of brush and ink drawings including rare and unpublished examples. Softcover, b&w, 8¹/₂x 11, 96pp. $15.00

The Frank Frazetta Print Catalog features the most recent selection of posters by the Grand Master of Fantastic Art. Printed in full color, the catalog is a quick reference to nearly 100 magnificent works—all reproduced from the original art and personally approved by Frank Frazetta. Posters are priced at $10 each (plus $5 postage). Fans on our mailing list are the first to learn about special products and unique offerings. Catalog price: $5.00

Make all checks payable to Frank Frazetta

P.O. BOX 919, MARSHALLS CREEK, PA 18335

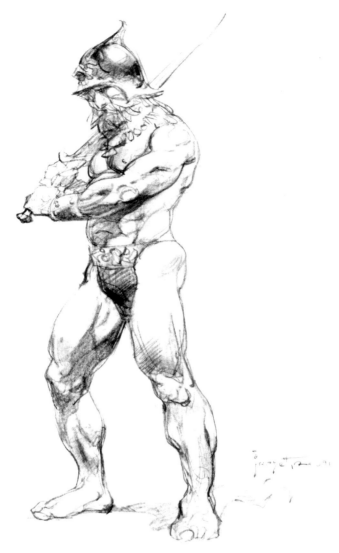

If you enjoyed *Legacy*, please look for Underwood Books' other
volumes devoted to the fantastic arts at your favorite bookstore including:

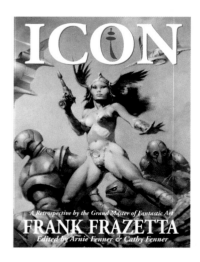